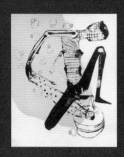 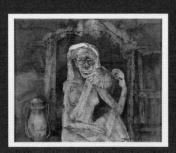 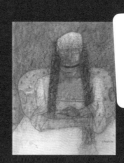

 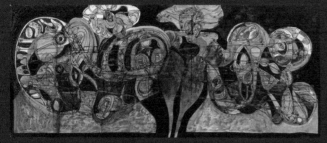

 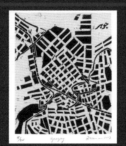 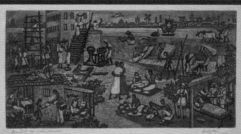 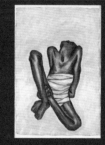

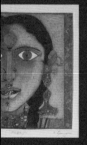 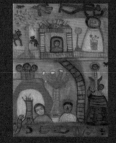 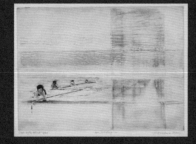 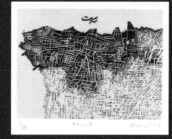

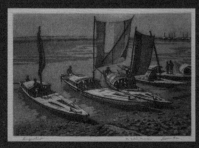 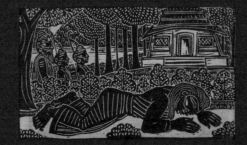 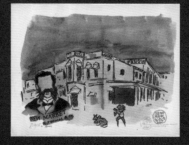 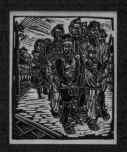

PAPER TRAILS

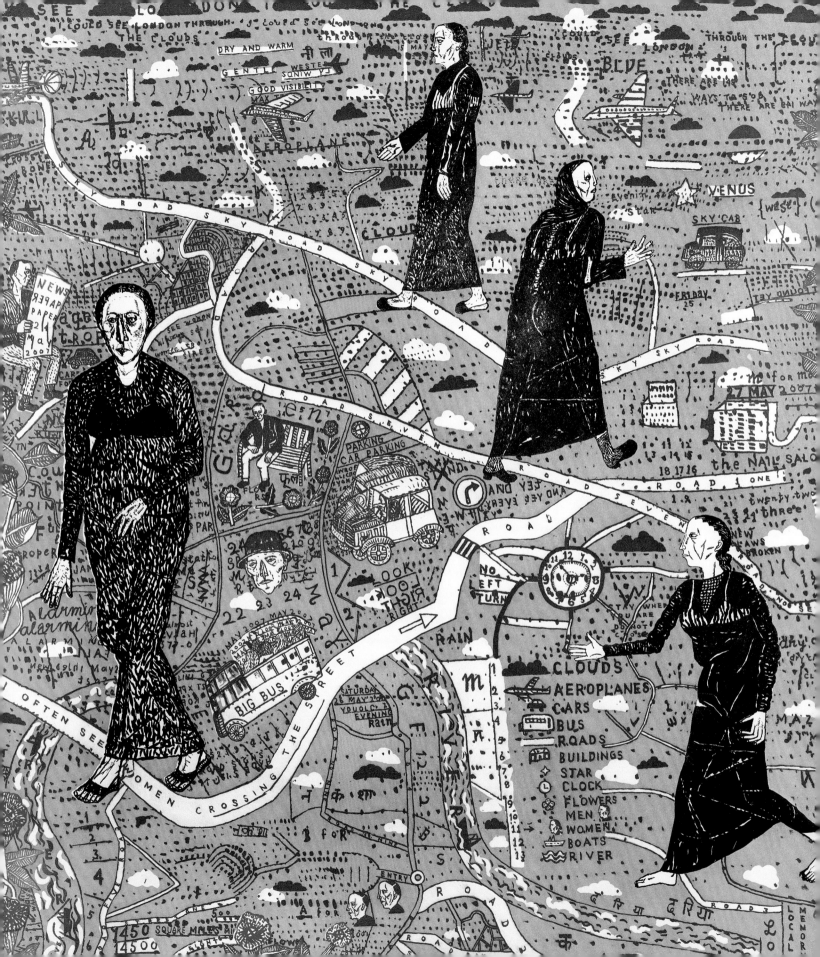

PAPER TRAILS

Modern Indian Works on Paper
from the Gaur Collection

EDITED BY

TAMARA SEARS

WITH CONTRIBUTIONS BY

TAMARA SEARS
MICHAEL MACKENZIE
PAULA SENGUPTA
EMMA OSLÉ
DARIELLE MASON
REBECCA M. BROWN
JEFFREY WECHSLER
KISHORE SINGH and
SWATHI GORLE

Grinnell College Museum of Art

IN ASSOCIATION WITH

MAPIN
PUBLISHING

First published in India in 2022 by

Grinnell College Museum of Art
1108 Park St, Grinnell, IA 50112, United States

in association with

Mapin Publishing Pvt. Ltd
706 Kaivanna, Panchvati, Ellisbridge
Ahmedabad 380006 INDIA
T: +91 79 40 228 228
F: +91 79 40 228 201
E: mapin@mapinpub.com
www.mapinpub.com

in conjunction with the exhibition '*Paper Trails: Works on Paper from the Gaur Collection*' from September 27 to December 10, 2022, at the Grinnell College Museum of Art, Iowa (USA).

International Distribution

North America
ACC Art Books
T: +1 800 252 5231
F: +1 212 989 3205
E: ussales@accartbooks.com
www.accartbooks.com/us/

United Kingdom, Europe and Asia
John Rule Art Book Distribution
40 Voltaire Road, London SW4 6DH
T: +44 020 7498 0115
E: johnrule@johnrule.co.uk
www.johnrule.co.uk

Rest of the World
Mapin Publishing Pvt. Ltd

ISBN: 978-93-94501-07-2

Copyediting:
Mithila Rangarajan / Mapin Editorial

Proofreading:
Marilyn Gore / Mapin Editorial

Design:
Deanna Luu

Production:
Mapin Design Studio

Printed in China

Grinnell College **Museum of Art**

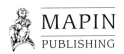

MAPIN
PUBLISHING

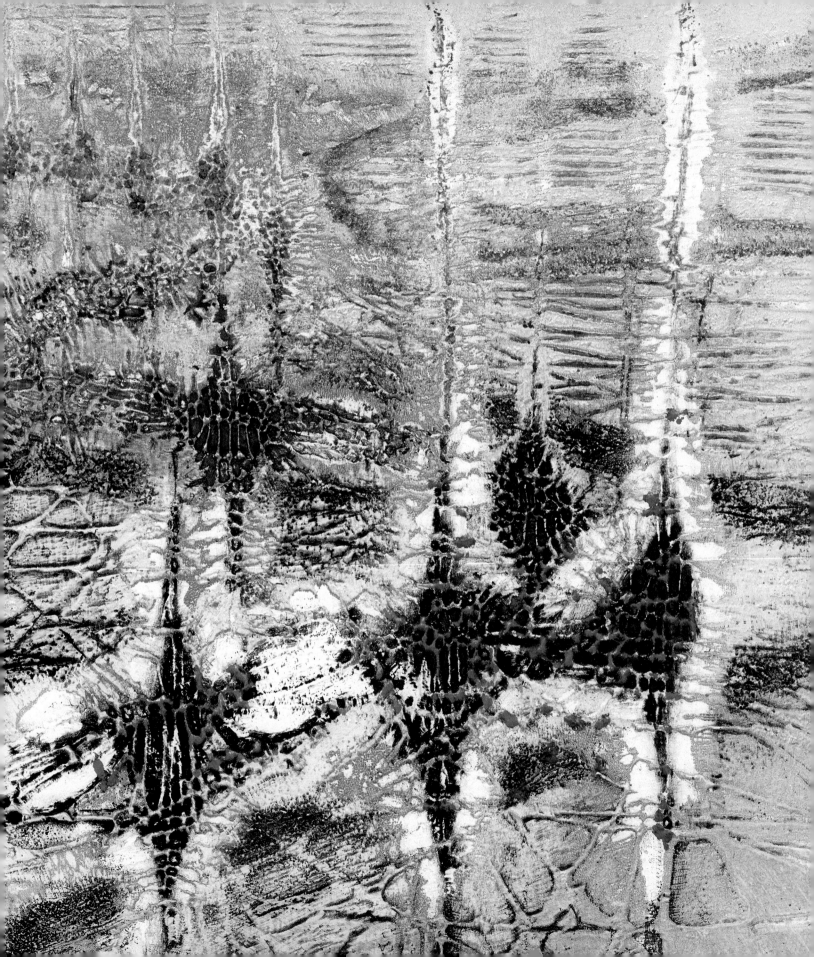

Contents

Foreword

Anne Harris, President, Grinnell College

The gathering of artists and audiences in this exhibition creates community around crucial issues of human experience and society. Through the vision of Umesh and Sunanda Gaur, Grinnell College has now had the honor of twice hosting the conversations, excitement, realizations, and further research that their collection of Indian art fosters. Coming to a small town in Iowa to think globally is not as paradoxical as it may first appear, for it speaks to the dynamic of the expansiveness of the art featured in this exhibition: works on paper occupy a specific and most often physically small place but, through interactions, the exchange of ideas, and the enthusiasm of shared experience, they have an expansive reach into the human imagination.

The act of gathering in front of a work of art, or over the pages of this catalog, puts viewers in community with artists and with each other. In this sense—and in this exhibition—art simultaneously is and creates a site for a community of inquiry. Works on paper have their materiality in common with books, which they then manipulate in scale, intensity, color, and, of course, content. In the material *commonality* between works on paper and books, we find the idea of knowledge, as human societies have long used books to codify what is known, imagined, and desired. In the material *manipulation* that works on paper creatively engage, we find the element of wonder: that two dimensions could project and provoke such depth of emotion, so many perspectives, and reach out so far into human experience. Knowledge and wonder are at the dynamic center of a thriving community of inquiry, and this exhibition brings both at every turn.

In its work of gathering and creating community, and in that community being one of curiosity and connection, this exhibition is doing the crucial work that institutions like Grinnell College and other sites of inquiry engage: bringing people together in a shared experience to create knowledge and learn from it—ideally and practically for the betterment of the

human condition. In the brilliant work of curator Dr. Tamara Sears, this exhibition enacts the work of the humanities as well, engaging the human experience in terms of space and place, identity, critique, myth and religion, storytelling, and the open invitation of abstraction. It also engages the work of the humanities by asking questions of us through its content and curatorial arrangements. A viewer of this exhibition is a participant and can find all of the joys of discovery of being a student in the questions and issues the works of art bring forth.

Art creates community; it also creates time—welcome and necessary time to think, consider, and critique. In a fascinating simultaneity, art both takes *and* creates time: it takes time to make, to come into being, both intellectually and materially. Once the work of art exists, it creates time by being gathered in a marvelous exhibition such as this one and inviting viewers into contemplation, by stilling them to wonder, and engaging us in a different pace of thinking and feeling. We have to work, perhaps harder than ever, to find that time for critical thinking and we must, because it is in that time that our understanding of the human condition deepens, and it is in that time that our creativity in addressing the challenges to human thriving awakens.

I noted at the beginning of this foreword that this exhibition is the second one from the Gaur Collection that Grinnell College has had the honor to host. Active in this renewed partnership is the dynamic of relationships that I find important to acknowledge as we consider the works of art in this exhibition. Of the many experiences that art is and creates, that of being a repository of relationships is crucial to the fostering of a community of inquiry that is itself so important in institutions like colleges and human societies. Within the physical memory of these works on paper are the relational gestures of artists, gallery owners, collectors, and curators, atop of which are layered the gazes and words of viewers. Looking at the works of art in this exhibition will put you in relationships with its artists and its other viewers and the societies in which they all create and exist. In those relationships exist endless possibilities of connection, discovery, and realization as the emotional, intellectual, and social *work* of the work of art takes place. I warmly welcome you to Grinnell College and wish you deeply meaningful experiences and exchanges in your engagement with *Paper Trails: Modern Indian Works on Paper from the Gaur Collection*.

Director's Acknowledgement

Susan Baley, Director, Grinnell College Museum of Art

"Our motivation to collect modern and contemporary Indian art is the pure joy of collecting... We also feel that our enjoyment of collecting is greatly enhanced by sharing the collection with a wider community of art lovers. In particular, we greatly enjoy working with museums in promoting modern Indian art in America."

Umesh and Sunanda Gaur

The Grinnell College Museum of Art is grateful to Umesh and Sunanda Gaur for sharing their collection with our audiences in rural Iowa. The Gaurs' generous spirit is reflected in their dedication to the educational impact of the collection when it is exhibited—especially in an area where there are few opportunities to view modern and contemporary art from India. In 2017, the Museum hosted the exhibition *Many Visions, Many Versions: Art from Indigenous Communities in India*, organized by International Arts and Artists, from the Gaur Collection. The positive response to that exhibition led to *Paper Trails: Modern Indian Works on Paper from the Gaur Collection*, displayed in the Museum's Faulconer Gallery from September 27 through December 10, 2022.

Paper Trails, featuring about a hundred paintings, drawings, and prints on paper, offered Grinnell College the opportunity to collaborate with faculty and students at Rutgers University. The exhibition was curated during a seminar on curatorial studies at Rutgers University's Department of Art History. Professor Tamara Sears, a specialist in South Asian art and architecture, taught the doctoral level course, with student participation from Emma Oslé, Swathi Gorle, Margo Weitzman, Sopio Gagoshidze, William Green, and David Cohen.

During the Spring 2022 semester, Michael Mackenzie, Art History Professor at Grinnell College, taught an introductory course in Indian art and assigned his students to do research about works included in *Paper Trails*. The text written by his students will be used as wall text for the exhibition at Grinnell College. Dr. Mackenzie's primary specialty is German

modernism between the World Wars, with additional academic interest in the art of India. His knowledge of modernism and Indian art reflects the origin story of the Gaur Collection, which began 25 years ago with works by members of the Bombay Progressive Artists' Group, a short-lived movement founded in 1947 to celebrate traditional Indian painting while acknowledging European and American Modernism.

Professor Sears and Professor Mackenzie also wrote essays for the catalog. Additional contributions were made by Paula Sengupta, Emma Oslé, Darielle Mason, Rebecca Brown, and Jeffrey Wechsler. Jeffrey Wechsler also served as a curatorial consultant for the exhibition. The Museum is appreciative of each scholar's role in this publication. We also wish to thank Deanna Luu who designed the catalog, generously funded through a grant from the E. Rhodes and Leona B. Carpenter Foundation.

Former Museum Director Lesley Wright, who retired in December 2021 after 22 years at Grinnell College, wrote the successful grant application to the Carpenter Foundation. Associate Director Daniel Strong has played a critical role in managing the details for the exhibition and its accompanying publication. I also want to acknowledge the other Grinnell College Museum of Art team members: Jodi Brandenburg, Museum Guard; Amanda Davenport, Administrative Assistant; Jocelyn Krueger, Collections Manager; Milton Severe, Director of Exhibition Design; and Tilly Woodward, Curator of Academic and Community Outreach.

We express gratitude to Shuchi Kapila, Professor of English at Grinnell College, for her enthusiasm in bringing both exhibitions from the Gaurs' collection to Grinnell, through her leadership role in the College's Institute for Global Engagement.

As always, the Museum is deeply appreciative of the support of President Anne Harris and the Grinnell College Board of Trustees. We are proud of the way this exhibition reflects the core values of the College: excellence in liberal arts education, a diverse community, and social responsibility.

Finally, we again extend thanks to Umesh and Sunanda Gaur for their dedication to collecting art connected to their cultural heritage and for sharing their collection with a wider community. This project would not have been possible without their passion for modern and contemporary art from India.

Curator's Preface and Acknowledgements

Tamara Sears

The *Paper Trails: Modern Indian Works on Paper from the Gaur Collection* exhibition emerged through a collaborative pedagogical process, as the culmination of a semester-long seminar, conducted during the spring of 2019, aimed at workshopping curatorial practices at the master's and doctoral level. The course was designed to fulfill both a general elective requirement for the graduate programs in Art History at Rutgers University, New Brunswick, NJ, and a specific practicum requirement for our curatorial studies program. Although the final version of the exhibition reflects significant revisions to the ordering and interpretation of specific works, the original underlying conceptualizations and curatorial logics bear the indelible imprint of the intensely collaborative conversations undertaken that spring. Whereas the first half of the semester was structured around a series of readings and discussions, the second half unfolded as a practicum spent primarily in the Gaurs' gallery space. We engaged the collection hands-on, looking at each work and each artist individually as situated within both a post-colonial present and a longer history of aesthetic practice in the Indian subcontinent. As we did so, we thought through the various ways in which the works could also be connected, in terms of both creative practice and broader social, cultural, or political thematics.

Throughout the semester, students brought their own personal experiences and fields of expertise into conversation with both the scholarly literature on art in post-Partition South Asia and the works themselves. That proved to be a fruitful triangulation, which sometimes reinforced established frameworks for writing about and understanding works by many of the artists whose work is highlighted in the exhibition, but which also sometimes led in unexpected directions. For example, Emma Oslé's dual expertise in the academic study of modern and contemporary Latin America and the artistic practice of printmaking, which she had studied first-hand, added new layers to our understanding of the works included in the section dedicated to "Topographic Engagements." Whereas her scholarly rooting in the Global South, with a particular attentiveness to the complexity of borders, confirmed our

sense that the experience of diaspora and migration offered many parallels across the post-colonial world, her experience as a printmaker brought new insight into the material processes through which artists such as Arpita Singh, Zarina, and Krishna Reddy engaged with these larger issues.

Similarly, Swathi Gorle's interest in South Asian intangible cultural heritage, and particularly in the relationship between religion, urbanism, and pilgrimage, framed our conversations about religious imagery, highlighting the ways in which traditional narratives were reoriented in order to engage post-colonial social, cultural, and political realities. Margo Weitzman and Sopio Gagoshidze brought their respective expertise in 14th- and 15th-century Italian and early medieval Georgian art to bear on engagements with Christian imagery and early modern European canons in works by artists such as F. N. Souza and Gulam Mohammad Sheikh. And, finally, William Green's rooting in Western modernism brought new dimensions to our engagement with abstraction, in thinking through the contributions of Indian artists to transnational artistic experiments in the nature of representation and the dissolution of form.

Organization of the Catalog

The exhibition design, as it emerged, mirrored an object-oriented pedagogical process. The themes that are represented in the catalog were not external superimpositions but rather those that emerged through our engagement with the works themselves. As much as possible, we tried to "listen" to the artists themselves, to understand their personal histories and intentions. We entitled the first theme "Topographic Engagements," as a way of capturing the complex geographies and mobilities, both imaginary and real, that were central to the experience of South Asia that followed both the trauma of Partition and the opening of the art world, which provided artists unprecedented opportunities to study, live, and travel elsewhere in the world. This is captured by Arpita Singh's striking evocations of international modes of transit, Zarina's commentaries on the notion of home in the diaspora, and Atul Dodiya's homage to the ongoing effects of communal violence fifty years after Independence. It also evoked the rapid transformations of India's urban landscape, beginning at the cusp of Independence, such as seen in works such as Sayed Haider Raza's 1945 *Untitled* (cat. 2) cityscape, and of the ongoing reckoning with India's past in the present, as seen through Gulam Mohammed Sheikh's prints in the collection. The complexity of Indian modernity, as a phenomenon rooted as much in rural as urban experiences, was evoked through M. F. Husain's *Yatra* (cat. 3), ca. 1950s, and Madhvi Parekh's *On Way to My Home* (cat. 7), made in 1999. As Chaitanya Sambrani noted in 2005, for South Asian artists, the "desire for place can be articulated as both a relationship with current locations and an aspiration for real or imagined places in which the artist has made an emotional investment."[1]

The next three sections on "Narrative," "Politics and Social Critique," and "Myth and Religion" are interconnected through the ways in which artists articulated present realities through

Paper Trails, Installation view, Gaur Gallery, 2019

engagements with past traditions by mobilizing practices of story-telling and visual world-building. From Avinash Chandra's exploration of modernity through the "sexualization of the city"[2] to Ganesh Pyne's highly complex reframing of a famous Mughal painting from the reign of the emperor Jahangir, the idea underlying "Narrative" is to allow space for artists to tell powerful tales. In some cases, the narratives were deeply personal and often metaphoric, as in Bhupen Khakhar's *Birth of Water* (cat. 21a), Anupam Sud's explorations of the relationship between genders, or Sudhir Patwardhan's *Wounds II* (cat. 13), in which the artist brought his long experience as a medical professional to bear on his evocation of societal wounds through the depiction of a contorted and broken body.

While many of the narrative works included in the initial concept possess elements of political and social critique, some represented more explicit ideological positions or commentary on specific events. These we moved to a new section on "Politics and Social Critique." Included among these are Somnath Hore's etchings and drawings, rooted in his early Marxist affiliations and motivated by the effects of war and famine on rural populations; K. G. Subramanyan's 2004 depiction of the Best Bakery incident during communal rioting in 2002 that resulted in the death of 14 people (11 of whom were Muslims); and Shyamal Dutta Ray's haunting evocation of urban decay and poverty in post-colonial Calcutta. "Myth and Religion" then turns to works that specifically draw upon the ongoing role of devotion in contemporary society. Here are featured M. F. Husain's re-imaginings of Hindu deities, including variations on Hanuman's siege of Lanka, and also his famous series on Mother Teresa, in which he drew together Catholic iconographies and Indic notions of mother

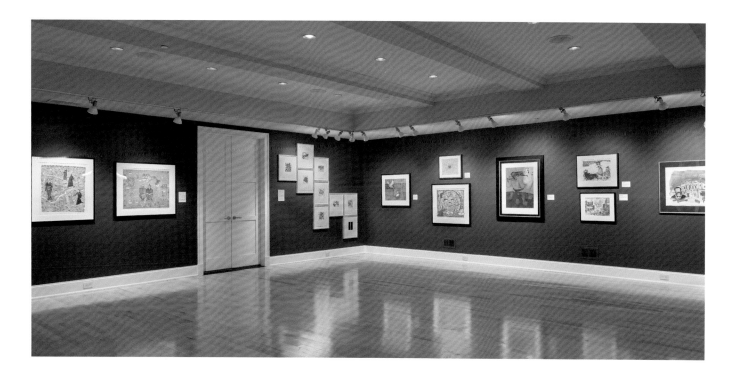

goddesses to simultaneously universalize and personalize her history. Also included is Atul Dodiya's re-imagining of the story of Sabari, drawn from the epic *Ramayana*, Chittaprosad's woodcuts illustrating myths for children's books, and Jyoti Bhatt's explicitly religious prints.

Paper Trails, Installation view, Gaur Gallery, 2019

Finally, the last two sections, on "Portraits/Personas" and "Abstraction," form a complementary pair. Whereas the former engages the myriad ways that modern artists approached the depiction of the human form, the latter brings together eschewals of figuration and experiments in the dissolution of representational form. Within Indian modernism, the two were not necessarily in contradiction. The approaches to figuration play around with elements of distortion and/or the dissolution of form in order to evoke the malleability of identity in an era of rapid urbanization and social, political, and economic change, such as in the works by F. N. Souza, Ved Nayar, and Jogen Chowdhury. The figures are variously individual and collective, global and local, urban and rural, affluent and indigent, educated and coarse, salacious and chaste, spontaneous and static. Some look outward, engaging the viewer, as in the works by Laxma Goud. Others turn away, building psychological tension and bringing the gaze inward, as in the work by Krishna Howlaji Ara and Paritosh Sen. The works included in "Abstraction" are more deeply philosophical and often spiritual. They transform the canvas into a space for exploring the very nature of existence and cosmic creation (Anish Kapoor); the ebb and flow of mortal existence (Ram Kumar); the raw, visual access to the infinity of divinity (Prabhakar Kolte); and the formless (im)materiality of the world (Krishna Reddy).

Together, the sections of the exhibition move the viewer through a wide range of ways in which artists responded to social, political, and economic changes brought about by increasing globalization, urbanization, and migration following Indian Independence. In the process, they also represent a distinct history of modernism in South Asia as one that was not distinct from but engaged with contemporary aesthetic movements on a global scale. All born prior to 1950s, the artists included here brought their lived experiences of the ruptures of decolonization to bear on their engagements with complex presents. At the same time, many of them lived and traveled internationally, where they contributed significantly to the reshaping not merely of South Asian art but of modernism as a whole.

Acknowledgements

This exhibition and catalog came together through a long and extended process, one that could not have been possible without the extensive labor of many institutions and individuals. Firstly, I am deeply indebted to my colleagues at Grinnell College, who have worked assiduously to ensure that both this catalog and the exhibition come to fruition at the Grinnell College Museum of Art. The planning began in conversation with Lesley Wright, Director, and Daniel Strong, Associate Director and Curator of Exhibitions, in the summer of 2021. They have been tireless in their support, submitting a successful application for a grant from the Carpenter Foundation to offset costs and providing endless support on site. Following Lesley Wright's retirement, the reins were passed seamlessly on to the new director, Susan Baley. I am also thankful to Professor Michael Mackenzie for his enthusiastic participation and his perceptive engagement as a specialist in modern European art.

The foundational conception of the exhibition could not have come together without the intellectual contributions and determination of the five Rutgers University art history doctoral students—Sopio Gagoshidze, Swathi Gorle, William Green, Emma Oslé, and Margo Weitzman—who participated in the initial conception and installation at the Gaur Gallery in the spring of 2019. Our weekly conversations over the course of the preceding semester vastly shaped the interpretation of individual works in the collection and the designation of the key thematics that structure the exhibition in the current form. The pilot installation would not have been the same without Jeffrey Wechsler, who leant his keen eye and long experience in exhibition design to the pilot installation in the Gaur gallery.

In its current state, the exhibition represents a recurated, expanded version of the earlier 2019 installation, in no small part due to a number of significant new acquisitions of the collection over the past few years, largely under the guidance of Ashish Anand, Kishore Singh and Sudarshana Sengupta at the DAG Modern Gallery. In addition to filling gaps in the collection, these works broaden the exhibition's scope and strengthen many aspects of the narrative by bringing underrepresented artists into

the conversation. Included among these are drawings and prints by artists such as Bhupen Khakhar, Jyoti Bhatt, Chittaprosad Bhattacharya, and Haren Das.

I am also grateful to the many insights gleaned through conversations in the gallery with Rebecca Brown, Deborah Hutton, Darielle Mason, Michael Meister, Gary Schneider, Cynthia Packert, Donna Gustafson, Tatiana Flores, and, most memorably, Manu and Madhvi Parekh. Thanks are also due to Susan Bean, Karin Zitzewltz, and Sumathi Ramaswamy for sharing their thoughts beyond the galleries and providing publications that were central to the development of the catalog.

Last, but certainly not least, it would be impossible to overstate my deep gratitude to Umesh and Sunanda Gaur, both for their inimitable generosity and hospitality in opening up their home and collection to my students and for their unceasingly inquisitive spirit. They worked endlessly alongside the students, giving countless hours of their time, and opening their collection and impressive personal library of publications on modern and contemporary South Asian art for our exploration and research.

Notes

1. Chaitanya Sambrani, "On the Double Edge of Desire," in *Edge of Desire: Recent Art in India*, 12–33 (Asia Society, 2005), 17.

2. See Kishore Singh's catalog entry later in this volume on p. 102.

Introduction

Michael Mackenzie

It gives me great pleasure to introduce the catalog to the exhibition *Paper Trails: Modern Indian Works on Paper from the Gaur Collection*, curated by Dr. Tamara Sears. This is the second exhibition of works from the Gaur Collection of modern and contemporary Indian art to be held at the Grinnell College Museum of Art, the first being *Many Visions, Many Versions: Art from Indigenous Communities in India*, in 2017. That earlier exhibition focused on what are sometimes called the "non-canonical" arts of various tribal peoples in India. In this case, the works in the exhibition are fully "canonical," in the sense that they are part of the mainstream of modern and contemporary developments in India since Independence in 1947. The Gaurs have built up a collection of great depth and completeness, an almost encyclopedic overview of the complexity and diversity of art in India over the seven decades since Independence. The connoisseurship which they have developed in their collecting practice has enabled them to focus on the materiality of the art object, especially works on paper, and to be attentive to the skill of the printing, the freshness of the plate, the quality of the paper support, as well as the immediacy of the artist's touch, whether with burin, etching needle, or brush. An exhibition of such works, with their rich materiality and intimacy of scale, offers an American audience the opportunity to experience up close the diversity of the work of modern and contemporary Indian artists.

Although I myself am a specialist in European art, specifically German modernism in the 20th century, I have also been privileged to teach an undergraduate course on the history of Indian art for many years, most recently at Grinnell College. I was first smitten by the sensuous and expressive beauty of Indian art at a major exhibition of an important private collection of ancient and medieval sculpture at the Art Institute of Chicago in 1997. After I saw that exhibition, I rushed back to the classroom to share these aesthetic pleasures with my students, forgetting in the first flush of discovery that my scholarly discipline, and the theoretical positions of modern and contemporary art, had taught me to treat such subjective judgments with suspicion, and to avoid them as unprofessional. And, after

all, my appreciation of premodern Buddhist and Hindu art was predicated on a certain Eurocentric, Orientalizing conception of Indian art as essentially static, its greatness located in an unrecoverable past. It had nothing to do with my primary work as a historian of modern art, and could not, so I presumed, trouble the categories in which I thought about that work. I was as yet unaware that there even *was* modern art from India. It was only after the appearance of Partha Mitter's history of Indian art, in 2001, which included several chapters at the end on modern and contemporary art, that I followed Indian art into the modern era.[1] And even still I persisted in thinking of it as some sort of secondary or provincial reflection of European modernism, peripheral to the main line of development. It took longer yet to begin to decenter or "provincialize" Europe and European modernism, to borrow a phrase from the post-colonial theorist Dipesh Chakrabarty.[2] Today, I try to think with my students about how the work of South Asian artists, those who work in Asia and those who work in Europe and America, is central to the story of modern and contemporary art, not peripheral to it.[3] What makes the Gaur Collection so important in the US, and what makes exhibitions like this one so important, is the opportunity to see and think about how Indian art is part of the story of modernism, to see Indian art that is not only beautiful but also aesthetically rigorous, powerfully expressive, and contextually complex.

Let us take up the thread of that story for a moment, if not at the starting point—for the question of starting points inevitably prevents the story from beginning—then at a crucial juncture. In 1919, two innovative art schools were founded, each with the goal of reforming not only art education, but the whole student and, eventually, the nation. One school was Kala Bhavana, the art school of Santiniketan University, outside the city of Calcutta (then the capital of the British Raj in India and now called Kolkata), founded by the writer and Nobel laureate Rabindranath Tagore. The other was the Bauhaus in Germany, founded by architect Walter Gropius. The two schools had similar objectives: to slough off an ossified academic system imposed by a spiritually inert imperial patronage, in order to allow a more authentic individual and national cultural expression to emerge. Tagore gathered what technical and industrial innovations he could from Europe and America to reform the practice of agriculture in rural Bengal, aiming at a unity of craft, farming, and village life that was, however, open to and benefitted from the wider world—a "cosmopolitan local" development not dependent on British imperial patronage.[4] At the Bauhaus, meanwhile, the idea of India was everywhere, especially in the early years. Students practiced meditation and breathing exercises, vegetarianism, and studied their chakras, hoping to harmonize industrial technology with spiritual practice. In preparing for his inaugural speech of the school, Walter Gropius made a note to himself to cite the Gothic cathedral and "India!" in the same breath.[5] Both European and Indian modernism looked to village, peasant life, and the spiritual life of the medieval past as a source of "authentic" cultural expression, freed from the vocabulary of realism and materialism imposed by the imperial rulers.[6] Each of the two art and design schools was fascinated by, and aspired to, their imagined perception

of the other culture. Santiniketan hosted an exhibition of Bauhaus works in 1922, organized with the help of Stella Kramrisch, a Viennese art historian who taught the history of Western modern art at Kala Bhavana. In 1923, there was, in return, an exhibition of Indian modernism in Berlin.[7] Tagore himself was revered at the Bauhaus, and in Germany generally, in the 1920s. Each school looked for a time to the other, reinterpreting the other as a model for achieving a higher unity of abstracted thought and representation, each pursuing its own purpose.[8] Sria Chatterjee calls the Bauhaus exhibition in Calcutta in 1922 an example of transcultural modernism, or "modernism-in-process." That is to say, rather than cultural transmission, or the influence of Western development on a backward, Eastern "other," there were "colliding perceptions of the other" on both sides, within a "network of object, interaction, and event."[9]

Later, in 1947, after World War II and the founding of independent India, when a group of modernist painters and sculptors joined together to form a group that called itself the "Progressive Artists' Group," they also had to navigate a network of interactions and events. The liberation and traumas of Independence and Partition, the conflict between nationalism and secularism in India, and the urgent tension between a modern, urban outlook and a rootedness in village life constituted their "modernism-in-process." The Progressives engaged directly with Western modern art, frequently traveling and studying in various Western art centers. Modernism in the post-war West was itself divided, not a unified, monolithic, static edifice. It was riven by innumerable fault lines, with artists embracing varying degrees of abstraction and figuration, formalism and social commitment, and ideological orientation. In other words, it was itself a modernism-in-process, not something finally arrived at. There were multiple centers, and everywhere was the periphery of somewhere else. Artists' styles were not static. They were pulled this way and that by competing, mutually exclusive imperatives of, on the one hand, New York Abstract Expressionism and Parisian Informel (and the work of smaller capitals in Northwestern Europe), and, on the other, Socialist Realism as practiced in the Eastern Bloc (and also in Paris). Several of the Indian Progressives worked in New York and Paris, where they formulated their perceptions of the European Other from their own perspective of an India that was rural for some, urban for others, modernizing for all of them. They had to rise above these internecine conflicts and internal divides with bemused self-sovereignty, a sort of aesthetic non-aligned position, reflecting India's political refusal to take a definitive side in the ideological struggles of the Cold War. Indian modernists had to negotiate, interpret, and choose. Nor was any choice necessarily permanent or irreversible. Their own positions were not static, but rather followed their multiple trails.

Take for example the career of Ram Kumar, a member of the Indian Progressive Artists' Group. He moved to Paris soon after the founding of the Progressives (as did Krishna Reddy and S. H. Raza, both also included in the present exhibition). Kumar studied with some of the early Cubists in Paris after the war, including Fernand Léger, who was following his own

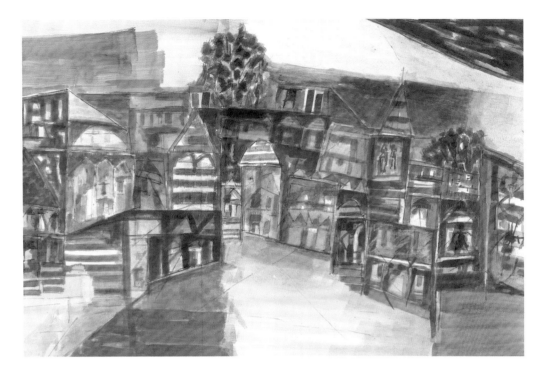

Fig. 1
Ram Kumar
Townscape, 1991
Grey wash on paper
22 ¼ × 35 in (cat. 1)

winding way from Cubism, through stylized abstraction, to a kind of flat, colorful figuration depicting the simple joys of the working class. In Paris, Kumar joined the Communist Party, of which Léger was also a member.[10] Nor was he the only one of the Progressives to associate with the communists early on. Like his French associates, Kumar adopted the visual language of Socialist Realism for a time in Paris. But, after the death of Stalin, followed by a cultural thaw in Moscow and its dependent parties across Europe, Kumar, too, moved away from Socialist Realism. He began painting cityscapes, influenced by trips to various cities in Europe and Asia. But no place was more important to him or his artistic development than the holy city of Varanasi (or Benaras), which he first visited in 1960. The ritual, spiritual nature of this very particular riverine urban landscape, so profound for a Hindu like Kumar, was transformative. *Townscape* (fig. 1)(cat. 1), made in 1991, in the present exhibition, is a typical example of the work that resulted from this juncture. Ten years later he was awarded a John D. Rockefeller III scholarship to spend a year in the US. The purpose of this program was to bring Asian artists to New York City and so draw them closer to the Western cultural sphere and away from Soviet Russia, while at the same time strengthening New York's cultural hand, not against Moscow so much as against Paris. Kumar's sojourn in New York did encourage him to make works that were fully abstract. (Other artists in this exhibition who traveled to New York on Nelson Rockefeller III scholarships include Akbar Padamsee, Bhupen Khakhar, K. G. Subramanyan, and Krishen Khanna.)[11] This did not mean that Kumar no longer painted recognizable urban views alongside his abstractions; note that *Townscape*, in this exhibition, was made 15 years after the abstract acrylic paintings. The point is that Kumar had to negotiate a transnational modernism-as-process, from the liberation of Independence and

the traumas of Partition, the dislocations of urbanization, the emergence of French communist artists from under the diktat of Socialist Realism, and the soft power—strategic nonetheless—of John D. Rockefeller III, by way of the artist's own spiritual and cultural connection to the sacred cityscape of Varanasi on the banks of the Ganges. Many of the other artists in the exhibition had similarly complex trajectories, with some of them settling and working permanently outside of India, including New York (Zarina), London (Anish Kapoor), and various art schools around the US (Krishna Reddy), while several others settled in Mumbai or Delhi.

The artworks in this exhibition could be readily divided into three historical periods. The first is the period immediately after Independence, from 1947 to the mid-1960s. Works from this era concentrate on the reconciliation of sculptural volume and the flatness and rectilinearity of the picture plane, emphasize the materiality of the medium, and, in the case of prints, develop the virtuosity of the intaglio process—much like modernisms in other parts of the world. Bodies and the spaces they inhabit are broken down into smaller units, given shallow shape through the use of color, texture, and disjointed figure/ground relations. A trajectory from the figurative to the abstract is often a feature. The second period, from the mid-1960s to the late 1980s, concentrates less on formal issues and more on inventive imagery, often centered on the body, social rituals, and disparate cultural references, including urban, pop culture. Relationships of color, space, volume, and composition are much less programmatic, liable instead to be inventive and particular to each individual work. Mark-making continues to be highly individual, even idiosyncratic, expressive of an individuality, which is especially in evidence in these works on paper. The final phase, emerging after the advent of neoliberal economic and political policies in India, in 1991, and the concomitant rapid growth of a collecting elite with means, evinces the joining up with the global, transnational trends of contemporary art, and with the general abandonment of traditional two-dimensional media. The artwork of this period shares a cosmopolitan, art world–savvy, wealthy and educated audience with other contemporary artists from around the world. The work of this period is less often two-dimensional or even portable. At the same time, many contemporary artists also use in parallel small-scale paintings and prints to reach an audience that has neither the means nor the space for extensive collections of large-scale sculpture or installation art. One such artist, represented in the current exhibition, is Anish Kapoor, who is very well known for his gigantic sculptural installations, but who has also maintained an intaglio print practice. Atul Dodiya often paints on shutters, suggesting a direct material connection with urban life. In this show, he is represented with two color lithographs on handmade paper, the especially tactile quality of the paper substituting for the unorthodox, real-life objects that normally serve the artist as a support for his images.

In conclusion, I would like to consider for a moment the Gaurs' own collecting practice. Their collection corresponds to and represents the history and also the diversity of

the modern Republic of India, the largest democracy in the world, from its founding in 1947 onwards. Rather than promoting a certain vision of India, either rural or urban, secular or communal, the goal is to be instead encyclopedic, representative. Sunanda Gaur, a professional in the biomedical field, has also emphasized to me in conversation how important it is to her that the collection includes a large number of female artists, countering a perception that the circumstances of women in modern India are backwards. Anupam Sud, well represented in this exhibition, is an example of one such female artist. Madhvi Parekh is another. The Gaurs have continued to widen the circle of artists they collect, keeping pace with the developments of contemporary art in India. It is an inclusive representation of modernism-in-process, not modernism as limited or defined by past ideas. Part of their mission is to facilitate the sorts of "colliding perceptions of the other" that might also allow diverse audiences in America—non-Indians, non-resident Indians, and the children of Indian immigrants who have grown up in the US—to encounter and perceive the works of Indian artists with similarly diverse situations.

Notes

1. Partha Mitter, *Indian Art* (Oxford: Oxford University Press, 2001).

2. Dipesh Chakrabarty, *Provincializing Europe. Postcolonial Thought and Historical Difference* (Princeton: Princeton University Press, 2000).

3. Rasheed Araeen, "Art and Postcolonial Society, in Jonathan Harris, ed., *Globalization and Contemporary Art* (New Jersey: Wiley-Blackwell, 2011) 365–374.

4. R. Siva Kumar, in conversation with Regina Bittner and Kathrin Rhomberg, "Shantiniketan: A World University," in Regina Bittner and Kathrin Rhomberg, eds., *The Bauhaus in Calcutta: An Encounter of Cosmopolitan Avant-Gardes* (Ostfildern: Hatje Cantz, 2013) 109–114.

5. Cited in Boris Friedwald, "The Bauhaus and India: A Look Back to the Future. 'Building! Design! Gothic – India!" in Regina Bittner and Kathrin Rhomberg, eds., *The Bauhaus in Calcutta: An Encounter of Cosmopolitan Avant-Gardes* (Ostfildern: Hatje Cantz, 2013) 117–133.

6. See Partha Mitter, *The Triumph of Modernism. India's Artists and the Avant-Garde, 1922-1947* (London: Reaktion Books, 2007).

7. Partha Mitter, *The Triumph of Modernism*, 27.

8. Sria Chatterjee, "Writing a Transcultural Modern: Calcutta, 1922," in *The Bauhaus in Calcutta*, 101–107.

9. Chatterjee, "Writing a Transcultural Modern."

10. Uma Prakash, "Ram Kumar, A Transition from Figurative to Abstract," in *Art News and Views*, November, 2010, online (retrieved March 16, 2022), and Seema Bawa, "Ram Kumar: Artistic Intensity of an Ascetic," in *Art Etc*. February, 2012 (retrieved March 17, 2022).

11. See Kishore Singh, ed., *India's Rockefeller Artists. An Indo-US Cultural Saga* (Delhi: Delhi Art Gallery, 2017).

The Intimacy of Paper

Tamara Sears

As a medium, paper is deceptively complex. At first glance, its softness and crispness offer an aura of intimacy and a distinctive tactility that encourages viewers to closely contemplate the texture of its surfaces and the complexity of the artists' individual brushstrokes and lines. At the same time, its innate fragility requires a level of care and maintenance that goes beyond that needed for works produced on canvas or board. Because of its low cost and ready availability, paper has often been perceived of as a lesser medium. Yet, paper has also played an essential role in artists' creative processes, both in working through compositional details for larger commissions, and in the production of a fully finalized painting or drawing. Within the context of modern and contemporary India, paper offered artists a way of cultivating transnational modernist expression while continuing to explore the potentialities of a medium that had deeper roots in older traditions native to the subcontinent. Simply put, highlighting works on paper draws attention to the central role that the medium has played in the history of both Indian modernism and artistic production within the subcontinent.

The history of painting and drawing in India begins on the walls of Paleolithic rock shelters, with the most famous today located at the archeological site of Bhimbetka in Madhya Pradesh. Cave frescos remain crucial to the history of Indian pictorial representation through the end of the first millennium C.E., with particularly spectacular compositions surviving in the rock-cut temples and monasteries of Ajanta and Ellora. At the same time, artists became adept at producing elaborately illustrated manuscripts on palm leaf surfaces. With the establishment of the Sultanate states and the importation of Persian artists in the 13th and 14th centuries, paper grew in importance as a prime medium for painting in both courtly and mercantile contexts. By the 15th and 16th centuries, artists based in the courts of the Mughals, Rajputs, and their contemporaries were masters at producing highly detailed and beautifully arranged compositions on handmade paper. Within ateliers, pigments were also naturally produced from organic materials, metallic extracts, and a variety of precious and semi-

precious stones, including lead, tin or zinc for white; indigo or lazarite for blue; cow urine for yellow; vermillion (mercuric sulfide) or red lead for red; verdigris (copper chloride) for green; and powdered gold and tin. Such works were typically intended for insertion in illustrated manuscripts or for *muraqqa* albums containing paintings and calligraphic text.

The advent of the British in the 18th century introduced the use of oil on canvas, which grew in popularity following the establishment of colonial art schools after 1850. Wealthy merchants and aristocratic patrons cultivated their Anglophone aspirations by commissioning well-known artists, such as Ravi Varma, to create oil paintings of family portraits and landscapes. By the late 19th century, works on paper had become increasingly relegated to the realms of commercial prints, bazaar painting, and folk traditions. This trend saw a brief reversal in the early decades of the 20th century, with the rise of the Bengal school of art, as artists such as Abanindranath Tagore rejected Western approaches in favor of reviving older Indian traditions. They emphasized an aesthetics of emotion (*bhava*) over Western classical ideals of realism in form (*rupa*), and re-embraced precolonial uses of paper, organic pigments, and calligraphic brushwork. Although many of the principles of the Bengal school came under critique by the 1920s and 1930s, and modernists began to experiment again in oil, the connection between paper and nation had become firmly entrenched, one of many associations upon which modern artists could draw meaning.

For the artists represented in the Gaur Collection, paper served in many different ways and had multiple connotations. For some, the materiality and history of paper has been central to their artistic production. Such is the case with Zarina, whose first retrospective, held at the Guggenheim in 2013, was entitled "Paper Like Skin." For Zarina, paper was not merely a surface well suited to the practice of printmaking, but "an organic material, almost like human skin."[1] Her works often played directly with the material, haptic, and olfactory properties of paper surfaces, and were frequently customized to enhance the visual impact of her finalized prints. The works included in the Gaur Collection reinforce this sensitivity and specificity of medium. Each work includes details regarding the composition and sourcing of the medium, or combinations thereof, in order to produce new layers of meaning. Printed on Okawara paper mounted on Somerset paper, *These Cities Blotted into the Wilderness* (cat. 9) creates a contrast that is both visual and semantic by juxtaposing a soft yet durable Japanese paper—produced of kozo, hemp, and pulp—with a highly popular stock produced by St. Cuthberts in Wells, Somerset, a mill with a long history dating back to the early 18th century. *One Morning the City Was Golden* (cat. 8b) strikingly brings together the contrasting surfaces of a naturally textured and colored Dutch hemp-based paper (zaan) with the synthetic hardness of sunboard.

For other artists, the immediacy of paper served as a medium for experimentation, for working through concepts and ideas for production on a grander scale. For example, the

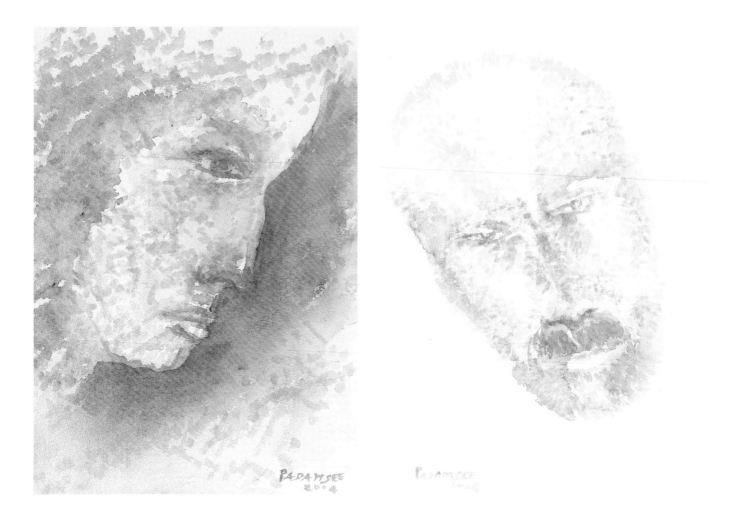

drawings by Krishen Khanna included in the exhibition and catalog represent close studies of individual figures who appear also in his larger paintings and murals. The Gaur Collection also includes two watercolor sketches by Akbar Padamsee, not included in the exhibition, that appear as small-scale studies, of efforts by the artist to convey complex human emotions through just a fleeting visage (figs 1 and 2). Delicately rendered in monochromatic tones, these sketches carry an intimacy that is often lost in his larger and more dramatic, polychromatic works.

The works by Ram Kumar included in this catalog present a counterpoint to the artist's oils on canvas, both of which are included also in the Gaur Collection. The untitled 1974 oil on canvas exemplifies the artist's growing obsession with the city of Varanasi (or Benaras), which he depicted with increasing frequency during the 1960s and early 1970s. Drawn by the city's "overwhelming impact on people," he described every sight as "like a new composition, a still life artistically organized to be interpreted in colors."[2] To capture the intensity of the city, he developed a new visual language, rooted in colorful abstraction, manifest through highly

textured, almost sculptural blocks of interlocking and overlapping color suggestive of the riverfront that found expression most readily through the medium of oil on canvas. Ram Kumar consistently worked on both canvas and paper throughout his career, and the two media offered different opportunities. Whereas oil enabled him to experiment with abstraction almost in three dimensions (fig. 3), paper seems to have provided a flat surface for exploring the line between abstraction and representation. His works on paper, such as seen in this catalog, are often monochrome, rendered primarily in black and white, with the exception of his acrylics, which frequently include bursts of color that begin to hint at the content of the form (fig. 4). His *Townscape* (cat. 1), from 1991, exemplifies this process but also brings it full circle, capturing the city of Varanasi in a subdued gray wash that brings new emotional subtlety to his earliest efforts at capturing the city through pen and ink drawings in the early 1960s.

For artists such as M. F. Husain, the speed of working with paper facilitated the prolific nature of his artistic practice, allowing him to produce many iterations of similar compositions for circulation and sale. His images of Hindu deities, such as Hanuman and Ganesha, represented elsewhere in this catalog, appear in multiple versions, and his untitled *Yatra* (cat. 3) from the 1950s presents a variation on a theme that he revisited many times, most famously in a finished oil painting from 1955, now in a private collection.[3] Husain's facility in paper was no doubt fostered by his beginnings as a commercial art painter designing billboards and popular toys for mass consumption. And his continued dedication to the medium, even after achieving international acclaim, ensured that his work remained accessible to broader audiences. Despite their commercial associations, Husain's watercolors on paper are arguably almost as significant as his oils on canvas. They exhibit a spontaneity and freshness that would be impossible to capture in nearly any other medium.

Paper was also the medium of preparatory drawings in the more traditional sense of the painting process. A good example can be found in a drawing by F. N. Souza of the story of

Fig. 3 [left]

Ram Kumar
Untitled (Brown Landscape)
1974
Oil on canvas
33 × 60 in

Fig. 4 [right]

Ram Kumar
Untitled, 1986
Acrylic on paper
11 × 16 in (cat. 42b)

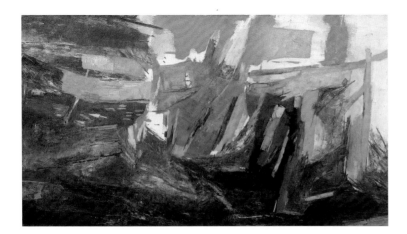

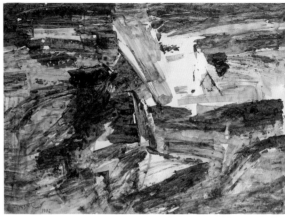

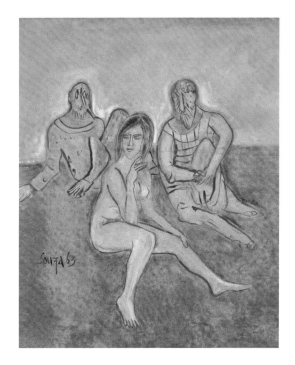

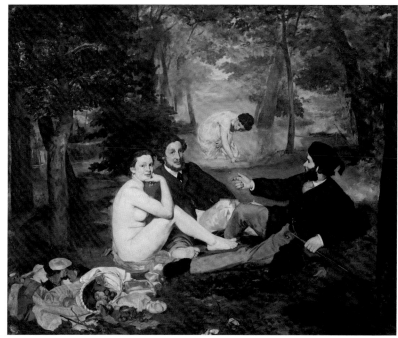

Fig. 5 [left]

Francis Newton Souza
Susannah and the Elders, 1963
Oil on canvas
41 × 38 in

Fig. 6 [right]

Édouard Manet
Le déjeuner sur l'herbe
(*Luncheon on the Grass*), 1863
Oil on canvas
81½ × 104 in

Susanna and the Elders (fig. 5), an apocryphal Old Testament narrative found as an addition to the *Book of Daniel*. The story tells of a maiden refusing the aggressive sexual advances of two elders, who catch a glimpse of her while she bathes in her garden, and celebrates the subsequent triumph of virtue over lechery and false accusations of promiscuity. It became a popular theme among Renaissance and Baroque painters, including, among others, Peter Paul Rubens (1607), Rembrandt (1647), and Artemisia Gentileschi (1610). In the 20th century, the story was modernized by Thomas Hart Benton (1938), who set the scene during the Great Depression, and Pablo Picasso (1955), who transformed Susanna into a reclining cubist nude lounging on a bed in a domestic interior.[4]

This version by Souza, curiously, takes as its inspiration not this genealogy of representation but rather Édouard Manet's 1863 *Luncheon on the Grass* (fig. 6), which itself was modeled on Titian's 1509 *Pastoral Concert*, which was rediscovered by the Pre-Raphaelites in the 19th century.[5] The finished version, completed in oil on canvas, portrays only the central trio of figures forming a triangular composition against a low horizon line. Manet's reimagining of the scene effectively broke with the tradition of timelessness embraced by Titian and his Renaissance contemporaries by reframing the poetic pastoral landscape as modern city park and placing the classical female muse not in the company of musicians but of late 19th-century *flaneurs*. By contrast, Souza's finalized canvas removes any markers of modernity, transforming the scene once again into a timeless and placeless narrative. The male elders are wearing not modern suits but the clothing of clergy, suggesting Souza's disdain of hypocrisy in religion, and Susanna is endowed with a chastity lacking in

the looseness of Manet's female bodies. She sits with her legs tightly pressed together, her right arm acting as a shield to protect her breasts from unwanted groping.

The preparatory drawing associated with this painting reveals the complexity of thought underlying these decisions (fig. 7). At first glance, it appears to be just a quick sketch rendered simply using a fine point pen. The lines have the clean and crisp quality of a notebook doodle, even as the content offers subversive surprises. The basic format of the central trio remains the same, albeit inverted. However, the larger landscape setting hearkens back to early Mughal painting, utilizing a tripartite composition, with the central trio occupying a meadow dotted with flowers in the foreground, clusters of buildings towering above rolling hills in the middle register, and a band of starry sky providing atmosphere at the top. In recasting Manet's figures within a distinctively Mughal composition, Souza's drawing foreshadows the timelessness and placelessness of the final oil on canvas but also more specifically translates the original Renaissance source material into a contemporary, ca. 16th- or early-17th-century Indian tradition of poetic painting. Souza was well known for constantly drawing, for using paper to focus his vision of the world. As critic and curator Uma Nair has noted, for Souza, drawings were not merely preparatory or incidental to the larger process of producing a finalized canvas. He had an obsession for drawing, and his drawings often took on a life of their own.[6]

Almost all of the artists represented in this collection worked widely across media. Anish Kapoor, for example, is better known for his sculptures than for his prints. And Arpita Singh achieved wide acclaim for her watercolors on paper before shifting to oil on canvas, in the 1990s, before producing the prints included in this exhibition (cat. 6a and 6b). By focusing entirely on their works on paper, this exhibition encourages the viewer to engage the intimacy of the works themselves, to think about the role of paper in the processes of artmaking, and to contemplate the ways in which paper has served as a site for the exploration of modernism's many forms.

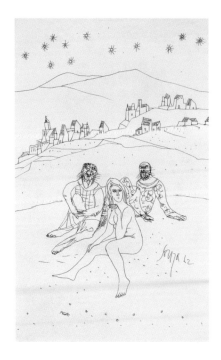

Fig. 7
Francis Newton Souza
Susannah and the Elders, 1962
Ink on paper
17 × 11 in

Notes

1. Quoted from Sadia Shirazi, "A Room of One's Own," in *Zarina: Weaving Darkness and Silence* (New Delhi: Gallery Espace, 2018). See also Allegra Pesenti, "Zarina: Paper Like Skin," in *Zarina: Paper Like Skin*, A. Pesenti, ed. (Los Angeles: Hammer Museum, 2012) 13–31.

2. From his writings on the city in 1996, published in *Ram Kumar: A Journey Within*, Gagan Gill, ed. (New Delhi: Vadehra Art Gallery, 1996), 89.

3. A longer discussion is included in the catalog entry on that work. See p. 74.

4. Benton's painting is currently in the collection of the de Young Museum in San Francisco, and Picasso's version is in the Picasso Museum in Málaga, Spain.

5. This version departs significantly from an earlier 1958 painting of the scene by Souza, sold at auction at Sotheby's in 2019, in which

the trio is depicted in Souza's characteristic style, combining expression and cubism to produce fiercely abstracted figures. In that version, Susanna stands completely naked, facing frontally between the two grisly elders, who are actively fondling her bare breasts.

6. Uma Nair, "JNAF: Souza in Victorian Bombay," pIUMAge, Lifestyle blog, *Times of India* (Nov 10, 2021), accessed April 21, 2022.

A Brief History of Printmaking in India

Paula Sengupta

The Gaur Collection of modern Indian works on paper is particularly notable for a remarkable variety of prints made by many of the subcontinent's most influential printmakers. These include intaglios, lithographs, serigraphs, and relief prints by such master printmakers as Zarina, Krishna Reddy, Anupam Sud, Laxma Goud, Chittaprosad Bhattacharya, Haren Das, Somnath Hore, and Jyoti Bhatt. The collection also possesses a number of prints by moderns best known for their work in other media, including Arpita Singh, M. F. Husain, F. N. Souza, and Anish Kapoor. The high representation of prints in a collection of works on paper may be linked to the surface qualities of handmade paper that lend themselves remarkably well to the tactile nature of print. This essay lays out a brief history of printmaking in India, with particular reference to artists in this collection.

From Reproductive to Creative

Printing arrived in India in the mid-1500s as a colonial import, first for evangelical purposes, and later to further economic and political ambitions. From "printing" emerged "printmaking" or "the art of the printed picture," as the demand for printed illustrations grew. By the mid-18th century, there was a thriving printing and publishing industry in Calcutta (now Kolkata), the capital of the British Raj in India. The advent of European artist-adventurers on Indian shores around this time led to the emergence of broadsheets, as opposed to illustration. Over time, a gradual infiltration of technology into the indigenous artisan community occurred, leading to the emergence of a vernacular print culture that manifested itself both in text and image. From the 19th to the early 20th century, we see vibrant schools of bazaar printmaking in the subcontinent, such as the Battala reliefs in Calcutta and the Punjab lithographs from Amritsar and Lahore.

The 1850s saw the establishment of five art schools in Calcutta, Madras (now Chennai), Bombay (now Mumbai), Jaypore (now Jaipur) and Lahore. All these imparted instruction in

printmaking as an industrial art, with the intention of developing an indigenous workforce to man British presses in India. Creative enterprise was discouraged, even though printmaking had been an active contributor to artistic enterprise in Europe since the Baroque period. However, the instruction that these students received in the art schools led them to establish art studios that practiced planographic printmaking for an Indian clientele. This gave rise to a huge wealth of popular pictures called the "Art Studio Pictures," catapulting artists such as Ravi Verma to fame and demand.

The first example of artistic printmaking occurred in 1917, with Gaganendranath Tagore publishing the lithographic cartoon album *Adbhut Lok* at Bichitra Club, the avant-garde salon in the Tagore residence in Calcutta. This marked a significant breakthrough, with printmaking being considered a medium of artistic exploration, rather than merely for purposes of reproduction.

Quest for a New Language

Explorations began in earnest with Rabindranath and Abanindranath Tagore's young prodigy Nandalal Bose assuming the reins at Kala Bhavana, Santiniketan as its first Principal in 1920–21. Nandalal's search was for a versatile new language in art that did not differentiate between "art" and "craft" as being synonymous with "high art" and "low art." His keen interest in printmaking was founded not merely in its techniques, processes, and grammar, but also in its democratic nature and aesthetic possibilities. He sought a new spontaneous language in printmaking that was concise, simple, and uncluttered. Instead of attempting to create the illusion of a three-dimensional surface in the print, Nandalal developed a relatively flat, two-dimensional perspective, evenly distributing black and white areas. The resultant prints are unusually crisp, the lines swift and taut, the blacks and whites in perfect unison. Despite continuing to remain subjectively realistic or representational, Nandalal's prints, due to their two-dimensional design, border on abstraction. By the 1930s, the mature Nandalal started to make significant reliefs, such as *Bapuji* (fig. 1), and the later lithographs of domestic pets and poverty-stricken humanity. Apart from artistic printmaking, Nandalal realized the potential of the medium as a means for mass communication. During the 1930s, Ramkinkar Baij and Nandalal printed political posters for the Non-cooperation Movement from cement blocks.

Of Angst and Fury

It is in light of Nandalal's graphic work that we will consider the work of Chittaprosad Bhattacharya, better known by his first name, who had wanted to study under the master at Santiniketan. Though this desire did not materialize, it would seem from Chittaprosad's prints that Nandalal was his role model. Not only did Chittaprosad reference the two-dimensional design sensibility and crisp chiaroscuro of Nandalal's reliefs, but his later work resonates with Nandalal's references to folk and classical art traditions, and also the

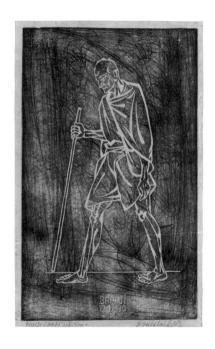

Fig. 1
Nandalal Bose
Bapuji, 1931
Linocut on paper
11 ½ × 7 in

master's later preoccupation with human suffering. It would seem that Chittaprosad seized upon Nandalal's realization of using printmaking as a medium for the masses in a manner that could be applied to political campaigns, as well as, later, to peace themes and children's book illustrations. In the turbulent years following Independence and Partition, Chittaprosad, with his strong socialist convictions, added direction and an unprecedented vitality and vigor to the idyllic art of the Santiniketan school. As Prabhas Sen describes him, Chittaprosad "was an artist of the people—the great multitude of India, poverty-ridden, exploited, but of unbounded vitality, keepers of its unique cultural heritage with a legacy of hundreds of years of stoic survival against all odds."[1]

Chittaprosad's work inspired the young Somnath Hore, who acknowledged him as his first mentor. As a member of the Communist Party of India (CPI), Hore traveled together with his comrades Chittaprosad, Zainul Abedin and Qamrul Hasan through famine-stricken Bengal, drawing and exhibiting to raise awareness of the widespread starvation. These years left an indelible impact on the psyche of the young artist, scars that haunted him and became his life's quest. An unbroken train of thought runs through the entire body of Hore's prints, right from the early reliefs to the final pulp prints—a preoccupation with "wounds." As in the prints in the Gaur Collection, Hore's journey begins with reliefs of famine-stricken victims, poverty-stricken rural Bengal, political rallies and meetings, victims of communal rioting— all images from Hore's impressionable years with the CPI. The middle phase is constituted of lithographs, etchings, viscosity prints, and metal engravings, with the artist moving progressively from indirect to direct processes in printmaking in his quest to realize his concept. The wounds grew deeper and more vicious with further forays into intaglio processes. As the acid bit further and further into the plate, the human figures struggled to survive. The form gradually disseminated, becoming a dark silhouette. What stood out were the deep wounds in embossed white. Gradually, the intaglio was almost done away with, both the figure and the wounds being printed in white on white, representing the final transition from the intaglios to the pulp prints. What followed were the pulp prints at the end of the 1970s. Hore had successfully done away with all representational elements, including form and color. What remained was the wound alone: a gash inflicted on the paper.

Of Yearning and Nostalgia
Haren Das, better known by his first name, was a contemporary of Hore, though radically different in temperament. He learned printmaking at the Art School in Calcutta, under the tutelage of Ramendranath Chakravarty of the Santiniketan school. In later years, Haren joined the faculty to teach printmaking. Educated in the strictest traditions of British academic art, Haren worked almost entirely from sketches from life, imagination rarely, if ever, playing a role in the conception of his images. While his avant-garde contemporaries in post-Independence India used their skills to evolve a new identity in art, Haren remained untouched by the turbulence of his times. What attracted him instead was the placid beauty

of the Bengal countryside, particularly the lyrical life and landscape of East Bengal. At a time when India was struggling for her freedom, and artists and intellectuals joined ranks with freedom fighters, Haren continued his search for idyllic beauty. Though a calm, faceless impersonality characterizes all his work, Haren's nostalgic love of his motherland and the simple folk who tilled it is the essence and beauty of his work.

The Philosopher-Printmakers

Besides Hore, the quite different, though equally masterly, Krishna Reddy is considered amongst India's pioneer printmakers. Atelier 17, in Paris, where he and master-printer Stanley William Hayter worked, was where they pioneered the viscosity printmaking process. In India, viscosity became a popular method of polychrome intaglio printmaking due to the influence of Reddy, who tutored many an Indian printmaker in the 1960s and 1970s, conducting workshops widely across the country. Reddy, who had his early education in sculpture at Santiniketan, spent most of his career in Europe and the US but remained a frequent visitor to India.

Reddy viewed the worked intaglio plate as a sculptural object—a miniature moonscape, which he sought to color, exploiting inks having various viscosities or rollers of different firmness, which could reach the middle and lower levels of the plate. To Reddy art, nature and life were inextricably connected.

It was not just Reddy's technical brilliance that attracted Indian printmakers, but also his abstract imagery and philosophy (fig. 2). It was radically different from the narrative trend that dominated Indian art of the 1950s and 1960s—it presented a new challenge, a new approach to aesthetic understanding. It is the essence of music, often seen as the most abstract of all art forms, that resonates through Reddy's works, amply demonstrated by the prints in the "Abstraction" section of this exhibition. The prints in the "Narratives" section are no exception, with Apu crawling in a rising crescendo or a rhythmic procession broken by a caesura when the line unexpectedly breaks.

Often seen as an abstractionist, Zarina Hashmi, who preferred to use her first name only, was a deeply political artist and very much a storyteller. One of the Indian subcontinent's many "midnight's children," Zarina lived in nine cities, yet had no place called "home." Loss was a reality and borders were drawn across her heart. Her politics and her art were shaped by this grim reality that she grappled to make peace with till her last breath. As a nomad or traveler, Zarina had long been a maker of maps and a marker of borders. The maps in *These Cities Blotted into the Wilderness* (cat. 9), from the Gaur Collection, are both personally and politically significant, rendered with restraint, almost like grids governed by Sufi thought and Zen practice, as in *One Morning the City Was Golden* (cat. 8b). Geometry, which Zarina regarded as a "sacred practice," is the basis of almost all her work, composed

Fig. 2

Krishna Reddy
Jellyfish, 1963
Mixed color intaglio
14½ × 18 ⅜ in (cat. 45d)

as it is within the three basic geometric forms of the square, circle and triangle. However, unlike the geometric abstraction of the Russian Constructivists, Zarina's brand of abstraction remains rooted in Indo-Persian architecture, cultures and language. There is extensive use of both Urdu poetry and script in her work, reflected also in the calligraphic nature of her maps. This is not merely an aesthetic ploy but a metaphor to place her work in a historic moment. To most of her viewers, the script is illegible and the language incomprehensible, even in Delhi where it was once born, indicating the painful loss of what was once a mother tongue.

Institutions, Collectives and the Moderns

The two decades that followed the declaration of independence were characterized by a mood for experimentation. The 1950s witnessed the beginning of organized promotion of the arts by public bodies in independent India. The atmosphere was one of international exchange and camaraderie, and the mood was receptive. Outside of institutions of art, where printmaking practice truly took shape, in these early decades of Indian modernism, artists across India organized themselves into small collectives to practice the medium. These collectives were housed in spaces as informal as artists' homes, garages or rented shop plots, often with very basic equipment and makeshift infrastructure. In 1957, the Shilalekh Group, which included M. F. Hussain, Ram Kumar, Tyeb Mehta, and V. S. Gaitonde, was established in Bombay. Emulating the highly successful example of Ravi Varma, they began to make lithographs at Mohammedi Fine Arts in Bombay, attempting to unsuccessfully sell original prints to art lovers at a minimal price.

N. B. Joglekar was instrumental in setting up the printmaking section at the Faculty of Fine Arts at Maharaja Sayajirao University, in Baroda (now Vadodara), in 1950. Under his initiative, and, later, that of Jyoti Bhatt, the city witnessed some printmaking activity in the 1960s and early 1970s. From the 1970s onwards, Bhatt and his colleagues were active contributors to printmaking in Baroda. While Kala Bhavana, Santiniketan, emerged as the stronghold of traditional printmaking processes, the Baroda artists turned their attentions to more innovative printmaking, incorporating serigraphy and photo-processes into the fold. Bhatt combined his unique pictorial sensibility, and a rich and varied visual vocabulary, with printmaking as a means. The resultant formal constructions are, whether symbolically or implicitly, the artist's comments on life, society, and self. To date, Baroda remains an active center for the graphic arts.

Apart from the Faculty of Fine Arts, organized printmaking initiatives include Chhaap, founded by Kavita Shah, Vijay Bagodi and Gulam Mohammed Sheikh in 1999. Though Sheikh was an occasional printmaker, his contemporary Bhupen Khakhar has a large and important body of etchings, including artist's books, which contain some of the most intimate work in his repertoire, among them two fine examples in the Gaur Collection.

Fig. 3

Anupam Sud
Tribute, 1989
Etching on paper
20 × 25 ¾ in

In Delhi, Jagmohan Chopra, along with Anupam Sud and other students, established Group 8 in 1968. Describing themselves as "an association of working artists devoted to printmaking,"[2] the group was an offshoot of a larger artist body, Delhi Shilpi Chakra, of which artists such as Arpita Singh were members. Group 8 established a makeshift studio at Shankar Market in New Delhi in the early days and organized national print exhibitions into the 1990s. Anupam Sud emerged as one of the most significant figurative printmakers in the 1980s, extensively using photo processes in intaglio printmaking, culminating in narratives that appeared hyper-real. Sud studied printmaking in 1969 at the Slade School of Art, London, where she says she was transformed into a "black and white"[3] person. A meticulous, craftsmanly printmaker, Sud's monochromatic work revolves around men and women, suspended in the urban predicament. Despite the figurative nature of her work, there is an element of abstraction in the manner in which she dissects and restructures her compositions, allowing the viewer voyeuristic glimpses of a fragmentary narrative. Sud's conservative and graphic application of the etching medium only complemented her sophisticated thought process, making her one of the more cerebral printmakers of the modernist era (fig. 3).

By 1970, Gaurishankar, Dakoji Devraj, Laxma Goud, and D. L. N. Reddy were practicing printmaking in Hyderabad. The latter three had together set up a press in a garage in Hyderabad. Laxma Goud emerged among the foremost of modernist printmakers.

Fig. 4

K. Laxma Goud
Untitled, 1972
Zinc etching
6 ½ × 10 ½ in

A figurative printmaker, Goud's delicate aquatints and line etchings are often given to wildly erotic imagery. His early work is a sensuous, intimate exploration of landscape informed by his pantheistic beliefs and his interest in Indian mythology. However, by the 1980s, he progresses into the world of libido, playing out wild sexual fantasies between humans, animals, and other anthropomorphic creatures. While much of his work is characterized by explicit sexual imagery, it is always tempered by his delicate use of the medium (fig. 4). Goud's depictions of the natural world are lovingly detailed and beautifully ornamented, further softened by delicately aquatinted tones. His use of the negative "white" space, so essential to the print, is masterful.

Legacies and Futures

Since most of the modernist printmakers were artist-pedagogues, they passed the mantle on to a second generation of artists, from amongst whom two significant collectives emerged—the Realist Group, in Santiniketan, and the Indian Printmakers Guild (IPG), in Delhi. The former followed in the footsteps of Chittaprosad and Hore, using printmaking as a medium of protest and propaganda. Significant among them were the relief printmaker Suranjan Basu and the very gifted Pinaki Barua, both of whom died early, though not without leaving a sizeable legacy. Debnath Basu followed in their footsteps, making deeply cerebral work, where both text and image play parallel roles, using both the print medium and also graphite. The IPG, on the other hand, included printmakers with diverse artistic quests and practices, united only by a dedication to the medium itself. In the 1990s, it was the IPG that was responsible for formalizing Indian printmaking, and also for charting new paths on which future generations walked. Most of the IPG artists were students of Anupam Sud, whose legacy, particularly in North India, is far-reaching. Shukla Sawant, Kavita Nayar, Kanchan Chander, and others constitute a part of this legacy.

Outside of an occasional exception such as Tanuja Rane, Mumbai did not develop a printmaking culture until very recently, when that changed due to the efforts of The Clark House Initiative in collaboration with Sir J. J. School of Art. By contrast, Baroda and Ahmedabad had a vibrant printmaking fraternity—the former at the Faculty of Fine Arts at M. S. University, and the latter at the Kanoria Centre for the Arts. Walter D'souza, again largely a black-and-white relief printmaker with socialist inclinations, was at the helm at the Kanoria Centre for many years. A host of printmakers emerged over the decades from Baroda, many of them pushing the envelope of the medium, cashing in on its graphic sensibilities, but stepping well without its limitations. These include artists such as Shakuntala Kulkarni, Archana Hande, Ravikumar Kashi and Anupam Chakraborty.

Recent entrants into the fray of printmaking collectives are Space Studios and Ravi Engineering Works in Baroda, both of which have contributed greatly to developing the printmaking ecology in India. Similar printmaking initiatives in other parts of the country include the artist-led India Printmaker House, based out of Delhi, and Atelier Prati, in Bengaluru. Printmaking's historic association with the realm of the popular has remained with printmakers such as the diasporic Chitra Ganesh, who often makes hand-tinted lithographs or digital prints, with images derived from sources as diverse as Indian myths to Japanese manga.

With printmaking infrastructure, funding, and support developing and becoming available outside of the institutional framework in India, emerging practitioners are staying with the medium even after their student years. In the last decade or so, the medium has received a fresh fillip, with young printmakers breathing new energy into the practice. The Covid-19 pandemic, in fact, has proved beneficial, rather than detrimental to the medium of printmaking, with both artists and consumers seeking affordable, yet exciting avenues in art. There is today a renewed interest in this medium, which appears to be translating into an escalating market for prints worldwide.

Notes

1. Prabhas Sen, "Chittaprosad—The Artist," in *Chittaprosad*, ed. Amit Mukhopaddhyay (New Delhi: Lalit Kala Akademi, 1993).

2. *Group 8* letterhead, New Delhi, 1991.

3. Anupam Sud. From personal correspondence with the artist in 1991.

An Aesthetics of Borders, Globalization, and Migration in Post-Partition India

Emma Oslé

Through their visual practices, artists from South Asia shape a distinct sense of place, engaging with migration, social geographies, and crossings in myriad ways. They invite viewers to look beyond the painted surface, to examine not only those boundaries that are explicitly depicted but also those which are not always visible. They highlight journeys and explore emotional connections. Sometimes their engagement is deeply personal, drawn from events in their own lives. Other times, they emphasize more broadly shared experiences of travel, diaspora, urban space, and the effects of globalization.

The South Asian perspectives seen in this catalog encompass a range of distinctive subjectivities. Artists featured in this exhibition have lived, either temporarily or permanently, as immigrants in 12 countries, including but not limited to India, England, France, Israel, Bangladesh, the US, Italy, Pakistan, Qatar, Thailand, Germany, and Japan. Many of these artists spent formative years of the late 20th century in Europe, particularly in Paris and in London.[1] Others spent substantial time in the US.[2] Of the 31 artists represented, 14 never left India even after Partition, and, of the 16 artists who did leave, 11 of them moved to at least two countries other than India, and in some cases many more than two. Some artists moved back "home," settling once more in India following their travels, and others stayed away indefinitely. Of those artists who are no longer living, many were buried within the borders of their chosen homeland rather than in their country of origin. Often, these artists did not inhabit the same diasporas, though crossover did happen, particularly within the Bombay Progressive Artists' Group and Stanley William Hayter's influential printmaking workshop, Atelier 17.

For artists of South Asian origin, for whom the 1947 Partition of India, Pakistan, and Bangladesh lives not in a distant ancestral past but as part of a collective present memory, ideas of migration, diaspora, and dispossession remain at the forefront of their studio

practices. The artists featured in this collection and its resulting exhibition largely came of age in a critical post-Partition period of nation-formation, in which an imagining of territory and nation took place during a moment of global decolonization spanning from Asia to the Americas. Forms of mobility play a key role in the lives, careers, and work of these artists, including those who lived and worked in India for the bulk of their careers. The works featured in the "Topographical Engagements" section of this exhibition rethink notions of migration, diaspora, urban space, and globalization in an attempt to pinpoint their own sense of the modern in India.

Artist as Migrant

Diaspora, as an overarching concept, goes beyond a sense of simply "those who have left." Inherently, the experiences of diaspora refer to the consequences of globalization as they impact the individual and the community. Diasporic subjects are never one and the same, as diasporas are formed in disparate circumstances. Phenomena such as war, famine, violence, personal choice for various gains, exile, and capitalism shape experiences of migration in very different ways. Most diasporas do share one thing in common, however: a distinct resistance to full assimilation, and the desire to hold on to ancestral memories, cultural heritage, and communal identity.[3]

In the introduction to *The Migrant's Time: Rethinking Art History and Diaspora*, Saloni Mathur sets up an inquiry into the ways in which Art History as a discipline needs to reconsider and highlight the significance of migration and diaspora.[4] Mathur emphasizes the importance of understanding the condition of globalization as it affects artmaking practices in the 21st century, and the ways that migration informs political space without necessitating a tropic view or an overemphasis on dispossession and mobility. Migration, in Mathur's frame of thought, represents a social entry point that is entangled with issues of homeland, a lack or loss of belonging, and the search for community in a world "both inextricably interconnected and mercilessly blocked by the politics of barriers and boundaries for historiography, writing, and the narratives of art history."[5]

This collection features a broad constellation of artists whose work directly engages with the conditions of globalization, migration, and diaspora that Mathur highlights. Their experiences are wholly heterogenous, making it impossible to pin down any single narrative or visual migratory sensibility. In the process of conceptualizing the exhibition, we were drawn to the repetition of certain forms and modes of subject formation, such as depictions of urban spaces and engagement with cartographical processes. We also noted a particular investment by many artists in conveying notions of journeying and travel by evoking a visual and mental sense of motion. These artists convey kinesis through inferred routes of travel, allusions to modes of transportation, literary referents, and the mental state of being in motion.

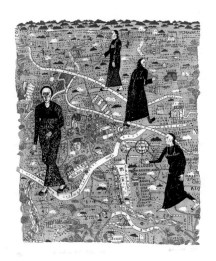

Fig. 1

Arpita Singh
*I could see London
through clouds*, 2007
Multiple-plate etching
33 × 27 ¾ in (cat. 6a)

For instance, Husain's *Yatra* (cat. 3), ca. 1950s, depicts three figures riding across a landscape. Choppy, angular mark-making evokes a sense of movement, and houses seen in the distance give the viewer the impression that these figures are either moving into or away from the town behind them. In Hindi, *yatra* can be literally translated as "journey" or "travel," giving the viewer a clear understanding of the action in which the figures are partaking. Krishna Reddy's *Flight* (cat. 46B), from 1963, also alludes to travel and motion, even within its intense visual abstraction. In this print, Reddy captures the moment of exit, impact, or stoppage of an unknown object.[6] Though the object is unknown, the sense of fast motion, with an almost starburst-like explosive form to the far right of the image, appears to visually reference airplane contrails crossing and intersecting one another as if the moving streak could have come from a series of overlapping flightpaths.

Arpita Singh's prints undertake a different mode of representing journeys, making explicit reference to the ways the human body is affected by travel and motion. *I could see London through clouds* (fig. 1) (cat. 6a), from 2007, particularly depicts various modes of transportation, from automobile travel, to air travel, and even foot traffic, via the four main figures walking through the image. The mobility of these four central female figures is paused mid-action as they notably move across streets. The title of the work also directly alludes to the experience of flying from one geography to another, noting the way a cityscape, like that of London, may peek through or become hidden by clouds while flying into or out of that place. On bringing the city into her work, Singh said, "There are so many things happening all the time around you[.] You are also a part of them, so these things start coming into your mind and it is up to you to give importance to them, and elaborate your ideas about them."[7]

With the increasing speed of transit through air and ground transportation, personal experience becomes blurred and complicated, incorporating multiple spatial temporalities into a single sense of self. Increasing migration, cross-cultural exchange, hybridity, and travel can also dissolve a sense of geographically rooted belonging. In *This could be us, you, or anybody else* (cat. 6b), another print from 2007, Singh conveys a sense of the fast-paced nature of global movement and travel through the use of embedded textual elements. Literary statements such as "The aeroplane that takes me to your land, and you to mine," "The fruits I eat may be you too," and "This could be us, you or anybody else" make objects, places and people difficult to pin down. The text evokes a complicated web of interconnectivity in which the everyday is inscribed not into a specificity of place but into the logic of constant motion and high-speed travel.

Contested Lands
Other artists engage with the interwoven histories of decolonization and violence. The period of post-colonization, for many countries, was followed closely by tumultuous

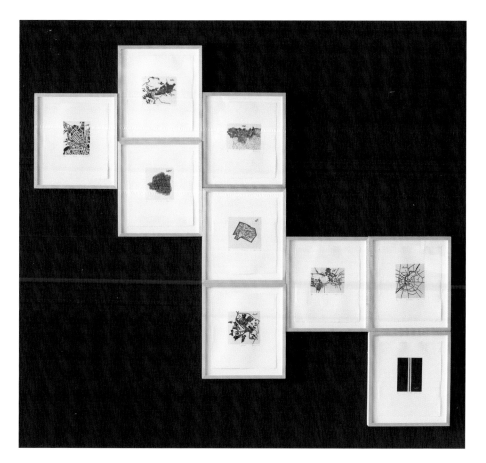

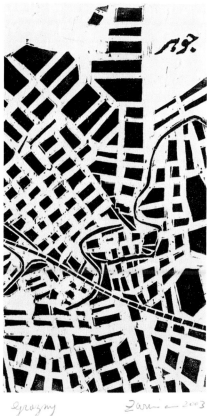

periods of civil war, political unrest, and complicated attempts at nation-building, which, for some, continue today. These issues are inexorably linked to the larger problems that permeate through time and across borders, such as the reimagining of racial and/or cultural belonging, understandings of personal and national difference, and inter-community animosity.

Zarina's 2003 series of woodcuts, *These Cities Blotted into the Wilderness* (fig. 2) (cat. 9a–h), speaks not only to her connection with a multitude of cities through her personal history of migration, but also to the ravages of war and military violence. Zarina lived in a total of seven countries—India, Thailand, France, Germany, Japan, the US, and England—before permanently settling in New York City, where she witnessed the bombing of the World Trade Center first-hand. This series of woodcuts references cities with recent histories of violence. For example, *Grozny* indirectly comments on contested territory through the use of language. Whereas the Urdu text phonetically evokes the Chechen separatist name for the city, the Russian name of "Grozny" is written in English.[8] Here, Zarina directly engages with the larger issue of naming and renaming, which has been a cornerstone of nationalist reclaimings of place throughout the post-colonial world (fig. 3).

Fig. 2 [left]

Zarina
These Cities Blotted into the Wilderness (Adrienne Rich After Ghalib), 2003
Portfolio of nine woodcuts with Urdu text printed in black on Okawara paper and mounted on Somerset paper, Edition of 20, variable sizes, sheet size: 16 ¼ × 14 ¼ in (cat. 9)
Installation view, Gaur Gallery, 2019

Fig. 3 [right]

Zarina
Grozny, from *These Cities Blotted into the Wilderness (Adrienne Rich after Ghalib)* (detail), 2003 (cat. 9a)

Similar to Zarina's *Grozny* print, a 2002 watercolor by Atul Dodiya, titled *Kiss* (cat. 4), also speaks to the contested nature of territory. In Dodiya's image, an emaciated, seemingly ill or diseased skeletal figure riding atop the mast of a small sailboat bestows a kiss—likely the kiss of death—upon the Northwestern tip of India. There, the battle over territorial rights to Jammu and Kashmir has raged on and off between India and Pakistan since 1947, and with China since 1962, creating alternating periods of peace and conflict. The national borders are intentionally ill-defined in the image, making the territorial irresolution a defining characteristic of the work.

At the time of writing this essay in early 2022, Russian troops are actively bombing Ukraine and invading its territory. Borders, crossings, and infiltration are on the forefront of countless minds, thrusting a particular global ethos of anxiety onto a world already laced with pandemic-related traumas, food insecurities, inflation, climate change, and environmental disasters. This palpable tension—fueled by NATO agreements, desperate pleas for assistance, government talks, and the possibility of nuclear and chemical warfare looming overhead—has the potential to color not only the way we look at our governments and international relations, but the way we experience the world around us, especially for those with emotional, ancestral, physical, and national ties to Ukraine and Russia.

Ultimately, the difficulty of contested borders and territorial conflict is one with which India is quite familiar. It is also an intellectual location from which many modern and contemporary artists are able to draw inspiration, content, and fuel for their own perspectives and self-reflections. From the Partition of 1947 to more recent turmoil over Jammu and Kashmir in Northwestern India, territorial disputes have shaped the whole of South Asia, and, even today, India continues to grapple with territorial disputes with such countries as the People's Republic of China, Pakistan and Nepal.

A South-South Perspective

Considered from a South-South perspective, we can come to understand that the Partition of India was just one episode during a larger moment of widespread global decolonization that originated at the conclusion of World War II. In 1947, a severely depleted economy in the United Kingdom led Britain to turn over its own government and eventually cede to the Quit India Movement, mandating the Partition of India and Pakistan, having granted both countries independence as of midnight of August 14–15. With a governmental decree, British India was divided into a Hindu-majority India and a Muslim-majority Pakistan. Due to tensions and violence over religious ideologies, the echoes of Partition forced massive migrations into and out of these newly formed countries, causing a substantial and widespread refugee crisis. Less than a year later, on May 14, 1948, Britain also ended the British Mandate for Palestine and terminated its responsibility for administering the territory, which initiated the 1948 Arab-Israeli War

and the signing of Israel's declaration of independence. This epitomizes the "divide and quit" concept levied by colonial powers in the 20th century when colonies became cumbersome or could no longer contribute to economic and imperial gain.[9]

The US similarly moved to protect its own interests through military actions, sloughing Axis occupation in Greece and liberating countries like South Korea from the Empire of Japan's rule. In the aftermath of World War II, border making was largely driven by Cold War politics, which had radical effects on the Global South. In Korea, the land was divided into two countries separated not by religion but perceived political affiliation: the communist North and the US-backed South.[10] Countries south of the US-Mexico border also felt the ripples of World War II's aftermath. As countries across the Americas started to embrace socialist ideals, the US ramped up its practice of hemispheric intervention. By the end of the millennium, of the 33 other recognized independent nations of the Western Hemisphere, the US had interfered in nearly 40% of them.[11]

Experience in the broader Global South can be tied together by a shared history of coloniality and imperial influence. In these spaces, communities must regularly forge new modes of global citizenship and communal belonging in an era of rapid globalization and interconnected geopolitics. They are often doing so while simultaneously undergoing nation-building, decolonization, and community formation. In this way, analogies can be drawn from artists connected to seemingly disparate locations, such as India, the Middle East, the US-Mexico border, and the Caribbean, especially those making work from their own diasporas.

Like the artist Zarina, Mexican-American artist Julio César Morales has engaged directly with borders and divisions, in his case those created in 1848 with the signing of the Treaty of Guadalupe-Hidalgo, where half of Mexico's territory was ceded to the US. Without leaving their homes, thousands of people were thrust into a new geopolitical territory, one which made lasting impact and pervades in the common phrase, "We didn't cross the border, the border crossed us."[12] Morales's 2019 sculpture, *Broken Line* (fig. 4), resonates with Zarina's evocation of the Radcliffe line that divided India and Pakistan, making the jagged wound of separation prominent, and seen most famously in her 2001 woodcut, *Dividing Line* (fig. 5).

While Zarina's woodcut print depicts a single calligraphic sprawling line that reaches violently across the image, Morales's sculpture creates a red neon rendition of the US-Mexico border, similarly deconstructed and envisioned as a single unconnected contour. By deconstructing borders and partitions, Zarina and Morales call to mind the ultimately arbitrary nature of geopolitical boundaries. In both instances, outsiders created these partitions, likely with no personal connection to the lands they cut in half. These works evoke a sense of wounding by using a minimalist emphasis on the line itself and, visually, they both

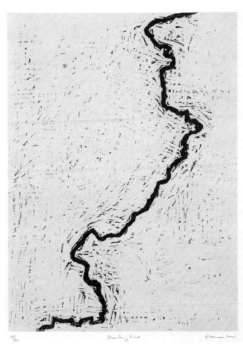

function as a scar— *Dividing Line* cuts through the paper surface, and *Broken Line* seems to crack the very earth beneath it.

In the Caribbean region, long histories of coloniality and the constantly rippling effects of decolonization deeply shape the intellectual and cultural makeup of the territories within it. Like India, the Caribbean is another area of the world prominently shaped by British colonialism, and in fact maintains large diasporic South Asian communities, especially on such islands as Trinidad and Tobago. Departing from the traditional trope of heterogeneity, Tatiana Flores and Michelle Stephens propose an archipelagic vision of the Caribbean that allows us to see beyond the fragmentation resulting from colonialism to unearth some of the ways these islands are, in fact, inexorably linked.[13] An archipelagic approach, similar to a South-South perspective, lets us tease out similarities and make connections from one space to another that might otherwise be overlooked.

Artists like Nyugen Smith, a first-generation Caribbean-American (USA, Haiti, Trinidad and Tobago), approach histories of colonialism in ways that bridge gaps and create connections, also in conversation with migration and diaspora. Key in Smith's practice are his "bundlehouses," which depict small homes and shelters created from found objects, running the gamut from assemblage to works on paper. The cartographic series, *Bundlehouse: Borderlines*, melds multiple islands into fictitious land masses and invents new ones such as "Isle de Tribamartica," "Sint Maricotín," and "Isla of Dominibuda." *Bundlehouse: Borderlines* calls attention to the way colonialism has shaped the

Caribbean region (figs 6 and 7). Envisioning these invented islands as giant refugee camps, the artist evokes the way that many must rebuild their lives after disaster and war, through that which is already available to them. The works are also colored with soil from Caribbean geographies, African countries, and diasporic Caribbean communities. Ideas of home, belonging, diaspora, and a sense of rebuilding with what remains are key components of the decolonial experience, wherever globally it may be happening

Beyond the Americas and South Asia, experiences in the Middle East are also particularly relevant, given the tumultuous histories of places like Palestine and Israel, where tensions have remained since Great Britain ended its mandate in 1948. Palestinian-American artist Emily Jacir, for instance, directly engages with the events of 1948 and its impact in starting the Israeli-Palestinian conflict that still wages today in her 2001 installation, *Memorial to 418 Palestinian Villages which were Destroyed, Depopulated and Occupied by Israel in 1948* (fig.8). The work incorporates a family-sized refugee tent embroidered with the names of all 418 destroyed, depopulated, and occupied villages of Palestine as of 2001. Not only does the work center dispossession and territorial violence, but it directly speaks to the forced migrant and refugee experience. In another series, we see her personal engagement with exile. In the work called *Where We Come From*, Jacir encountered the exiles of those barred from entry into Palestinian borders by utilizing the privileges of her US passport. She often completed tasks, or attended certain places they longed to see, and documented it with photography.[14]

Fig. 6 [left]

Nyugen Smith
Bundlehouse: Borderlines No.4 (Sint Maricotín), 2017
Pen and ink, watercolor, thread, colored pencil, acrylic, graphite, gesso, metallic marker, tea, Diaspora soil, lace on paper
48 × 54 in

Fig. 7 [right]

Nyugen Smith
Bundlehouse: Borderlines No.3 (Isle de Tribamartica), 2017
Pen and ink, watercolor, thread, colored pencil, acrylic, graphite, gesso, metallic marker, colored pencil, tea, Trinidadian and Zambian soil on paper
60 × 48 in

Fig. 8

Emily Jacir
Memorial to 418 Palestinian Villages which were Destroyed, Depopulated and Occupied by Israel in 1948, 2001
Refugee tent, embroidery thread, daily log of names of people who worked on tent
8 × 12 × 10 ft

Like the examples of Julio César Morales, Nyugen Smith, and Emily Jacir, the South Asian artists of the generation represented in this collection deeply engage with migration, territory, and globalization. Particularly, the artists in this exhibition use post-Partition India as the referent, which leads them to call forth questions of belonging, movement, travel, and the nation. Their images do not merely recapitulate identifiable locations in a two-dimensional plane. Instead, they intervene directly into the topographies and state-defined spaces that make up place, complicating our understanding of cartographic givens, travel, and diasporas. In this way, they establish their own sense of an aesthetic of borders: one that is supremely subjective and personal, and yet directly engaged with a shared communal sense of fracture and tension, instigated by Partition and furthered by individual experience.

Notes

1. Within this collection of works, artists Akbar Padamsee, Atul Dodiya, Jogen Chowdhury, Krishna Reddy, Paritosh Sen, Ram Kumar, S. H. Raza, and Zarina lived in France at some point during their careers. Artists Anish Kapoor, Avinash Chandra, Anupam Sud, F. N. Souza, Gulam Mohammed Sheikh, Krishen Khanna, Krishna Reddy, M. F. Husain, and Zarina lived in England at some point in their careers.

2. Artists who lived in the US include F. N. Souza, Gulam Mohammed Sheikh, Jyoti Bhatt, K. G. Subramanyan, Krishen Khanna, Krishna Reddy, Paritosh Sen, S. H. Raza, and Zarina.

3. Tobias Wofford, "Whose Diaspora?," Art Journal 75, no. 1 (2016): 74–79.

4. Saloni Mathur, The Migrant's Time: Rethinking Art History and Diaspora, Clark Studies in the Visual Arts (Williamstown: Yale University Press, 2011).

5. Ibid., viii.

6. Krishna Reddy et al., Krishna Reddy: A Retrospective. (Bronx, N.Y.: Bronx Museum of the Arts, 1981), 69.

7. Yashodhara Dalmia, "Arpita Singh," in Journeys: Four Generations of Indian Artists in Their Own Words, 2 vols. (New Delhi: Oxford University Press, 2011), vol. 2, 69.

8. Aamir R. Mufti, "Zarina's Language Question," in Zarina: Paper Like Skin (Los Angeles, CA: DelMonico Books-Prestel, 2012), 152.

9. Radha Kumar, "The Troubled History of Partition," Foreign Affairs 76, no. 1 (1997): 22–34, https://doi.org/10.2307/20047907.

10. Ibid., 25.

11. The US supported the opposition of Costa Rica's civil war of 1948, executed a coup in Guatemala in 1954, and engaged in Cuban invasion and attempted assassinations from 1959–1962 once Fidel Castro became President. The US also colluded in the 1961 murder of Dominican Republic dictator Rafael Trujillo, and aided a government coup in Brazil in 1964. In the 1970s, the US was involved in destabilizing Soviet/communist interests in Chile, and supported coups in Bolivia and Argentina. In the 1980s and 90s, they cut off aid to Nicaragua and aided the Honduran-based Contras in turning over the government, invaded Panama and Haiti, and meddled in Paraguayan governments.

12. Edward J. McCaughan, "'We Didn't Cross the Border, the Border Crossed Us': Artists' Images of the US-Mexico Border and Immigration," Latin American and Latinx Visual Culture 2, no. 1 (January 1, 2020): 6–31, https://doi.org/10.1525/lavc.2020.210003.

13. See Tatiana Flores and Michelle Stephens, "Relational Undercurrents: Toward an Archipelagic Model of Insular Caribbean Art," in Relational Undercurrents: Contemporary Art of the Caribbean Archipelago (Long Beach, CA: Museum of Latin American Art, 2017), 14–28.; and Tatiana Flores and Michelle Stephens, "Contemporary Art of the Hispanophone Caribbean Islands in an Archipelagic Framework," Small Axe: A Caribbean Journal of Criticism 20, no. 3 (51) (November 1, 2016): 80–99. https://doi.org/10.1215/07990537-3726878.

14. T. J. Demos, "Desire in Diaspora: Emily Jacir." Art Journal (New York, 1960) 62, no. 4 (2003): 68–79. https://doi.org/10.1080/00043249.2003.10792185.

Ancient Narratives of Devotion: Replication, Transformation, Rejection

Darielle Mason

When I was asked to write an essay on "religion and mythology" for this catalog, it seemed a straightforward task for a specialist in the art of historic India. I would point out some of the referents and themes—the ideas and iconographies—that demonstrated links with the past and popular religion, and explore how artists selected and recontextualized them. I soon found the task nowhere near so simple. Characters or stories from the past, ancient and more recent, might be readily recognizable—Hanuman burning Lanka, Rama hunting the golden deer, Majnun being brought before Laila, St. Francis and the birds, the birth of the Ganges. But, for each artist, historical motifs are only a beginning point in their process to fuse the personal and political, societal and social, secular and sacred. Myth and religion become malleable tools so that their imagery deflects the hackneyed practice of forensically tracking iconography, showing up this art historical tactic as both limited and reflexive.

A part of my choice of artists and works of art for this essay is to acknowledge the role that chronology plays in the uses of iconographies drawn from narratives of devotion. Because of the time frame in which these artists work (1950s to the present), they consciously give themselves permission to pull from any period, place, religion, or culture—in other words they claim universal "ownership," as did and do modern and contemporary artists throughout the world.[1] What differs among them is not *that* they pull but *why* they pull and *what* they pull.[2] By looking for mythological references in their works, I came to understand that the term "mythology" applies equally to an artist's self-identity. Each of these practitioners knowingly inserts themselves into the lineage of not only Indian but also global art.

M. F. Husain's modernist imaging, his mature style alternately termed "expressionist" and "cubist," deliberately countered the realist-romantic vision of Raja Ravi Varma, which had created the elegantly bourgeois Hindu pantheon popular from early in the 20th century.[3] Reams have been written about Husain's fascination with Hindu mythology—praising and condemning, depending on the perspective—although he also engaged with the

mythologies of Islam, Christianity, village India, colonialism, and Independence. His illustrations of the *Ramayana* and *Mahabharata,* as has often been noted, emerged from his own childhood. But Husain was drawn as well to the intrinsic narrative and spiritual power of these epic tales, recognizing in them the ability to express universal concepts embodying the new nation of which he proudly included himself as a citizen.

Throughout his oeuvre, Husain's images preserve their illustrative core, an icon remains an icon. Symbolism coexists, overlays, even submerges story, but never ruptures it. Veena Das writes,

> ... in the depiction of ... Ravan, Sita and Hanuman, the painting drips with narrative. In order for many who are steeped in these narratives, the eye must learn to see ... without the narrative ... Husain's oft-quoted remark that for villagers among whom his depiction of Ramayana was displayed, the story immediately provided the frame for 'understanding', is to belie the Modernist ... claim [to] the autonomy of the image ... Husain's images, intentionally or not, take a whole contentious past as part of their inheritance.[4]

Das presents it as an imperative that viewers "learn to see" by piercing through this "dripping" narrative. She also questions Husain's awareness of the contested pasts his works embody. But is it possible in his densely narrative works ever to limit one's perceptions solely to the language of form? And could Husain, the barefoot sophisticate, have desired this even of his most elite audiences? Husain seems to raise larger questions that encompass the uses of the past and his role in defining the new nation. What *is* India's cultural heritage, he asks? Is it merely a selection of iconographies extracted by British archaeologists, thrown by post-Independence secularists, and fired by Hindu nationalists? Or is it the vast tangible-intangibility of the subcontinent's millennia-deep storied legacy, and the impact of that legacy on the world?

Fig. 1 [left]

Maqbool Fida Husain
Untitled (Hanuman), ca. 1990s
Watercolor on paper
22 × 30 in (cat. 29c)

Fig. 2 [right]

Maqbool Fida Husain,
Hanuman-Nineteen, 1984
Ink and watercolor on paper
15 × 21 ¾ in (cat.29b)

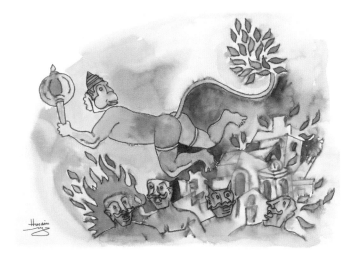

Husain's two depictions of Hanuman burning Lanka in *Paper Trails: Modern Indian Works on Paper from the Gaur Collection* forefront the same character and tell the same story, or seem to. Yet, in one, *Hanuman* (cat. 29c), the artist presents a puppet-play, while another, *Hanuman-Nineteen* (cat. 29b), represents the anger of cosmic destruction (figs 1 and 2). A third image from the many he did of this episode, now in the collection of the British Museum, shows yet another spin.[5] Here the black imperium silhouettes Hanuman's great golden body with his mace for a head. He raises one arm to bear the orb of the sun, which is sparked by his flaming tail. Muscular legs overstretch a diminutive earthly plane. Neither adorable nor terrible, this Hanuman epitomizes divinity, vast and awe-inspiring.

Though his visual vocabulary and rapid brushwork were, during most of his life and still today, considered by many as anti-traditional, Husain told tales of the mythic and the iconic in a relatively linear, coherent (and, in those ways, traditional) fashion. Gulam Mohammed Sheikh's narrative mode, on the other hand, is far from traditional, although his precise and often photorealistic vocabulary may lull the viewer into believing the opposite. Sheikh grabs, manipulates, juggles, and juxtaposes the devotional, historical, and everyday. His aim is to create from these independent motifs a larger, overarching mythology. Carefully slotting each image into an intricate mosaic, he conjures a complex, non-linear narrative.

In *Mappamundi* (cat. 5b), our focus is drawn first to the four large figures at the corners who seem to represent the passion and madness of faith. In the lower left, Mary Magdalene reaches toward an invisible resurrected Jesus. Above her, insane Majnun, in chains, approaches his beloved Laila, while Kabir sits across, weaving his own shroud. At lower right, a Mughal mystic torques in ecstatic dance. Even when the viewer cannot identify specific referents, the images share an emotion that seems emphasized rather than diminished by their stylistic dissonance.

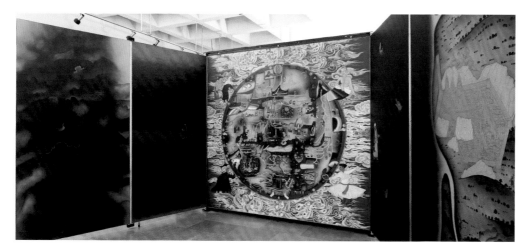

Fig. 5

Gulam Mohammed Sheikh
Kaavad: Travelling Shrine (detail),
2008, Room with folding doors
and walls (made of boards
mounted on steel structure)
painted in acrylic and oil
90 × 308 × 288 in

Persian, Mughal, and Rajput manuscripts inform Sheikh's overarching vocabulary as well as his process. He moves his viewers' eyes from color-block composition inward and inward toward ever-smaller details. In *Mappamundi*, he emphasizes certain other figures not by size but by repetition. St. Francis of Assisi, leaning forward in his brown cassock, stands stationed at each of the cardinal directions as he preaches to the birds, in variations on an early Italian Renaissance model. Does St. Francis represent care of the natural world as per his legend, or might his placement at the extremes of the compass imply the expansion of Europe's colonial conquest, or perhaps its messianic grasping of its flocks? Within and outside the circle, nine renditions of blue-skinned Rama stride forward, a crescent arrow notched on his great bow. Like other quotations the artist selects, the flat, bold profile makes this figure easily legible. The Rama figure is excerpted from an early 18th-century painting from the Himalayan foothills in which Rama hunts the golden antelope desired by his wife, Sita. In the story, his quest could be read as mistaken, since it leads to Sita's abduction, or as essential, since it leads to the death of Ravana and restoration of cosmic balance. But what is the purpose of the multiple Ramas here? Is he searching the globe, conquering it, or circumambulating it as a pilgrim? Sheikh intentionally opens these alternative meanings to his viewers (figs 3 and 4).

Mappamundi challenges the Eurocentric and Christian-centric worldview by implanting and integrating, or owning, imagery quoted from historical paintings located around Asia and Europe, works Sheikh saw in person or in photographs. Through placement and context, he imbues the images he selects with new and, at times, multivalent meanings. Do we understand the motifs as illustrations or as icons, as pictograms or as metaphors? Is the overarching subject of *Mappamundi* faith or conflict, history or lived experience—or all of these? *Mappamundi* evolved through a number of iterations from an accordion book into a human-scale inhabitable installation (fig. 5). Sheikh's montage-like compositions mine his visual universe. Never self-censored by fear of ownership, he draws historical imagery from

any period, nation, and religion just as he does from the cityscapes and domestic interiors of his life in Gujarat. Appropriation has no meaning here.[6] Coherence emerges from multiplicity, juncture from disjuncture.

Although she works in many mediums, Anupam Sud is primarily a printmaker, creating mostly monochrome compositions, which often consist of frames, such as windows or doors. Unlike Sheikh's prismatic montages, Sud's elements cleanly abut. When they do overlap, a layer of dense, filagree imagery may act as background for her sculpturesque, ungendered, and de-particularized visions of the human body. Sud counterposes the substance of figure, geometry of framing, and lightness of ground to accentuate her wry storytelling. With formal adjacencies, she transforms seemingly mundane subjects into explosive plots, such as in *The Conference* (cat. 16e), where the arms of a shadowy, surreptitious architect-oligarch, almost invisible above a screen, pulls the Rajasthani-puppet-politicians' strings.

What is identifiable as "myth and legend" in Sud's work appears most often behind the main images. There she may quote details of artworks from monuments or museum collections. These delicate, photogravure-like backgrounds offset her nude, bald, unadorned bodies and act rather like symbolic wallpaper.[7] Sud notes, "I didn't want to limit myself to being Indian because I wasn't talking about Indianness, I was talking about humanness."[8] In her hands, then, historic Indic images nod to the local but function as footnotes to the universal.

Fig. 6 [left]

Anupam Sud
Cosmic Dancer, 2005
Etching and aquatint on paper
20 × 15 ¾ in

Fig. 7 [right]

Goddess Bhadrakali Worshipped by the Gods, page from the dispersed *Tantric Devi* series, Himachal Pradesh, India, ca. 1660–1670
Opaque watercolor, gold, silver and beetle wing cases on paper
8 ½ × 8 ½ in

She does not take "myth and religion" as subjects in themselves, nor are these images "simple" archetypes. Instead, they act as tools that help her merge past and present, specific and generic, to create visions at once mundane and mystical, humorous and hallowed.

Sud often takes as her target the fight for gender equality. As an unmarried woman, a professional, and a printmaker (considered a man's occupation), she stands outside the margins of Delhi's Punjabi society. In her own telling, she remains emotionally linked with her natal community but feels required to assert and reassert her independent identity. Sud's subjects overtly and implicitly—but always consciously— give form to the struggle women face to be considered fully human within India's—and global— patriarchy. Literally or figuratively, she limns the narrow boundaries of female lives. In one striking print, she captures the contradictions of female power and claustrophobia (fig. 6). The primary figure, cropped just below her breasts, stands in the lower foreground with her open palms raised, arms separated from her body like those of a multi-armed deity. She gazes at the viewer in an act resembling *darshan*, the interactive seeing and being seen of devotee and deity. Woman as goddess is emphasized by the visual quotation in the background. It is a detail of a page from one of the most compelling visions of female power ever produced—a wild-eyed, multi-armed goddess Bhadrakali from the so-called *Tantric Devi* series, painted in a small kingdom in the Himalayan foothills in the late 1600s (fig. 7). Contorted across the top of the print is a four-armed male figure, the cosmic dancer of the title, who is Shiva himself. Here, though, his arched back is skewered on the prongs of Bhadrakali's red lotus crown in a pose that evokes that of Andhakasura, embodiment of darkness, a demon that in the myth is skewered by Shiva on his trident.

Sud also references myth and religion without direct recourse to historical art. Yet even here, her universal seems infused, however subtly, with the Indian. *Aqua Pura* (cat. 16c) is such a case. A man and woman, in their primes and shorn of ethnic, national, or religious attributes, face one another. The pure water of the title, flowing and contained, appears ubiquitous. It snakes behind them, a bubble-laden river in ribbons that links their lower bodies. The man's hand seems to reach for the woman's but instead he grasps one of a line of plastic water bottles. She holds up a glass to drink, apparently filled with water from the bottle furthest to the left, which is without its cap. The bottles themselves are not generic, rather they are a type used by Bisleri, an Indian brand that, by the late 1990s, had become the public's definition of pure, safe drinking water across the subcontinent.[9] The river implies India's holy Ganges, the streams falling like its embodiment, the goddess Ganga, whose descent to earth was softened by wandering through Shiva's tangled hairs.

The water of the Ganges is perpetually pure, purifying body and karma. Ganges water is not a symbol but the literal substance of purity for Hindus and for a good percentage of others of different religious affiliations across India, making it not only intrinsic to national identity but

also representative of the blending that characterizes the larger region's supposedly separate streams of devotion.[10] Further, Ganga's irrigating properties have, since time immemorial, made her the quintessence of the mother. Might Sud be intending these pure streams of water as a means of procreation, linking the generative organs of man and woman? If so, it appears to be a distracted act. Sud depicts the man glancing past the woman's shoulder as she gazes downward, eyes in shadow. Is this a bond "intimate but nonverbal," as some of the artist's other depictions of couples have been described,[11] or is the connection only via the water, liquid not limpid? If the aqua, the river, the goddess is so pure, why the emotional evasion?

Like Sud's identity as an unmarried female printmaker, Bhupen Khakhar's identity as a gay man in India in the second half of the 20th century also put him outside the margins of middle-class social norms. Khakhar, by all accounts effervescent and gregarious, engaged avidly, perhaps obsessively, with people from all walks of life. Sheikh and Khakhar have biographies that intertwine from their early days at M. S. University in Baroda (now Vadodara) as members of what has been designated "The Baroda School."[12] Their art as well as writings speak of their shared celebration of the figure, the everyday, vivid colors, flat figuration, storytelling, and their rejection of modernist "expressionism." But these similarities may blur their fundamental differences. As opposed to Sheikh's distant prisms, Khakhar painted piercingly tender portraits.

Most obviously (but not only) Khakhar's later works craft his queer self-identity in a seemingly awkward but in fact highly accomplished and achingly eloquent fashion. At the same time, this immensely complex artist lovingly and knowingly opens our gaze to some of the previously invisible personalities, who inhabit a Gujarati working class that is neither wealthy celebrity nor abjectly poor. Khakhar paints these individuals from the perspective of both an insider and a transgressor.

In terms of his use of "myth and religion," like his use of the past and memory, it is as scrupulously intentional as the artist himself. Khakhar completed a degree in art history (then called "art criticism") at Baroda, and was well aware of the canon of "Fine Art" in both India and abroad. What he chose to collect, live with, and mine for content, though, were not museum masterpieces, but India's ephemera—the seemingly simple prints and objects worshiped as icons or depicting popular films that are found in most Gujarati homes. This source material was loaded with the allure of the ordinary. He bought, pasted, and quoted freely from such local ephemera. The question, then, is does the face value of such images in the context of Khakhar's art define them as "religion" or "mythology" as classified through the diagnostic of the discipline of art history? Or do they instead speak about the social context that the artist wishes to excavate? Khakhar did fully engage with Fine Art, but rather than mining Mantegna or Lorenzetti as image repositories, as did Sheikh, he used them as springboards for compositional and narrative modes.[13]

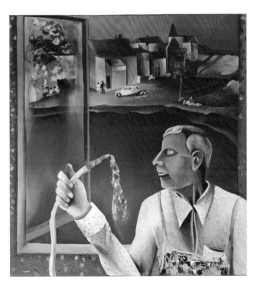

Khakhar speaks his truth in his work throughout his career despite the way his style and depiction of homoerotic subjects shifted over the decades. Throughout his life he also showed a complicated relationship with "religion." As a number of scholars have written, his early paint-collages create what appear as living icons. Throughout most of his career, though, he blended devout participation in the activities of faith with affectionate ridicule of those same activities (fig. 8). Participation and ridicule are intentional and he accomplishes both with respect and love, not contradiction. There seems no doubt that Khakhar followed the tradition of Vaishnava bhakti, the intense love of Krishna, as well as Rama, that infuses and enriches the lives of many Gujaratis. At the same time, both his painting and body language (for example in the 1983 film *Messages from Bhupen Khakhar*)[14] demonstrate Sheikh's comment on Khakhar's devotional practice: "I do not know how much [Bhupen] remained in and how much he watched from outside."[15]

Ranjit Hoskote, on the other hand, movingly articulates the sense of mobile faith embedded in Khakhar's art, which resonates with my personal experience sharing life with a Gujarati Vaishnava family over a number of years. Along with what one does every day, Khakhar regularly made the pilgrimage to Nathdwara in Rajasthan, headquarters of the Pushti Marg Sampradaya. Here, the god Krishna lives in His form as Shrinathji, and here His lushly ornamental actions, roughly translatable as "play" (*lilas*), are celebrated daily. Hoskote writes, "I would choose to read Khakhar's later art as a constant interplay between modes of *lila*: the first being the play of multiple forms assumed by the Deity (playfully surrogated by Khakhar in self-portraiture mode) and the second indicating the manifest Deity's bawdy, anarchic deeds as he blazes a trail of topsy-turvy enlightenment through the routines of social life (as found in the robust vernacular religious traditions of inner India)."[16] Looking at Khakhar's earlier works, I find these words equally applicable, reaching to the concept of *lila*

as embedded in Krishna bhakti even beyond Nathdwara. Krishna's erotic side, both sensuous and sensual, is embedded in his worship. What follows naturally, as Hoskote succinctly puts it, is that "Khakhar doubles the sacred and the erotic as mutual tropes."[17]

Khakhar's *Birth of Water* (cat. 21a), included in *Paper Trails*, creates an extraordinary complement to Sud's *Aqua Pura*, playing with the same theme (the birth of the sacred river), and in ways equally reverent and subversive. Liquid—as water, river, ocean, pool, temple tank, urine, and sperm— plays an outsized role in Khakhar's imagery (fig. 9). In *Birth of Water*, liquid serves to blend the sacred and the erotic. The titillating motif of a man watching another urinating, found as a sub-motif in a few of the artist's paintings,[18] transforms here into an act of creation and thereby sacrality. The seeming focus of the print is an oversized, crowned male deity.[19] He rises from a river to bless two male pilgrims who submerge and supplicate before him. The background is packed with figures, including a temple inhabited by a teacher and pupil, shadowy seated figures, and a herd of cows.

But the focus is neither the deity, the lustration, nor even the river. As the title denotes, it is the *birth* of water. "Water" here is made by man—not the generic human but the male person, likely the painter himself. At the far right, delicately sketched, stands a man. He glances out of the frame and unselfconsciously urinates. His water darkens, spreads, transforms into the great river that cleanses sins and fructifies the landscape. In the context of India, urine has more positive connotations than in most "Western" cultures. Not only the purity and health benefits of cow urine (*gomutra*) but also that of certain other animals and indeed of humans, stemming from the lineage of Ayurvedic remedies to the current health practice of *shivambu* (drinking one's own urine). This leads the substance to be considered, at times, the pure basis of life.[20] Khakhar's reinterpretation of the myth of the birth of the Ganges, then, jumps from pure substance to a play between purity and prurience, a cleansing by coming clean.

Atul Dodiya, the only artist discussed here who was born post-Independence, celebrates his direct artistic lineage, from Bhupen Khakhar as well as others of both the Baroda school and India's founding modernists. Dodiya forefronts—and glories in— excavating, owning, and manipulating stories, histories, and images from both India's and a global, particularly Euro-American, past and present. While the freedom to grasp and remix is a prerogative he shares with the other four artists discussed in this essay, they could not be more different in their utilizations of "myth and religion." Dodiya's comfort with world art moves far beyond image and allows him to play simultaneously with form, symbol, and implication. At times his referents are well known to his viewers. At other times they seem intentionally obscure; he implants well-hidden clues to unanticipated conclusions and new narratives, forcing the viewer into their own act of poetic excavation. Rather than Husain's literal if untraditionally fractured narratives, Sheikh's magical mosaics, Khakhar's use of the familiar and shockingly

everyday to alter perspective, or Sud's intentional local-universality, Dodiya's references resemble those of a symbolic novelist. One expects his figuration to illustrate but instead he conjures palimpsests, repeatedly compelling evaluation, never allowing a fixed reading.

Sabari Throwing Rings into the Chakri and *Sabari with Birds* (cat. 31a and 31b) come from a series of 31 prints and mixed-media pulp works which the artist titled *The Wet Sleeves of My Paper Robe (Sabari in Her Youth: After Nandalal Bose).*[21] Sabari's tale from the *Ramayana* is a moving lesson on the power of faith. Although Sabari appears in the text only in old age, there is reference to her back story. A girl from one of India's Indigenous communities, the mass killing of birds for her wedding feast so disgusts her that she abandons family to become a forest renunciant. In a forest ashram, she spends a lifetime tasting every wild berry to find one sweet enough for God, whom she knows will someday visit her. When Rama wanders by, Sabari recognizes his true nature and devoutly makes her offering. Although her touch and, worse, her bite has polluted the berry, Rama accepts and consumes, recognizing that the pure intention of the devotee purifies the gift. At this moment of communion, Sabari dies in bliss.

While an obscure substory within the larger text, Sabari has been utilized for political purposes at various times in India's history. The 15th-century rulers of the Deccani Vijayanagar empire, for example, identified the ashram of Matangi, where Sabari lived, along with certain other forest locales mentioned in the *Ramayana* as being within their own territory in order to legitimize their dynasty. More recently, the tale has been reinterpreted by Dalit[22] organizers who embrace Sabari's tribal identity to empower their communities. Simultaneously, certain Brahmanical (caste Hindu) groups have positioned this "outcaste" woman as the exemplary female devotee and one whose acceptance by Rama models the benefit of assimilation for tribal and other Dalit groups.

The subtitle of Dodiya's series, "Sabari in Her Youth: After Nandalal Bose," references another mythology, that of the lineage of South Asia's art history into which the artist has written himself throughout his career.[23] Nandalal Bose's 1941 tempera trilogy of Sabari paintings envisions Sabari in an intentionally local modernism, here a loosely impressionist-revival vocabulary, as a woman from the Santhal community, an Indigenous group living around Bose's home of Santiniketan, in rural eastern India. Along with the elderly woman we meet in the text, Bose paints Sabari as both a young and middle-aged woman.[24] This deeper biography imbues her—and, through her, all marginalized people—with a new level of humanity. Dodiya fills in and wildly expands Sabari's origin story—her horror at violence, her renunciation, her salvation. He transmutes it into universal experience not only through imagery that uses both X-ray and intentionally obscured perspectives, but also via collaged materials like paper pulp, hair, cloth, and ready-made shirt sleeves.

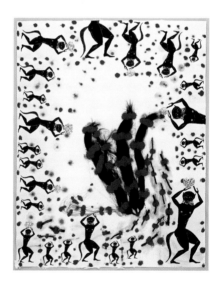

Fig. 10

Atul Dodiya
Lanka burns, 2005
Kozo paper, carbon toner, paper pulp, gold leeaf, synthetic hair, wine charcoal, handmadeSTIPI cotton and linen paper
66 × 52 in

The fact that Sabari's tale comes from the *Ramayana* is far from incidental, and Dodiya weaves the frame tale into "The Wet Sleeves." To do this, he often references another ancient civilization, the Greek, including using silhouetted figures taken from Attic black-figured vases—athletes in *Men from Athens*, satyrs as Hanuman in *Lanka burns* (fig. 10). The prints and collages in "The Wet Sleeves" are of a uniformly large scale of white ground rectangles. As much as possible in the gallery spaces where the set was displayed, they were hung to encircle the viewer (fig. 11). Nancy Adajania points to the performative aspect of the series and Dodiya's use of repeated symbols for secondary characters (what she calls "heraldic icons," e.g., synthetic hair for Sita, a sword for Ravana), relating it to the Ramleela street performances Dodiya experienced growing up in Gujarat.

These same characteristics conjoin with the ancient Greek motifs to echo, for me, another epic and a particular work of art beyond India.[25] That epic is Homer's *Iliad*, the foundational European statement on the savagery of war, and the art is American painter Cy Twombly's 1978 series *Fifty Days at Iliam* (fig. 12), which narrates the Iliad through "heraldic icons," gesture, color, and word. Like *The Wet Sleeves*, *Fifty Days at Iliam* surrounds the viewer, not cleanly linear in its telling yet forcing performative circumambulation through the visceral horror of rising human violence and its aftermath. Dodiya created *The Wet Sleeves* soon after Gujarat heard shouts of "Ramrajya"— the rule of Rama, or ideal just governance— leading to the bloody sectarian pogroms of 2002. As a series, Dodiya's *The Wet Sleeves*, like Twombly's *Fifty Days at Iliam* (or the murals of Kara Walker), exposes humankind's infinite capacity both to inspire and to violate.

Fig. 11 [left]

Atul Dodiya
The Wet Sleeves of My Paper Robe (Sabari in Her Youth: After Nandalal Bose), exhibition view at STPI Gallery, Singapore

Fig. 12 [right]

Cy Twombly
Fifty Days at Iliam, 1978
Installation in the Philadelphia Museum of Art, 2012

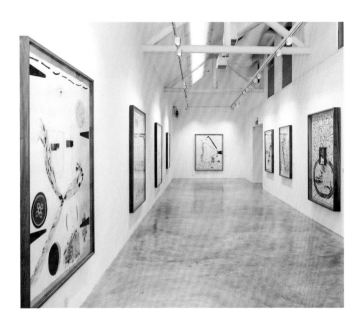
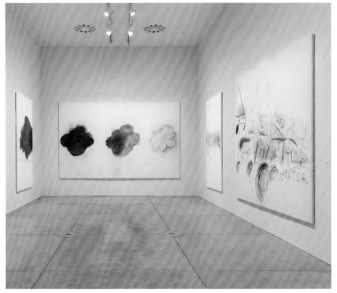

Dodiya has termed himself "an artist of non-violence," adopting a quotation from Mahatma Gandhi. I believe that each of these artists does, would, or could say the same of themselves. The works—and artists— we have examined each non-violently battled to express personal truths and to open paths for others. But, in order to speak their truths, each of these artists has made choices on how, and how not, to negotiate narratives of devotion. Their choices of what to replicate, transform, or reject of India's—and the world's—myths and religions are as individual, interconnected, and fraught as are the meanings of the terms "myth" and "religion" themselves.

Notes

1. The self-consciousness of this may be seen as connected with how Karin Zitzewitz describes "secularity." See Karin Zitzewitz, *The Art of Secularism: The Cultural Politics of Modernist Art in Contemporary India* (New York: Oxford University Press, 2014).

2. Accusation of "cultural appropriation," with its implication of exclusive ownership, might be thought to contest such assertions. At its root, however, "cultural appropriation," as most often currently defined, seems to request a combination of unequal power dynamics and frivolous use.

3. Husain's detractors, in the late 20th and early 21st century, found his modernist language confusing and his stout secularism annoying, but it was his identity as a Muslim that put him in the crosshairs. The spark of this persecution was (ostensibly) a few female goddesses painted without lower garments. See, among much else written, the rich essays gathered in *Barefoot Across the Nation: Maqbool Fida Husain and the Idea of India*, ed. Sumathi Ramaswamy (London and New York: Routledge, 2011).

4. Veena Das, "Of M. F. Husain and an Impossible Love," in *Barefoot Across the Nation*, 121.

5. Published in Daniel Alan Herwitz, *Husain* (Bombay: Tata Steel, 1988). See also https://www.britishmuseum.org/collection/object/A_1997-0503-0-30

6. See note 2.

7. In *Do not touch the Halo*, two of the same detail, flipped, appear at the upper corners. They are part of a Khmer relief, *Fronton with dancing apsaras*, at the Musee Guimet, Paris. Obviously, her references in this print do not end with Buddhism's heavenly dancers. The haloed male figure sits, arms akimbo, on a cross-like chair with skull beneath, echoing the Christian myth of Adam's skull at the foot of the cross at Golgotha or Calvary, the "skull hill." In the *Zodiac Series*, on the other hand, various of the signs are backed by details drawn from monuments throughout India probably visited, and perhaps photographed, by Sud on her extensive travels.

8. 2011 video interview with the artist by Kathryn Myers, https://vimeo.com/98219216.

9. Bisleri has since changed the design of its bottles, the striations now wavy rather than straight.

10. A 2019–2020 study by the Pew Research Center "... not only do most Hindus [81%] and Jains believe the Ganges River has the power to purify – a belief with roots in Hindu scripture – but substantial minorities of Indian Christians [32%] and Muslims believe this as well. And Muslims are just as likely as Hindus (77% each) to believe in the concept of karma, which is not inherent to Islam. Meanwhile, a majority of Hindus, Muslims and Christians all believe in some form of heaven." https://www.pewresearch.org/religion/2021/06/29/religious-beliefs-2/

11. Bhavna Kakar and Satyajit Dave, *The Print: Matter in Matrix* (catalog for an exhibition at Latitude Gallery, 2–11 March 2020), 11.

12. See *Contemporary Art in Baroda*, ed. by Gulam Mohammed Sheikh (New Delhi: Tulika, 1997).

13. See, for example, Timothy Hyman's description of Khakhar's inspiration for his 1980 "The Celebration of Guru Jayanti" as an "explicit homage to Ambrogio Lorenzetti's fresco *The Well-Governed City* in the Palazzo Pubblico, Siena." See, Hyman, "You Can't Please All," in *Bhupen Khakhar: You Can't Please All*, eds. Chris Dercon and Nada Raza (Seattle: University of Washington Press, 2016), 50.

14. *Messages from Bhupen Khakhar*, a film by Judy Marle, Arts Council England, 1983. https://www.youtube.com/watch?v=tqz_fKZZDJg,

15. Gulam Mohammed Sheikh, "Kaavad: Travelling Shrine: Home," quoted by Ranjit Hoskote in "A Crazy Pair of Eyes: Remembering Bhupen Khakhar," in *Touched by Bhupen* (Mumbai: Galerie Mirchandani + Steinruecke, 2013), 23.

16. "A Crazy Pair of Eyes," 33.

17. Ibid

18. See, for example, the detail of one man surreptitiously watching another urinate in the lower left of his 1997 painting "Son is the Father of Man." *You Can't Please All*, 89.

19. The figure resembles a blue-bodied crowned figure in an untitled accordion book painted by the artist in 1990 (*You Can't Please All*, 74–75). Clearly a deity and, by his color, likely Vishnu/Krishna, he sits enshrined within a curtained enclosure waving a fly whisk (cauri, a ritual implement) over two men who make love in front of the enclosure. The crowned figure in the stage-like enclosure is not unlike Khakhar's own self-presentation in the film *Messages from Bhupen Khakhar*.

20. Joseph S. Altar, *Yoga in Modern India: The Body between Science and Philosophy* (Princeton, Princeton University Press, 2004), especially 196.

21. *Atul Dodiya—The Wet Sleeves of My Paper Robe (Sabari in Her Youth: After Nandalal Bose)* (Singapore, New Delhi: Bodhi Art, 2005).

22. "Dalit" may be defined as oppressed and references those born outside the traditional caste structure or at its lowest end.

23. Dodiya's homage to his Baroda and Mumbai artistic lineage weave throughout his oeuvre, i.e., his 1994 *Bombay Buccaneer* (now in the Peabody-Essex Museum of Art), where Bhupen Khakhar and Howard Hodgkins reflect in the sunglasses of his self-portrait, to the rows of resin Bhupen busts that comprised his 2005 Shri Khakhar *Prasanna*.

24. Dodiya includes Xerox-like images of Bose's trilogy in *The fourth Sabari*, one of the "The Wet Sleeves" collages (70–71; also reproduced in the essay in that volume by Nancy Adajania, "Reading the Clouds," 11, figs 8, 9, and 10).

25. Of course, Dodiya embeds multiple references from beyond India in this series, as in all his work. The most obvious is to the paintings of Piet Mondrian; one of the lithographs in *The Wet Sleeves* is titled *Sabari Shaking Mondrian* and shows the renunciant's skeletal body bending Mondrian's grid like a tree in her single-minded determination to obtain its fruit.

Cacophonies and Silence: Hearing Abstraction

Rebecca M. Brown

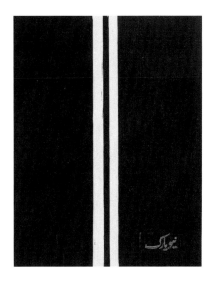

Fig. 1
Zarina
New York, from *These Cities Blotted into the Wilderness (Adrienne Rich after Ghalib)*, 2003
Portfolio of nine woodcuts with Urdu text printed in black on Okawara paper and mounted on Somerset paper, Edition of 20, image size: variable, sheet size: 16 ¼ × 14 ¼ in (cat.9i)

Zarina's woodcut entitled "New York" (cat. 9i) required a precision in her hand and tools such that she carved away the wood of two perfectly vertical stripes, cutting edge to edge across the paper, itself in an orientation we often describe as "portrait" in distinction from "landscape" (fig. 1). The work is a landscape of sorts, but also a memory of rupture and breakage, a site of a moment of booming, crashing noise and one collective horrified intake of breath, both sound and silence echoing through the subsequent years and across the globe. An abstract form, yes, which one could compare to earlier, canonical, avant-garde, and modernist gambits in black and with vertical stripes, from Malevich's black square and Rothko's chapel to Barnett Newman's zips. Abstract and not. Portrait and landscape. Sound and silence.

Abstraction has long been a slippery framework for art historical thinking; very few works of art fall firmly into that category, and very few two-dimensional works fully escape a connection to the body, to history, or to representation. Zarina's *New York* might be one of the more "abstract" works in this exhibition, but at the same time its representation of the two towers, the wound on the surface of the woodblock and the darkness of the inky surround, suggests an emotionally poignant landscape and memory-scape. It invites us into a particular moment and its aftermath, reminding us of the empty space left by the towers and the dead, and, in part by labeling the work in both English and Urdu, bringing politics, history, and representation right back into the remaining black field.

Following Zarina's emotive, multi-sensory evocation of New York, I am inspired here to explore the Gaur Collection of works on paper through a similarly extra-visual approach to abstraction, specifically as something that might be heard, spoken, and read as much as seen. Like Zarina's maps, for example, Jyoti Bhatt's prints include text, both within the field of the print and, as is traditional for prints, across the bottom, where the artist writes his name, alongside the title, date, and number of prints. Bhatt's prints *Om Mani Padmaham* (cat. 30c)

and *Om Mani Padmaham II* (cat. 30b) (figs 2 and 3) both center on the same bold black text, which appears as if written over a multifaceted field of symbols, drawings, and further texts. The title of each print is a version of the Sanskrit mantra associated with Avalokiteshvara, the Bodhisattva of compassion, and used quite widely across the Buddhist world. The script emulates—but does not fully embody—Tibetan (*uchen*) script. The dot that should indicate the nasal "m" in Om is missing, and the final hum seems to be entirely missing, unless one reads the large form at left as a version of that syllable, in the Devanagari script (used in many parts of northern, western and central India) instead of in Tibetan.[1] The text becomes more confusing as one tries to parse the other passages, which comprise what looks like the word "Rama" in a Tibetan-styled Devanagari, and what might be a version of the artist's first name in a mashup between Tibetan and Devanagari at right. The artist has successfully made us come closer to read the work, perhaps as we sound out the powerful Buddhist mantra alongside the name of a Hindu divinity, which is also often used as a mantra: Gandhi is said to have uttered "He Ram" as his last words. We struggle to read the text, even if we are fluent in Tibetan, familiar with the Buddhist mantra, or able to parse Devanagari. And then, as we lean in closer, we see text everywhere: inscribed on the two faces above, hiding amidst the symbols and forms underneath the bold text in the main field below. The faces seem to join us in our reading, with their open mouths perhaps intoning the text on their own faces: the Vaishnavite one, on the left, chanting "Rama" over and over; the Buddhist, at right, chanting the words of refuge (*sharanam*): *Buddham sharanam gacchami, Dhammam sharanam gacchami* (I take refuge in the Buddha, I take refuge in the Dharma). Bhatt has given us sound with the mantra, meant to be spoken and heard in one's head even if one reads it silently. But then he lets that mantra slide out of its specificity—as Buddhist, as Tibetan, as Devanagari, as read-able—and steps back to engage the question of words, writing, and sound as foundational elements of modern art and modernist abstraction.

Text, typeface, and calligraphy create a fascinating conjuncture for modernism and abstraction. Writing is, at its core, mark-making, and writing suggests a certain kind of meaning-making as well, when and if the symbols and marks coalesce into recognizable forms. These two elements, mark-making and meaning-making, also drive questions central to modernism across its long, international history, from the floating letters in the works of the Swiss-German Paul Klee to the calligraphic modernism of Sudanese painter Ibrahim El-Salahi, the ancient hieroglyphic forms of Uruguayan Joaquín Torres-García, and the pseudo-Chinese characters in the work of Xu Bing. Bhatt's work enters into that multifaceted experimentation with word, symbol, mark, and meaning, and brings that to bear on many of the different mantra practices associated with South Asia and the Himalayas. The forms of the letters then, especially as they dance on the edge of illegibility, crossing over between different scripts, repeating in scratches amidst swirling vegetal forms and spindly asterisks, embody the slipperiness of sound and meaning. We "read" *om mani padme hum*, but then realize that it's not quite right, and we read "Rama"

Fig. 2

Jyoti Bhatt
Om Mani Padmaham, 2014
Etching, 18 ¾ × 13 ½ in (cat. 30c)

Fig. 3

Jyoti Bhatt
Om Mani Padmaham II, 2014
Etching, 15 ¼ × 8 ½ in (cat. 30b)

but squint as the typeface doesn't quite conform to expectation. Is that outlined text in the center the mantra in Devanagari, but mirrored? And we look at the vegetal designs and wonder: could they also be hiding text? Everything starts to look like readable marks, and then it all looks like abstract gestures. The slippage emulates the shift into nonsense (a kind of aural abstraction) whenever one repeats words and syllables over and over. Bhatt gives us the mantra in all its repetitive, floating glory—as sound, as mark, as text, as abstraction. And the repetition in print, on paper, reversed, scratched, inked, circulating widely—that too reinforces the echoing sound and gesture of the mantra.

Arpita Singh also offers us a chance to read, or to attempt to read, her intricate prints. Like Zarina, she explores the abstracting qualities of the map, and the view from an airplane, in *I could see London through clouds* (cat. 6a). At first glance, the work is as representative as they come—not only do we have recognizable forms, from the airplanes to the woman clad in black, striding across the map, but we also have textual labels for almost everything, and a "key" to the map, listing the types of objects one might see, with labels in friendly capital letters. But the work quickly belies that transparency, as we see the protagonist stride across the words and symbols, wearing a series of different shoes, bras, and head coverings, and realize that the surfeit of text, numbers, and symbols only serves to increase the overwhelming fullness of the cityscape. Words dot the landscape like the dots that cover the surface of the print as well. And not just English words and letters but Devanagari too, often mirroring an English word, as the two syllables "*ni*" and "*la*" at the top left are balanced by "BLUE" on the right. Or the word *dariya*, meaning "river," marking the river at bottom right, echoing other labels in English. If Zarina's prints abstract a cityscape into the outlines of a map, or the iconic forms of the twin towers, Singh makes the city into a readable surface, engulfing the body of her visitor in words, numbers, symbols, and letters from two different linguistic spaces, resulting in a cacophony of things read and seen—from above, but also from within our mind. The woman cloaked but vulnerable with her striped, black, or tiger-patterned bra peeking through, wanders through this word- and symbol-scape, operating on a different register of scale and color, never quite inhabiting the golden ground below. "Good visibility" we read, and we can see quite a lot, but our understanding of it, our inclusion in it, is pushed back by the chatter and the constant negotiation with dots, roads, clouds, letters, buses, and dates. By evoking sound, writing, and reading, Singh brings us into the state of wandering through a city, seeing it "from above" and never quite fully inhabiting it. Her alienated protagonist marks time, observes, reads forwards and backwards, and yet continues to wander.

Bhatt's heads have mouths open, speaking the mantras that cover the surface of their faces; Singh's figure has mouth closed in mask-like countenance, showing nothing to the world as she navigates the city—indeed none of the faces or heads in the work communicates emotion. Other works in the collection use an open mouth and contorted bodies to

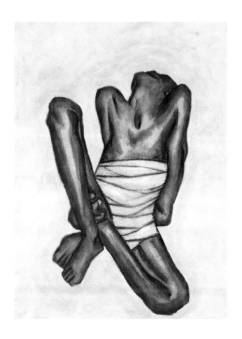
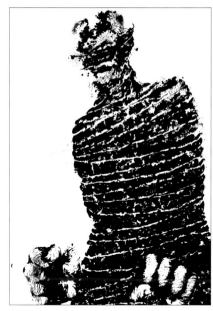
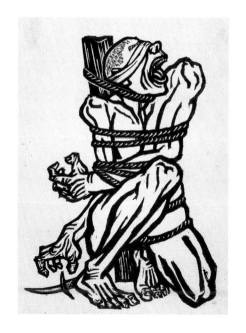

communicate both sound and silence. K. G. Subramanyan's untitled gouache graphically depicts the burning of Best Bakery, a shop in Vadodara, where Subramanyan lived and taught, which was destroyed in the 2002 Gujarat pogrom by a mob that surrounded the shop and then burned it to the ground, killing 14 family members and employees (cat. 22). Targeted because they were Muslim, 11 members of the Sheikh family died in the violence. Subramanyan's painting depicts two women and a child perishing in flames, mouths open as they collapse or, in the case of the figure by the door, try to flee. Subramanyan draws on a small range of simple gestures, such that the hair of one victim echoes the form of the flames that engulf her, and the red splotches on the other woman's garment—perhaps blood—echo the ashy marks that penetrate the composition inside and out. The horror of bodies ripped open, children burning, and screams going unanswered echo from this work, gripping us as we sit in silence in front of it, missing the voices of this family and the others who died in the pogrom of 2002. Subramanyan uses the open mouth as a sign of crying out, silence, and death; the multivalence of this bodily gesture often also calls on us to emulate it—to cry out in response, to recognize the deafening silence.

In *Wounds II* (fig. 4) (cat. 13), Sudhir Patwardhan gives us, in a minimum of gestures and with deft modeling of form, a body in pain, head thrown back, throat exposed, mouth open to the sky. Without the face itself visible, we are left to contemplate a body in extremis, medical wrappings around the torso, hand gripping the leg, shoulders and a knee pointing to the sky, another knee pointing downward in a rhythm of limbs. Patwardhan is not alone in choosing the wounded, restricted body as a subject for its communicable pain and anguish. Navjot Altaf, in works from 1977, also turned to bodies in pain, wrapped and squeezed, hands forming fists underscoring the struggle against the binding wrapped around the torso,

[left to right]

Fig. 4

Sudhir Patwardhan
Wounds II, 2003
Acrylic on paper
40 × 29 in (cat. 13)

Fig. 5

Navjot
Squeezed, 1977
Ink on gateway tracing paper
28 × 18 in

Fig. 6

Li Hua
Roar, China!, 1935
Woodblock print
9 × 6 ½ in

mouth open in inky blackness (fig 5). In Navjot's case, these works directly relate to the suppression of Marxist activism and politics during India's Emergency (1975–77). As her friends were taken into custody and tortured by the state, Navjot and her husband, Altaf Mohamedi, hid the printing press they had been using to disseminate Marxist ideas, burned pamphlets and other documents, and went into hiding. For Navjot it was a turning point: "We thought we could read, grasp, explain and communicate. But what we were saying people did not understand."[2] The failure of words, and of textual communication, meant a shift for the artist to other modes of communication through gesture, ink on paper, and abstracted bodily forms struggling against their bonds. Both Patwardhan and Navjot's works resonate with another node of printed political imagery, Li Hua's woodblock print *Roar, China!* (1935), which uses bold lines like Patwardhan's, one knee up, one down, body bound by a rope, mouth open in a cry or a shout, reaching with sinewy hands for a knife that might cut him free (fig. 6). If Patwardhan gives us a wounded figure struggling to survive, and Navjot gives us a politically silenced figure straining to break free, the muscled body in Li's print calls on the viewer to cut him loose, to roar with him: a wound, torture, binding, countered by a grip, an exhalation, a roar. Li's print circulated globally, within a communist movement calling for international solidarity among workers from Russia and China to the US and Europe.[3] In the failure of words, an embodied sound emerges as a resonance outward from the page. Subramanyan, Patwardhan, Navjot, and Li deploy the open mouth and the bound body to both represent and abstract political conflagrations—moments that evade description. The artists instead turn to sound and silence and ask us to join them in opening our mouths, sounding the alarm, raising our voices. Across the Gaur Collection we can find additional moments of this call—and of an embodied abstraction: in the delicate silence of Somnath Hore's famine drawings, and the raw desperation of Ganesh Pyne's skeletal open-mouthed Inayat Khan. Bringing the body and sound into dialogue with an abstracted body enables us to bend our bodies and voices to the struggle on the paper, such that we might feel an urgency to respond, to join in the call, to heal, to cut free.

Fig. 7 [left]

Krishna Reddy
La Vague, 1955
Mixed color intaglio
17 × 13 in (cat. 45e)

Fig. 8 [right]

Hokusai
The Great Wave, 1831
Woodblock print
10 × 15 in

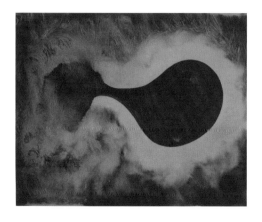

Other sounds beckon across the collection. In addition to the sound of the mantra, the cacophony of the city, and the cry of struggle, several artists seek out the sound of the natural world and of landscape. Krishna Reddy's *La Vague* (fig. 7) (cat. 45e), for example, evokes the ocean wave of the title, and in its composition distantly echoes Hokusai's *The Great Wave* (fig. 8). Reddy's work uses the malleability of the multi-colored viscosity print to explore forms of water, webs, networks, and rays of light, often, as in *La Vague*, embracing the liquid quality of the print process, which uses oil to vary the level of viscosity for each color. His works evoke both external landscapes and internal, bodily membranes, something that Anish Kapoor's etchings from 2007 also do (cat. 43c and 43d). These works evoke root systems and branching veins or nerves, orifices in a plant or a body, cells in transformation or the beginning of a supernova.

We hear blood moving through the body, but also the creaking of the tree root slowly taking shape. Kapoor's balloon-like form in the blood-red surface of one etching (fig. 9) evokes his broader body of work, and particularly his 2013 collaboration with Arata Isozaki titled *Ark Nova*, an inflatable concert hall whose form and portability enables it to bring performances and art to communities whose very land has been remade through the devastation of earthquake and tsunami (figs 10 and 11). The architectural form is an inflatable bubble, a toroidal shape producing a hole that frames a small circle of sky for those standing outside—this, too, echoes another of Kapoor's prints in the Gaur Collection. Inside, seating is made from cedar trees downed by the 2011 Tohoku earthquake and tsunami, anchoring the synthetic shiny purple surface of the bubble in the landscapes and ecologies that it commemorates and serves. *La vague*—the wave—a sound of nature and destruction, answered by the sound of the concert hall, the texture of the fallen trees, and the hope of rebirth with an opening pointed to the sky.

[left to right]
Fig. 9

Anish Kapoor
Untitled (number 1),
from *12 Etchings* series, 2007
Etching
20 ½ × 26 in (cat. 43c)

Figs 10 & 11

Anish Kapoor and Arata Isozaki
ARK NOVA, the world's first inflatable mobile concert hall, Matsushima, Japan, 2013

Ram Kumar's long career also moves us from an abstracted, built environment, anchored in his many works depicting Varanasi, to his landscapes unmoored from the specificity of the holy city that offer dynamic brushstrokes and vibrating color across canvas and paper. Moving back and forth between his two modes, one can sometimes sense the horizon line in the abstractions, see the movement of the river or the spire of a temple, the flash of blue paint creating three-dimensionality only to return us to the surface itself once again. Kumar's cityscapes are oddly silent—often devoid of people, focused on the blocky patterns of buildings and the parting of a river or a road (cat. 1). His more abstract works (for both are abstractions), bring us closer to the movement of paint, perhaps reminding us that one can have noise without people—the river moving past, the wind in the trees, the friction of paint against surface, of stroke over stroke.

The ecological engagements of Reddy, Kapoor, and Kumar return us to Zarina's abstractions, encapsulated in an early woodcut that gives us the very materiality that she works with: the veins and living fiber of the tree. Her 1969 work offers the cosmological—the sun, the moon, the turning of the earth year after year—as it's mapped onto the concentric rings of the tree, a lifeform transcending human-scaled time, and yet also subject to nature's violence and humanity's destructiveness (cat. 8a). Perhaps this too is a call to listen—a cry out from the cut and reshaped wood that comprises Zarina's print medium, from the downed trees that audiences sit on in *Ark Nova*, from the wood burned and charred by a mob in Gujarat, the paper of Marxist pamphlets destroyed in the face of government suppression, from the collective cry of the lives lost in war and terror.

Notes

1. Wikipedia, "Om mani padme hum," https://en.wikipedia.org/wiki/Om_mani_padme_hum, accessed 23 March 2022.

2. Nancy Adajania, *The Thirteenth Place: Positionality as Critique in the Work of Navjot Altaf* (Mumbai: Guild Gallery, 2016), 57, quoting personal communication with Navjot.

3. Xiaobing Tang, "Echoes of *Roar, China!* On Vision and Voice in Modern Chinese Art," *positions: East Asia Cultures Critique* 14.2 (2006): 467–94.

CATALOG

Catalog entries written by Tamara Sears [TS], Emma Osle [EO], Kishore Singh [KS], Paula Sengupta [PS] and Swathi Gorle [SG].

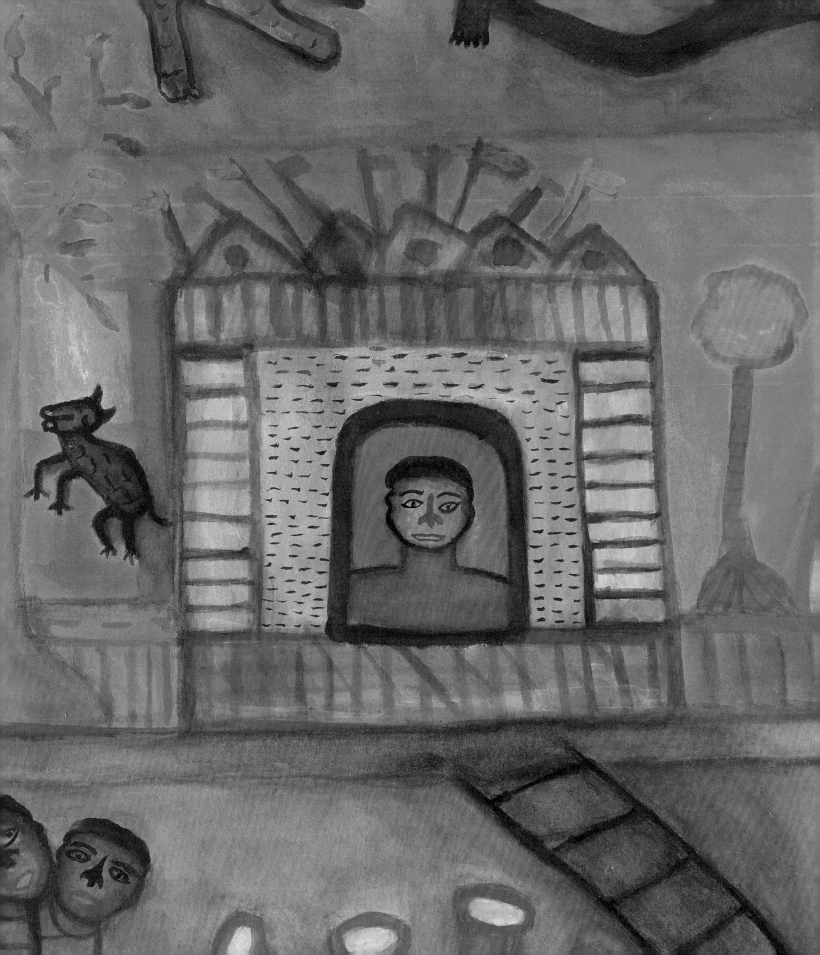

Topographic
Engagements

Ram Kumar (1924–2018)

1
Townscape, 1991
Grey wash on paper
22 ¼ × 35 in

Born into a middle-class family in the scenic hill station of Shimla, Ram Kumar's trajectory as an artist took a direction very different from many of his contemporaries. After earning an advanced degree in Economics from the prestigious St. Stephen's College at Delhi University, he discovered a passion for art. In 1949, with encouragement from Sayed Haider Raza and to the consternation of his father, he resigned his lucrative job as a banker and set off to Paris to study painting under the tutelage of André Lhote and Fernand Léger. Ranjit Hoskote has written that "to trace Ram Kumar's evolution as a painter is to map the course of contemporary Indian painting: in the spiritual crises he has undergone, the choices of style he has made, we see reflected the tensions of an unfolding post-colonial modernity, full of surprises and uncertainties."[1] His early experiments in figuration, in the 1950s, gave way to increasingly abstracted cityscapes and landscapes in the 1960s and 1970s, often dissolving into metaphors through which planes of color and networks of lines evoked, rather than represented, the streets of Varanasi, the thick forests of the Shivaliks, or the nest of a bird.

In the 1990s, Ram Kumar's work took a turn back towards more recognizable forms. The city again began to appear through a discernable architectural framework, sometimes populated with select groupings of abstracted figures.

Townscape, in the Gaur Collection, exemplifies this phase of Kumar's exploration. We are confronted by the façade of a riverfront city, whose tall buildings are reflected in the shimmering of the silvery waters that dominate the foreground. The flattened surfaces are almost transparent in places, inviting the viewer to look into and beyond the interior spaces. Here and there, one gets the impression that the city is inhabited by abstract yet vaguely human forms. On an upper-story terrace, to the right, a couple gazes downward, and elsewhere we see blurs of movements surrounding stick-like figures. Large outcroppings of trees and vegetation jut upwards beyond the city, penetrating the sky, dense with clouds, or perhaps smog. The choice of medium, of grey wash on paper, heightens the work's haunting beauty. The precise location is intentionally obscure. Kumar is presenting us with his characteristic composite city, one in which the "ghosts" of many cities— Varanasi, Delhi, Rome, Venice, Moscow, and Baghdad— intermingle. What is being represented is what Hoskote has described as "the city at the very moment when it is about to be overwhelmed by catastrophe," a place that offers habitation but not refuge.[2] *Townscape* exemplifies Kumar's remarkable talent for expressing the human condition, what he has described as "the tragedy of life and death" through abstraction.[3] [TS]

1 | *Townscape*

Sayed Haider Raza (1922–2016)

2
Untitled (Landscape), 1945
Watercolor on paper
12 × 16 in

A founding member of the Progressive Artists' Group (PAG) in Bombay (now Mumbai), Sayed Haider Raza was one of the leading voices in early efforts to develop new forms of modernism within early post-colonial India. Born in 1922 in a small village in what was at the time the Central Provinces of British India (now the modern state of Madhya Pradesh), where his father served as deputy forest ranger, he studied first at the Nagpur School of Art before receiving a government scholarship to study at the Sir J. J. School of Art in Bombay in 1943. Although the scholarship was rescinded, he stayed in the city, taking a job at Express Block studios and painting scenes inspired by the streets in his spare time. His talent was quickly recognized by Jewish émigrés Rudolph von Leyden, the art critic for *The Times of India*, and the artist and critic Walter Langhammer, who had fled Vienna in anticipation of World War II. In 1950, he received a scholarship from the government of France to study at the École nationale supérieure des Beaux-Arts.

While Raza is best known today for his explorations of Indian spirituality through his *Bindu* paintings and his role as one of the key progenitors in the development of Neo-Tantric abstraction, in the 1960s and 1970s, his earlier works of the 1940s and 1950s consisted primarily of landscapes and cityscapes, combining elements of both impressionist and expressionist painting, and inspired by his life in Bombay and his frequent visits to Varanasi (or Benaras) and Srinagar. He was drawn particularly to the works of the Austrian artist Oskar Kokoschka (1886–1980), who was known for his intensely colorful portraits and landscapes. In 1948,

Raza was introduced to the work of French modernists at an exhibition, featuring reproduction in print, at the French Consulate, and he has described Paul Cézanne (1839–1906), as one of the most significant influences on his early work.

This untitled work from 1945 represents a particularly early phase in Raza's emergence as a painter, prior to the formation of the PAG. The artist presents us with a sweeping view of a bustling market street, filled with stalls and shops, converging upon a large mosque or *dargah* looming in the far distance. The flurry of activity is captured in vibrantly contrasting brushstrokes, a symphony in blue and gold. The brightness of the sun shining from above is hinted at through streaks of orange dancing along the rooftops, terraces, and crowds. Although the scene is dominated by a Mughal-era monument, the street reflects India's dynamic religious pluralism through the prominent profile of the façade and curving tower of a temple situated at the midpoint of the street to the left. Although born a Muslim, Raza was part of a growing community of secular intellectuals who saw themselves as neither intrinsically Hindu nor Muslim, but as Indian first and foremost. The intense beauty of the city's portrayal embodies Raza's enthusiasm as a young student, during which his "burning desire" to know and learn was cultivated by a wide array of painters, writers, and musicians. In an interview with Yashodhara Dalmia, Raza describes this time as one in which Bombay itself seemed very beautiful, and in which he traveled extensively "looking for and admiring landscapes" that he captured through vivid watercolor.[4] [TS]

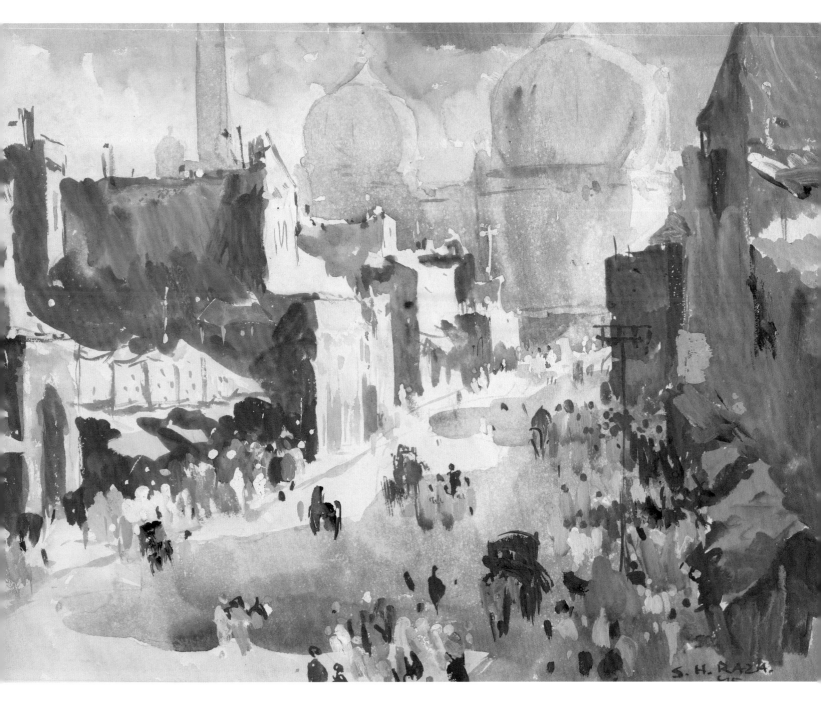

2 | *Untitled (Landscape)*

Maqbool Fida Husain (1915–2011)

3
Yatra, ca. 1950
Lithograph
17 ¾ × 22 ⅛ in

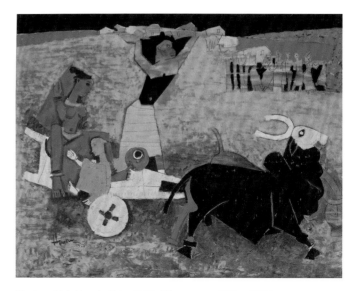

Maqbool Fida Husain, *Yatra*, 1955, Oil on canvas, 33½ × 42 ⅞ in

One of India's most internationally revered artists, Maqbool Fida Husain was frequently hailed as a global nomad. He was born in the remote pilgrimage town of Pandharpur in Maharashtra but was raised primarily in Indore (Madhya Pradesh), which at the time was a vibrant city under the suzerainty of the royal Holkars. Having displayed a distinct talent for calligraphy and poetry at an early age, while staying with an uncle in a *madrasa* in Baroda (now Vadodara), in Gujarat, he taught himself to paint and took great joy in cycling around, finding new ways to represent the lush, rural landscape. Driven by his desire to become an artist, Husain set off in 1937 for Bombay (now Mumbai) where he supported himself as a painter for hire, designing cinema billboards and commercial toys. After garnering acclaim at the annual exhibition of the Bombay Art Society, in 1947, he joined forces with F. N. Souza, S. H. Raza, K. H. Ara, H. A. Gade, and S. K. Bakre to establish the Progressive Artists' Group (PAG). By the 1950s, he was widely recognized as one of India's leading artists. Although frequently heralded for his empathetic understanding and embrace of South Asia's manifold religious traditions, his nude depictions of Hindu deities drew outrage in the early 2000s, and, in 2006, he was charged with promoting obscenities and "hurting sentiments of people." Fearing prosecution, he lived in self-imposed exile and in 2010 officially became a citizen of Qatar.

This lithograph exemplifies Husain's early work, which focused on village life as a rumination on the complex, and sometimes contradictory, realities of modernity in India. Although untitled, it appears as a mirror image of a well-known oil painting titled *Yatra*, or "Pilgrimage," dated to 1955, reproduced in obverse, with which it shares all but a few select details.[5] The scene appears deceptively transparent: a village woman and her child are riding on a flatbed bullock cart, driven by a man standing in front and clad in a *lungi*, which is wrapped around his waist, forming a skirt around his legs. Just visible at the center of the vast and hilly landscape is a small town whose outskirts give way to a dense crop of forest. However, upon closer reflection the scene is anything but simple. Both the figures and the bullock cart draw upon Husain's earlier life as a commercial artist by drawing upon the form of the stock toys mass-produced, largely for urban audiences, by the company for which he worked in the 1940s.[6] At the same time, the title imbues the work with an aura of religiosity, noted more precisely by Ebrahim Alkazi in his 1978 monograph on Husain. He notes the strong resemblance of the driver, who stands at the center of the composition with one hand raised with the palm facing upward, to the Hindu god Hanuman, who, in his quest to procure healing herbs for Lakshmana, the brother of the god Rama, raised aloft an entire hilltop village.[7] This interweaving of rural and urban worlds—as well as present, historical, and mythic temporalities—is characteristic of Husain's complex topographic engagements. [TS]

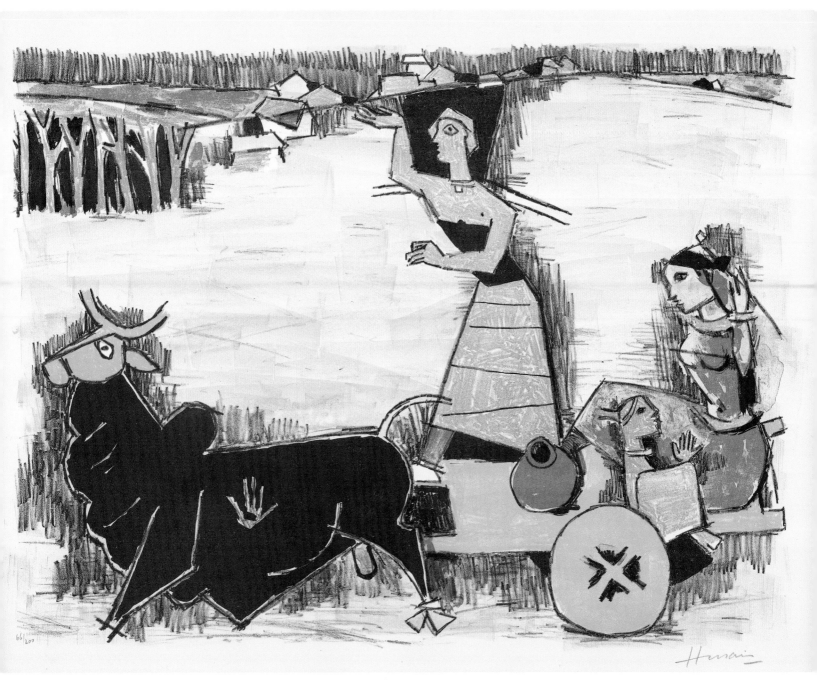

3 | *Yatra*

Atul Dodiya (b. 1959)

4
Kiss, 2000
Watercolor on paper
29 ½ × 21 ½ in

A native of Bombay (now Mumbai), born to a Gujarati family, Atul Dodiya studied at the Sir J. J. School of Art, from which he received his Bachelor of Fine Arts diploma in 1982. More than almost any other artist represented in this exhibition, Dodiya's work has defied simple categorization by style, approach, or media. After first building acclaim for his photorealistic canvases, Dodiya began incorporating references from popular culture, cinema, and literature, drawing upon the sly and satirical engagements with Pop Art in the work of artists such as Bhupen Khakhar, who served as a particular inspiration. Although he has famously claimed that he does not make political statements, his works frequently serve as smartly crafted social and political critiques.

In the 1990s, Dodiya began experimenting with new media and modes of representation, as seen in his iconic roller-shutter paintings, which he developed in response to the escalating riots that accompanied the rise of majoritarian Hindu nationalism. He was particularly affected by the 1992 destruction of the Babri mosque in Ayodhya, which coincided with his return from a year living abroad on a French government scholarship in Paris. The resulting riots in Bombay and his native Gujarat left him despairing of the fate and future of the nation. In an interview with Yashodhara Dalmia, he reflected upon his ambivalence, in 1997, as the nation was preparing to celebrate a half century of Indian independence. Noting the rising corruption in government, criminal enterprises, terrorism and violence, he remembered thinking, "Are we really happy, are things absolutely normal, fine in the state of the country?"[8] This sentiment intensified after 2002, when Gujarat became once again the site of widespread communal riots. In grappling with these issues, he drew inspiration from Gandhi and experimented with new visual forms. Among these was the map of India, which entered his work for the first time in 1992 and culminated in the 1999–2000 *Tearscape* series of haunting, oversize watercolors, which drew attention to the fragility of history and challenged the "territorial integrity," unity, and hospitality of the nation, particularly for marginalized social, religious, and ethnic groups, whose victimhood is evoked through the grotesque figures superimposed on the geobody.[9]

Although executed on a smaller scale, Dodiya's 2000 *Kiss* can be seen almost as a coda to the *Tearscape* series. An emaciated and diseased peasant hovers horizontally across a smoky tangerine sky, supported awkwardly by a ship that is precariously tipped along the surface of the Indian Ocean. The contours of the nation are intentionally hazy. They hover between abstraction and representation through the fading transitions between light and dark. As in the *Tearscape* paintings, the figure's body maps out a contested terrain in which potential for violence is ever-present. The ship's mast and sharply jagged sail point upward between the figure's knees, threatening to impale and disembowel him over the state of Gujarat, while his head extends forward to bestow the kiss of death upon the contested lands of Jammu and Kashmir. While the nature of the physical landscape along the partition line is reinforced, through the gesture towards the Himalaya Mountains along the rippling lines of the figure's spine, the imagined borders between India and its neighboring states are purposely elided. [TS]

4 | *Kiss*

Gulam Mohammed Sheikh (b. 1937)

5a
City and Statues, 2000
Etching and aquatint
13 ¾ × 16 ¾ in

5b
The Mappamundi Suite 4, Marichika II, 2003
Gouache on inkjet digital collage
23 × 28 in

Born in Gujarat in 1937, Gulam Mohammed Sheikh remains one of India's most important living artists of his generation. After finishing a degree at the Faculty of Fine Arts in Baroda (now Vadodara), he traveled to London to continue his study of painting at the Royal College of Art. Upon returning to India, he took up a post teaching art history and painting at M.S. University, in Baroda, where he served as guiding force in the rise of the school as a major center for the transformation of modern art. Throughout his career, Sheikh found new ways to explore the narrative potential of painting to map both personal, sometimes autobiographic, as well as collective journeys, often intermingling references to canonical art histories with ephemera found in the realm of popular imagery. *City and Statues* represents his turn towards exploring cartographic modes of representation to examine history and memory, presenting the viewer with a dense and impenetrable urban center, whose branching outskirts are populated not with people but with monuments, sarcophagi, and sculpted figures, some whole and some existing only in fragments. Produced just three years later, Sheikh's *Mappamundi* series represents an even more ambitious effort to exploit both the potentialities and expectations of cartography to raise troubling questions about the globalizing present. Sheikh draws upon precolonial European map-making traditions to imagine, as Cóilín Parsons has suggested, "a world as yet uncreated—a globe yet undefiled by modern empires and nations" that is as of yet unscarred by "the inescapably modern violence of ethnic nationalism... in the wake of decolonization."[10] Sheikh's series is based on the Ebstorf Mappa Mundi, dated to ca. 1300, which famously was destroyed when the Allied forces bombed the German city of Hanover in 1943. The map's history, notably, is framed by moments of comparative peace and violence. Its original conception dates to an era just prior to the medieval crusades, whose legacy inspired long-lasting discourses of religious conflict that fueled later imperial projects, and whose demise came, with an almost eerie portent, at a turning point of the worldwide war that brought about the end of European empires and spurred processes of subsequent decolonization. When he came across a postcard depicting the Ebstorf map at the British Library shop, Sheikh was fascinated with the idea of the map as allegory unfolding over the body of Christ, whose head, hands and feet typically appeared at the cardinal points along the edges of medieval *mappamundae*.

In his own reimagining, Sheikh maintains the close relationship between map and divine body but infuses the image instead with a more diverse iconography. The work was produced largely through a digital process of scanning and collage, and many of its details are excerpted from well-known sources that gesture towards the fluidity of borders

Ebstorf Map (Reproduction), ca. 1235
Ziegenpergament, 137 × 140 in

Etching-Aquatint (soft-ground) city and statues [signature]

5a | *City and Statues*

and mobility of images. On the upper left is the recognizable figure of Majnun, the protagonist from a 12th-century tale penned by the Persian poet Nizami, here drawn from a 16th-century Safavid painting, now in the British Library, by Mir Sayyid Ali, who would later relocate to India to oversee the establishment of the Mughal atelier under the emperors Humayun and Akbar. Appearing on the upper right is a portrait, drawn from late Mughal representations, of the 15th-century poet-saint Kabir, who combined elements from multiple Indic religions, and whose teachings emphasized love for all humanity and the dissolution of sectarian hatred. Kabir is notably shown in the act of weaving, which may be a clever reference to the etymology of the term *mappamundi*,

which is derived from the Latin compound literally denoting a "cloth" (*mappa*) of the "world" (*mundi*). On the lower left is Mary Magdalene holding her hands out, following Christ's resurrection, reproduced from Giotto's 1304–06 fresco in the Scrovegni Chapel in Padua. Just opposite, on the lower right, whirls a dancing figure, reproduced from a ca. 1730 painting, attributed to Pandit Seu, an artist in the Pahari court of Guler, and currently in the collections of the Los Angeles County Museum of Art.[11]

In addition to complicating geographic boundedness and gesturing towards religious pluralism, these figures set up a dynamic tension, between longing for a lost love (as

5b | *The Mappamundi Suite 4, Marichika II*

represented by Mary Magdalene and Majnun) and spiritual reunification through ecstatic performances of spiritual devotion that transcend sectarian boundaries. This tension permeates the composition, as suggested by the repeated figures of both St. Francis, shown preaching to the birds after a fresco by Giotto for the Basilica of Saint Francis of Assisi (ca. 1297–99), and of Rama wandering with his bow in pursuit of the golden deer, whose trickery led to his separation from his beloved Sita. Well known for his ecumenism and efforts to negotiate peace between Christians and Muslims during the Fifth Crusade in 1219, St. Francis infuses the image with a sense of hope for the quelling of the many communal conflicts continuing throughout the post-colonial world.

The wanderings of Rama gesture not merely towards ancient geographic imaginings but also the role of the *Ramayana* in sparking ongoing violence between Hindus and Muslims in Sheikh's native India. Appropriately, in lieu of the face of Christ in the golden halo, at the map's top center is an image of a two-headed, duplicitous golden deer. Together, this juxtaposition of conflict and resolution offers both a critique of the political undercurrents running through the post-colonial world and also an optimistic hope for the resolution of religious divisions woven through the complex temporalities and intersecting paths of his reimagined map. [TS]

Arpita Singh (b. 1937)

6a
I could see London through clouds, 2007
Multiple-plate etching
32 ⅞ × 27 ¾ in

6b
This could be us, you or anybody else, 2007
Multiple-plate etching
30 ¼ × 34 ½ in

A native of Calcutta (now Kolkata), Arpita Singh and her family moved to Delhi in 1946. In Delhi, she attended the School of Art at the Delhi Polytechnic, after which she worked as a designer in the textile industry. Her expertise in textiles often manifests in her visual compositions, and she has become known for her feminist approach to artmaking. Women frequently figure as main subjects in her practice, and the historical conflation of textile making with "woman's work" compounds their importance. After many years of working in a largely abstract visual lexicon, Singh turned to figuration in the 1970s and is now best known for her figural engagements, most often focused on images of women which challenge conventions of feminine representation. The girls and women featured in her works are not the idealized female figures created primarily for the pleasure of a male gaze. Instead, they subversively take on hostile social environments. They are shown increasingly as middle-aged women, with aging bodies and sagging breasts.[12] Often placed in the direct center of the composition, Singh's female figures visually dominate their painted and printed surfaces.

Arpita Singh's work is largely known through her paintings, though she has also worked in other mediums and has shown herself to be an adept printmaker. Her 2007 etching, *I could see London through clouds*, brings together text and figuration to evoke the possibility of a complex web of physical journeys. Circling around the center of the composition, four women walk through an intricate imagined cartography of roads, buildings, bystanders, and modes of transportation. Interspersed around the figures and filling the open space is a multitude of printed text, providing context and also visual texture to the represented space. The mobility of the women, as well as the mobility of the transport vehicles, alludes to the importance of travel in contemporary life. Each woman is depicted in the act of walking, her legs straddling one or more of the many roads weaving throughout the image. The written text of the widest road, curving across the lower left quadrant, literalizes the action, stating, "I often see women crossing the street." Other roads are labelled plainly, with such titles as "road 2" or "road six."

Also created in 2007, *This could be us, you or anybody else* similarly hints at a sense of the complexity of globalization through text and figuration. Featuring a prominent, aging couple in the center, the work is encircled by references to myriad modes of transportation, both ancient and modern. Singh places the cardinal directions in the corners of the work, orienting the viewer at 45-degree angles, and prominently flips the orientation of North and South, physically crossing out the original direction with a white "X." The overall circular makeup of the composition feels visually reminiscent of a compass, and the text, throughout the image and title of the work, clearly references an increasing monotony of place. In an interview with Yashodhara Dalmia, Singh spoke about her usage of text: "Sometimes in maps, you use the words or a chart to mark the location and directions. Words to me are other forms, but you can also explain what you mean through them."[13] In Singh's work, text functions both as subject matter and as context to situate her figures in imagined cartographies. Through these printed works, Singh maps nonlinear journeys that are deeply rooted in the visual structure of language and travel. [EO]

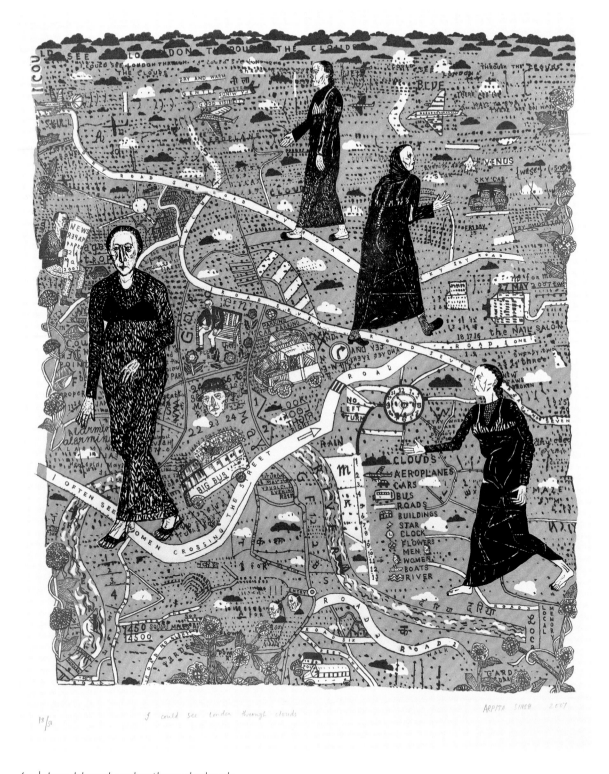

18/30 I could see London through clouds ARPITA SINGH 2007

6a | *I could see London through clouds*

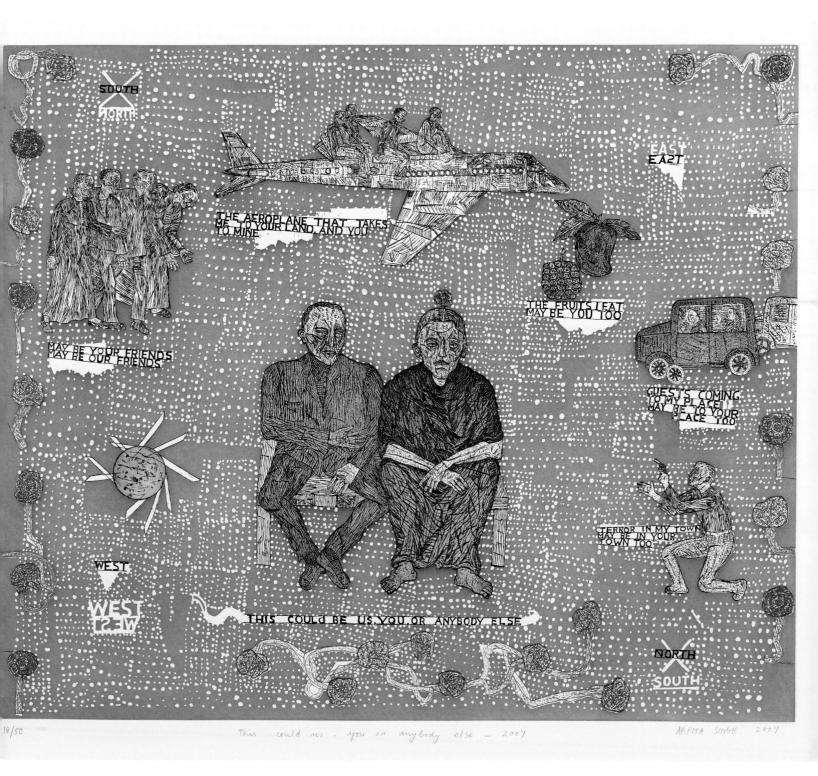

Text within the artwork:

SOUTH
NORTH

EAST
EAST

THE AEROPLANE THAT TAKES
ME TO YOUR LAND, AND YOU
TO MINE

THE FRUITS I EAT
MAY BE YOU TOO

MAY BE YOUR FRIENDS
MAY BE OUR FRIENDS

GUESTS COMING
TO MY PLACE
MAY BE TO YOUR
PLACE TOO

TERROR IN MY TOWN
MAY BE IN YOUR
TOWN TOO

WEST
WEST

THIS COULD BE US, YOU OR ANYBODY ELSE

NORTH
SOUTH

18/50 This could us, you or anybody else - 2007 ARPITA SINGH 2007

6b | *This could be us, you or anybody else*

Madhvi Parekh (b. 1942)

7
On Way to My Home, 1999
Watercolor on paper
30 × 22 in

Art writers are wont to begin any discourse on Madhvi Parekh with a description of her childhood in Sanjaya, a village in Gujarat, though the artist is disarmingly urbane, with a mind that shuns conservatism. Married when very young to a struggling artist and thespian, Parekh's painterly life was shaped by three cities. The first of these was Bombay (now Mumbai) where she lived close to the central art district and made frequent excursions to art galleries, where she benefited from looking at the works of both popular and radical artists. Moving next to Calcutta (now Kolkata), she enjoyed the city's social and artistic environment and informed her husband that she too would like to paint. That journey began with a study of Paul Klee's *Pedagogical Sketchbook,* a source to which she continues to remain indebted. As she began to work independently, she created a startlingly new, folk-derived modern lexicon. By the time the couple settled in New Delhi, she was already an established artist, much in demand by galleries and curators. She went on to win the national Lalit Kala Award, in 1979, three years before her professionally trained husband, Manu Parekh. A popular figure on India's art circuit, her work—and that of her husband—was recently chosen by Dior to represent the backdrop for its spring-summer 2022 haute couture collection in Paris by way of large hand-embroidered tapestries. Retrospectives of her work have also been shown in New York, Mumbai, New Delhi and Ahmedabad.

Like many of her paintings, *On Way to My Home,* which was featured prominently on the cover of the January 2001 cover of *Art India,* appears to be an homage to Parekh's memories of a happy childhood, though the work has to be seen in an imaginary—and imagined—context: the arid desert of her childhood years was more likely to be parched than boast the kind of waterbody the artist flaunts at the bottom of the painting. In looking at Parekh's works, one must rid oneself of all of one's prejudices imbibed in the study of art. Parekh rejects perspective, plays with form, and animates and humanizes all her subjects, thereby creating an environmental relationship between all objects, whether living or nonliving. Thus it is that boats appear smaller than fish, humans fly in the sky and communicate with birds, plants sprout faces as do other objects that appear to have no other identity than to exist.

Pictorially, Parekh divides the painting like a narrative miniature or fresco, where different activities occur simultaneously. The pennants on the building in the upper half attest to its likelihood as a temple, casting the built form in the lower portion as the likely "Home" of the title. A path connecting the halves is literally a bridge between the two worlds—of the sacred and the existential—and as believable as her ability to connect the animate and non-animate without restraint; a freedom given to a lucky few not reined in by their formal training in art. [KS]

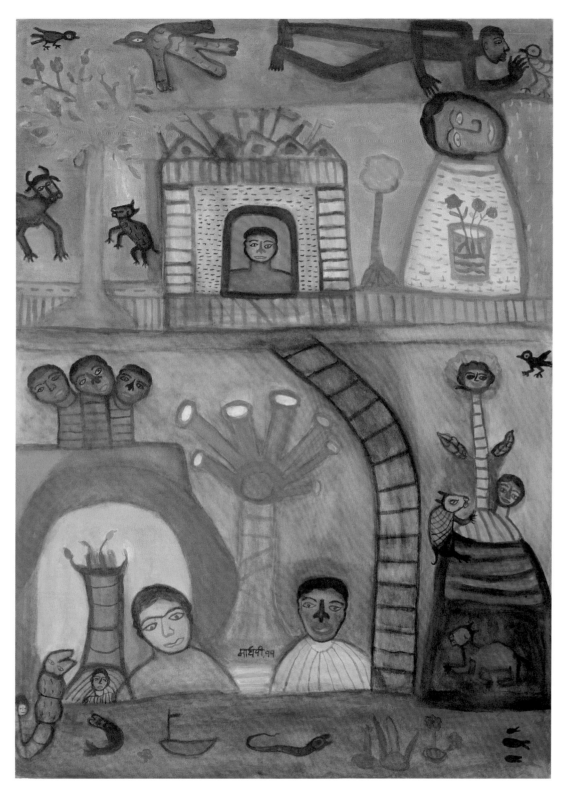

7 | *On Way to My Home*

Zarina (1937–2020)

8a
Untitled, 1969
Relief print from collaged
wood on handmade paper
22 ⅝ × 21 ⅞ in

8b
*One Morning the City Was
Golden*, 1981
Etching with gold ink on zaan paper
pasted on sun board, 28 ¾ × 24 in

8c
Spaces to Hide, 1981
Embossed print of woven paper
16 × 13 in

Foremost a printmaker, Zarina was known for directly engaging with her personal migratory experience throughout her art-making career. During the Partition of India, in 1947, her family was forced, for their own safety, to relocate temporarily from their home in Aligarh to a refugee camp in Delhi. Zarina spent another ten years in India. She received a degree in mathematics with honors from the prestigious Aligarh Muslim University, where her father was a professor of history, and married a classmate who served in the foreign service. In 1958, she left India to follow her husband to a posting in Bangkok.

Between 1963 and 1967, Zarina studied printmaking during an apprenticeship with Stanley William Hayter at the experimental print shop in Paris known as Atelier 17. The experimental Parisian printmaking studio was massively influential, known for fostering major innovation in printmaking processes and for the slew of influential artists that made their way through its doors, such as Joan Miró, Pablo Picasso, Alberto Giacometti, Juan Cardenas, and Constantin Brâncuşi. During Zarina's tenure there, she became an expert at understanding the various textures and densities of paper, as well as gaining a "confidence that empowered her to pursue her career."[14] Zarina also studied Krishna Reddy's unique intaglio technique, known as viscosity printing, going as far as to create her own copies of some of his iconic prints, such as *Flight I*.

Often associated with the Minimalism movement, Zarina's works, though largely personal and sometimes even narrative in nature, regularly teeter on the edge of formal description and rote abstraction. *Untitled*, for instance, created during her time at Atelier 17, foremost considers shape, composition, color, and texture. In this series of works, Zarina collaged thin pieces of wood onto a printing matrix, the physical surface which holds ink for transfer onto a paper substrate. This technique of collaging objects onto the matrix directly generated a linear wood grain texture in the resulting image, which would be difficult, if not impossible, to achieve by hand. Though the use of vibrant color and experimental processes largely left her imagery by the early 1970s, the influence of paper and printmaking as medium permeated her practice for the rest of her career.

Two later works from 1981, *One Morning the City Was Golden* and *Spaces to Hide*, feature constant repetition as means of forming the composition. The repetition of abstracted houses in *One Morning the City Was Golden* calls to mind the seemingly endless rows of cookie-cutter buildings in major cities undergoing heavy urban development. This satire of unappealing, repetitive houses printed with gold ink on an earth-toned substrate represents a "golden moment" for the city and offers a cheeky critique of manufactured urban spaces. *Spaces to Hide*, however, is a series that, in and of itself, is a repetition. Multiple works from this series reiterate similar triangle shapes, spaced out differently from print to print, and displaying more or less detail. The triangle shapes in this work contain a central shape, reminiscent of a door or tent flap. In this way, *Spaces to Hide* calls to mind the impersonal homogeneity of tents in a refugee camp, much like the one in Delhi within which her family resided shortly after the Partition of India.[15] [EO]

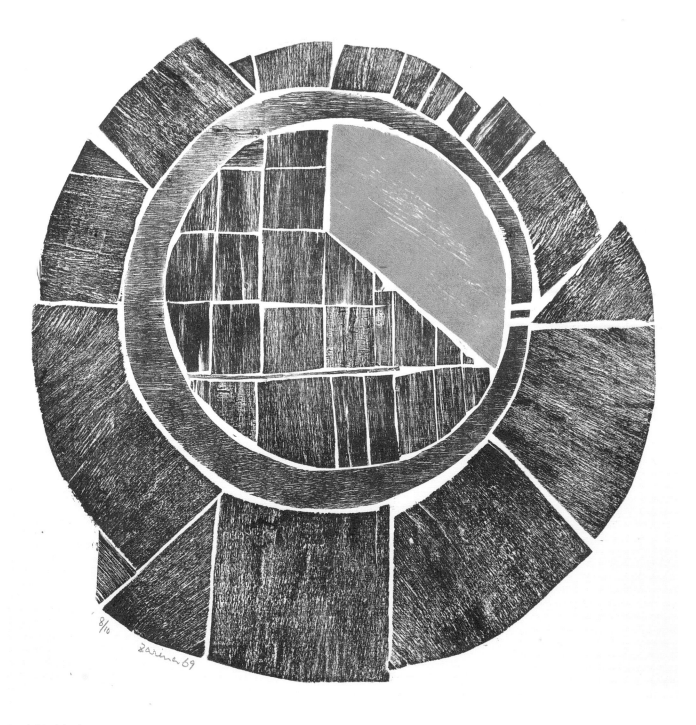

8a | *Untitled*

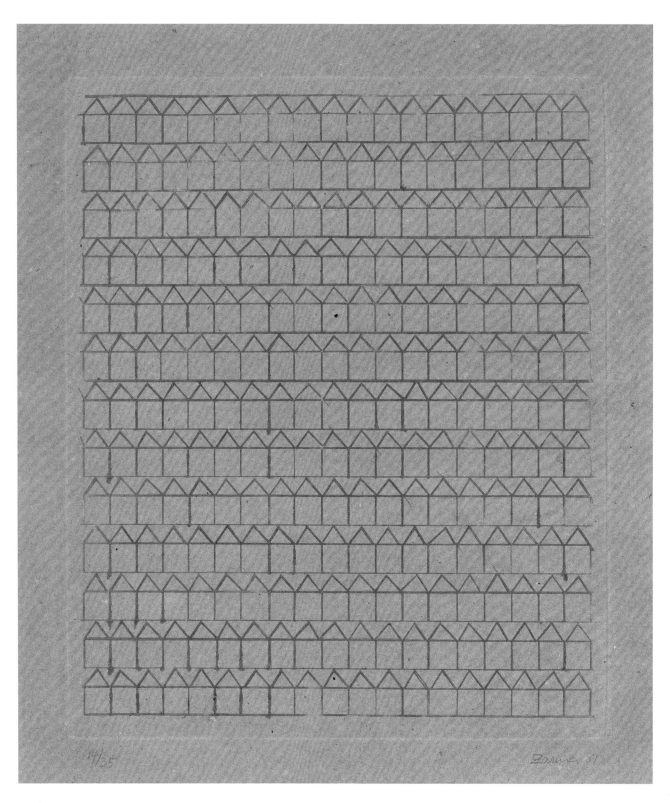

8b | *One Morning the City Was Golden*

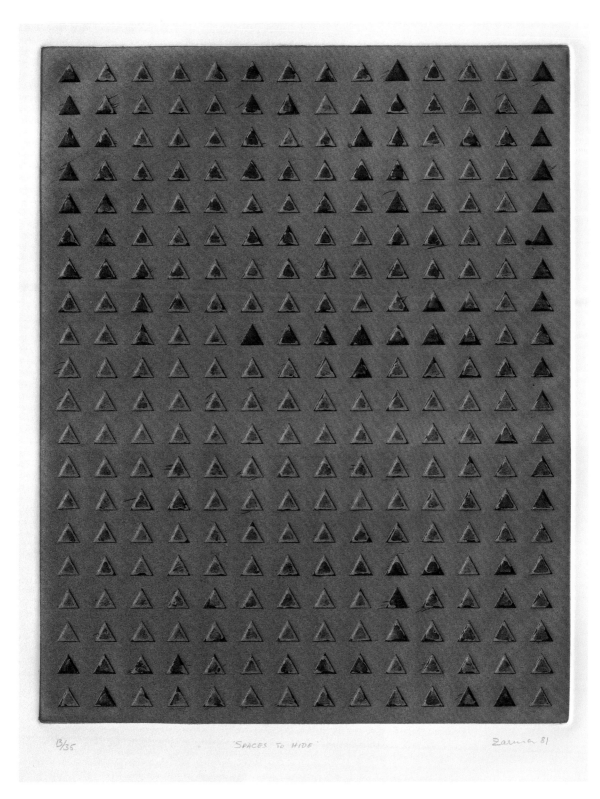

B/35 'SPACES TO HIDE' Zarina 81

8c | *Spaces to Hide*

Zarina

9a–9h
These Cities Blotted into the Wilderness (Adrienne Rich After Ghalib), 2003
Portfolio of nine woodcuts with Urdu text printed in black on Okawara paper and mounted on Somerset paper
Edition of 20, sheet size 16 × 14 in

The question of "home," as both a geographic and temporal location, appears frequently in Zarina's work. In her 2003 series of woodcuts, *These Cities Blotted into the Wilderness (Adrienne Rich after Ghalib)*, Zarina created individual woodcut renditions of places associated with then-recent acts of violence. Oriented to real cities with real geopolitical boundaries, the woodcuts experiment with different modes of representation. Some, such as *Kabul* and *Baghdad*, bear resemblance to the form of an identifiable street map as seen from a bird's eye view. Others, such as the images of *New York* and *Srebrenica*, are more significantly abstracted. *New York*, for instance, prominently features two vertical strips, representing the twin towers of the World Trade Center before the events of September 11, 2001.

In describing her methods for this work and others involved in cartography, Zarina commented on her engagement with maps: "Aerial views have no part in my memories of Partition, but it is the vocabulary that resounds. I think the idea of separation and borders made its way into my imagery, taking the form of maps."[16] Here, she engages an exercise of mapmaking, one that memorializes and confronts the ravages of violence and war. The bird's eye view that is central to many of the woodcuts in this series is largely off-putting, likening the viewer to the perspective of the assailant in the moments before destruction.[17] Zarina's engagement with the complexity of such histories of violence also appears in her choice to title each woodcut twice, in English and in Urdu. The title, signature, and edition number are notably written in English, but in the printed space of each image, the title is written again in Urdu script. English appears in the place of a print conventionally reserved for finalizing a series and serves to formalize the reference to real world cities. By contrast, Urdu occupies the space through which Zarina memorializes the history of violence and violation. Although the conventional positioning of the English text appears privileged, visually the Urdu script takes precedence. It appears not lesser or parenthetical to the English title, but a singularly prominent and inextricable part of the place itself.

In the print titled "Grozny," Zarina does not use a direct translation of the English name in her Urdu script rendition. Instead, she refers to the city as "Jauhar," which, as Aamir R. Mufti has noted, is "an Urdu-Hindi rendering of the word (of Arabic origin) by which Chechen separatists have renamed the city," in order to mark it as contested terrain.[18] In choosing to use both the separatist name as well as the Russian/English of the title, Zarina subverts common perceptions of the borders of Grozny as they stood after the end of the Second Chechen War in 2000. [EO]

5/20 Grozny Zaric 2003

9a | *Grozny*

9b | *Kabul*

9c | *Jenin*

9d | *Beirut*

9e | *Baghdad*

9f | *Sarajevo*

9g | *Ahmedabad*

9h | *Srebrenica*

9i | *New York*

Krishna Reddy (1925–2018)

10a	10b	10c
River, 1960	*Apu Crawling*, 1975	*Rhythm Broken*, 1977
Mixed color intaglio	Etching	Etching
13 × 18 in	12 × 17 in	14 × 20 in

Born in 1925 in Andhra Pradesh as the child of two farm workers, Krishna Reddy's desire to become an artist was inspired by his father, who created sculptures and murals for their local temple in his spare time.[19] After studying under Nandalal Bose at Visva-Bharati University's Kala Bhavana, in Santiniketan, from 1941 to 1946, he moved first to Madras (now Chennai) and then to London in 1949, where he studied under Henry Moore at the Slade School of Arts. While there, he was introduced to Stanley William Hayter and the work coming out of Atelier 17, of which he became the co-director in 1965.

During his time with the workshop, Reddy pioneered and mastered an experimental form of intaglio printmaking, known as the viscosity print, alongside Kaiko Moti, a fellow Indian artist. Whereas traditional intaglio etching practices required each individual color to be printed with a separate plate, this new inking process made it possible to produce multicolor intaglio etchings from a single plate. The technique required a mastery of the viscosity of the inks to enable the printmaker to change their particular thickness or thinness to allow for overlap and variegation. *River*, for instance, is a prime example of this method's ability to showcase not only an intense and varied color palette but a robust implementation of textures. Though the process of creating a viscosity print is complicated and labor-intensive, it produces vibrant abstractions, which could only be rendered by a carefully practiced and masterful hand.

The human form entered Reddy's imagery in the late 1960s, following a period of political unrest in France, where Atelier 17 was located until it dissolved in 1988. Up until this moment, Reddy's work was almost exclusively abstract.

The *Apu* series, prominently featuring the figure of a child, began after a trip to the circus with his young daughter. *Apu Crawling*, from 1975, offers an image of Reddy's daughter moving into and out of a landscape of delicately etched lines. A black winding line following her repeated form culminates in an arrow pointing downwards, a testament to the way her crawling leads her forward developmentally, that also signals her motion through the scene. Though this transition from abstraction towards figuration also had deeper political implications in the activism and protests of students and workers in Paris in the late 1960s, a sense of abstraction, motion, and movement maintained throughout this time period.

Rhythm Broken similarly recapitulates a figure back-to-back through horizontal patterning across the picture plane. Off-center, to the right of the image, the rhythmic patterning literally breaks, as if a double door is opening through the abstracted figure and into an unknown space behind the inked surface. These images are dynamic and expressive, calling to mind the ideologies of futurism and cubism, without their specific political connotations. [EO]

10a | *River*

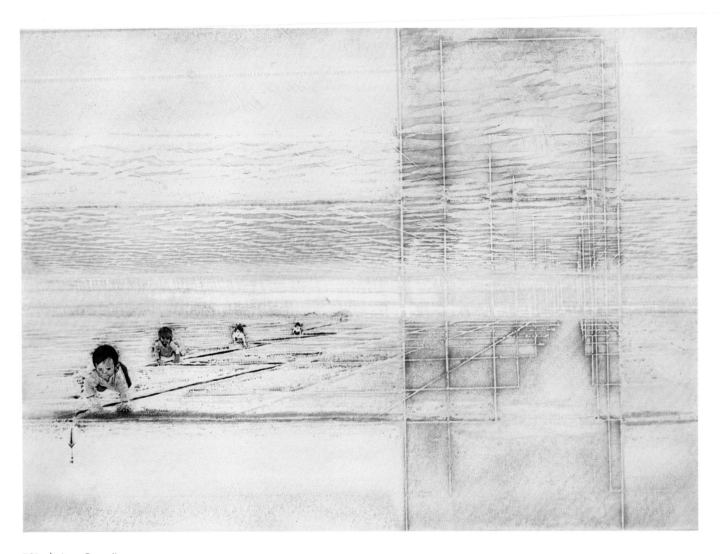

10b | *Apu Crawling*

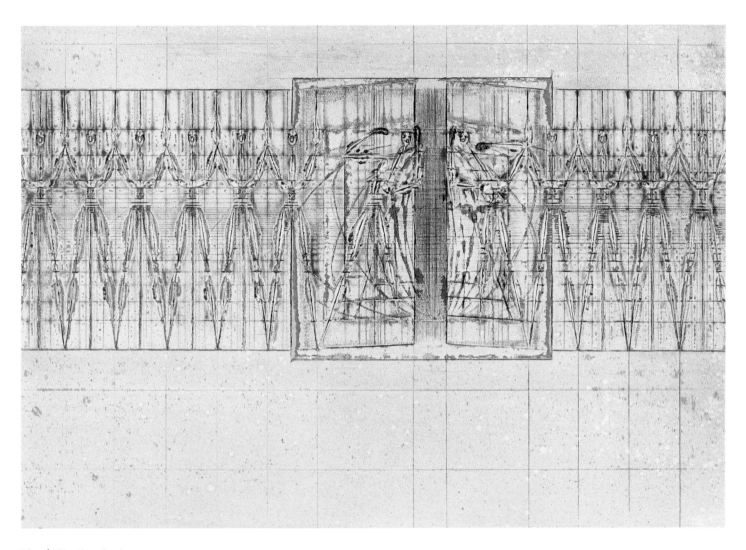

10c | *Rhythm Broken*

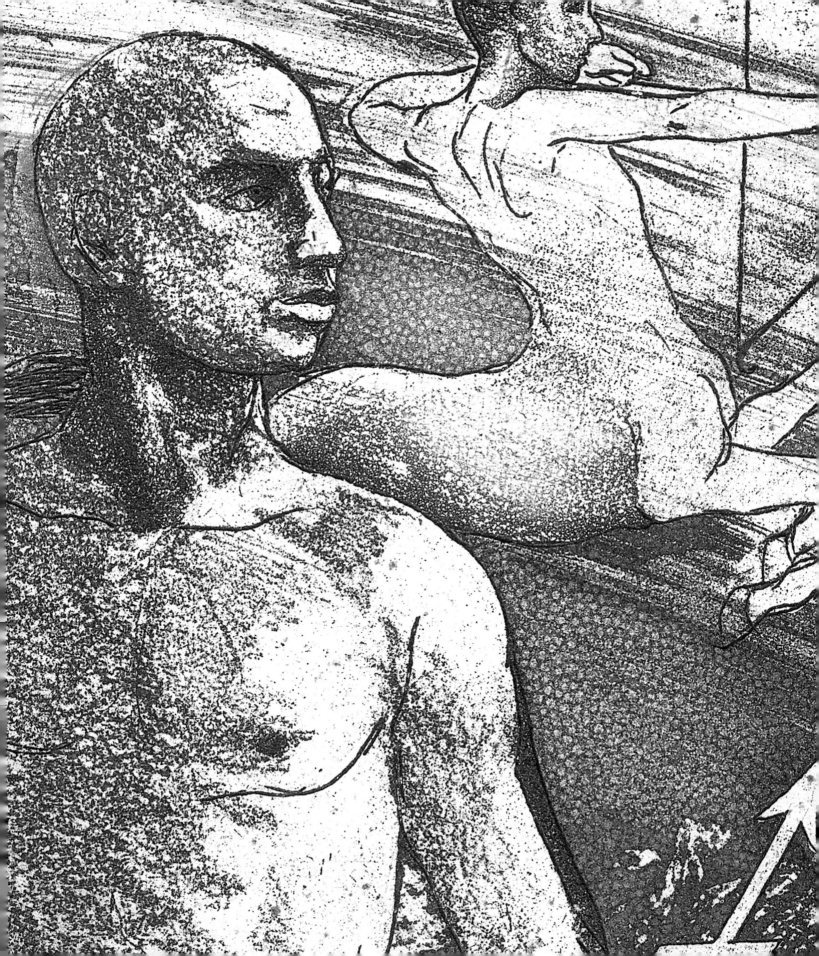

Narrative

Ganesh Pyne (1937–2013)

11
Untitled (The Dying Inayat Khan), 1983
Tempera over pen and ink on paper
17 × 13 ¾ in

Dying Inayat Khan, Attributed to Balchand, Indian, active
ca. 1600–1640, Ink and light wash on paper, 4 ¹⁄₁₆ × 5 ¼ in

A native of West Bengal, Ganesh Pyne began his career as an acolyte of the Bengal school of art, having trained at the Government College of Art and Craft in Calcutta (now Kolkata). He quickly developed a unique style of poetic surrealism that interwove characters inspired by Bengali folktales with a darkness rooted in the trauma of Partition that he experienced as a young child. Often small in scale, Pyne's work is notably layered and labor-intensive, as can be seen in this work, depicting a well-known episode from the memoirs of the Mughal emperor Jahangir (the *Jahangirnama*), which has been widely available in translation since the 19th century. The episode in question describes the death of the emperor's beloved servant Inayat Khan in extensive detail and as an extended process. The accompanying illustration, painted by the renowned artist Balchand, survives in the form of a preparatory drawing (Boston Museum of Fine Arts), as well as a completed folio (Bodleian Library, Oxford). It depicts Inayat Khan in profile, his body emaciated and slumped listlessly on his deathbed. The full text of the *Jahangirnama*, pertaining to this event, describes Inayat Khan having perished from the wasting away of his body due to chronic alcoholism and opium abuse, to the point at which he had become literally, in Jahangir's words, "skin stretched over bone."

Here, Pyne reframes "death" as an ongoing process, rather than as a final moment, and transforms the objectified courtier into a postmodern, post-colonial subject who remains fully aware of his viewer. Inayat Khan is positioned frontally, staring unflinchingly forward, his gaping mouth displaying an impossibly full set of teeth. As in the Mughal work, he rests against an embroidered cushion, but he sits cross-legged, his knees bent and lower body folded almost completely into his torso. His face is skeletal, the flesh and skin already disintegrated. He has lost his hat, and his hair appears as unkempt columnar masses, extending down past his shoulders, as if they continued to grow even after his passing. The Inayat Khan that Pyne reimagines hovers in a liminal process between living and dying.

In its engagement with a Mughal past, Pyne's work also translates its subject for a contemporary audience. Although Inayat Khan ostensibly died of dissipation, purportedly due to alcoholism and opium overuse, "his countenance," as Ellen Smart has suggested, "is so close to that of a person dying from cancer or AIDS that it shocks the viewer at the close of the twentieth century."[20] At the same time, the clear emaciation of the body in contrast to the prominence of the skull calls to mind the tragic effects of famine in his native Bengal, as featured in the work of Somnath Hore, who was also based in Calcutta. An ardent member of the Communist Party, Hore became well known for his painstaking, and often graphic, documentation of the effects of war on marginalized communities. His experience during the Great Bengal Famine of 1943 spurred his life-long investment in portraying human suffering in emotionally arresting ways, as can be seen elsewhere in the exhibition through a series of etchings and prints dating similarly between 1975 and 1983. [TS]

11 | *Untitled (The Dying Inayat Khan)*

Avinash Chandra (1931–1991)

12a
Untitled (women), 1977
Watercolor on paper
21 × 21 in

12b
Untitled, 1964
Ink and watercolor on paper laid on board
29 7/8 × 71 1/8 in

The British media was particularly kind to Avinash Chandra, with art critic W. G. Archer hailing him as "one of the most significant artists since Independence" who would "contribute significantly to emerging Western modern art." Similar paeans in his early years in London led to his significant success and kept him away from India for long stretches of time. Born in Simla (now Shimla) and educated at the College of Art, New Delhi, he moved to London in 1957 to begin an artistic career, beginning with painted landscapes. But the seductive wiles of the city soon drew him into a more profane space, and his dissolving landscapes appeared to grow human limbs. The sharp line gave way to the rounded form, the steeple was replaced by the phallus, and a new art was born.

Fairly early in his career, Chandra moved from painting in oil or acrylic to working with colored inks, both for their fluidity and because they dried faster. Chandra was as prolific as he was fast, and he soon embarked on an alternate career as a muralist, bringing flowing shapes and colors to works in glass. In 1964, he became the first Indian modernist whose works were included in Documenta, Kassel. A John D. Rockefeller III Fund fellowship in 1965, followed by a Fairfield Fellowship, saw him shift to New York, where the human form in his work gained a significant foothold and his paintings became increasingly sexualized. Chandra returned to London in 1973, where he continued to paint, though his later years were dogged with ill health. Around

this time, another seismic shift in his career saw him move to painting foliagescapes, completing the circle he had begun when painting landscapes.

A gap of 13 years separates these two works in the Gaur Collection, a period of great metamorphosis for Chandra. In the painting, dated 1964, the artist is at the peak of his success and on the cusp of a great change. The architecture and planets that form the subject of his previous work have now given way to a profusion of limbs and tubular body parts, almost a sexualization of the city that is now a siren, laying out her charms like so many wares before the viewer. The ovulating forms hold the whole composition together even as Chandra breaks it up into the sum of its parts.

A decade later, having lived in New York and returned to London, Chandra's picture-plane appears just as busy but he has dispensed with the parts in favor of the whole. The patterns and lines collide and merge to spread out a fête of lithe bodies—some standing, others seated—a voyeuristic feast of nude women who may or may not be engaged in sexual calisthenics. As in his earlier architecture-led cityscapes, the first impression is of a kaleidoscopic pattern in which the viewer finds the eye drawn greedily to different points before it can steady itself sufficiently to study the details the artist may or may not have intended as its primary focus. [KS]

12a | *Untitled (women)*

12b | *Untitled*

Sudhir Patwardhan (b. 1948)

13
Wounds II, 2003
Acrylic on paper
40 × 29 in

Born in Maharashtra, Sudhir Patwardhan earned a degree in medicine in 1972 and built a career as a medical radiologist for over 30 years before becoming a full-time artist in 2005. Known for creating highly detailed and hyper-realistic urban landscapes, Patwardhan has frequently described his investment in observing the human condition, in depicting marginal, working-class communities, who live on the peripheries of society, and in highlighting their perseverance and honor, particularly in instances where their dignity as individual human beings is socially contested.[21] Taking inspiration from his medical experience, Patwardhan's unique sense of the body permeates throughout the subjects of his paintings. However, his medical experience has also influenced his experiments in scales of representation. In a recent interview, he described the "essence of medical training" as "learning how to be fully involved in the subject," while also maintaining objective distance.[22] Accordingly, his works vacillate between distant, panoramic views of the city, emphasizing the cost of urban expansion, and close-up views that detail the lives of individuals, who might otherwise remain invisible.

Wounds II represents a particularly intimate view of a single abject individual, whose broken and misshapen body is obscured through a swath of bandages. The figure's almost impossibly twisted and contorted pose evokes a sense of deep suffering and seemingly excruciating pain that hearkens back to Somnath Hore's famine-inspired images featured elsewhere in this catalog. The head tilts sharply upwards, the arms are stretched behind the back, and the legs are folded together in a posture that almost reads as a perversion of yoga. Patwardhan purposefully removes any identifiable features, including gender and age, and omits any visible referent to injured flesh, rendering the precise nature of the wounds unknowable to the viewer. Positioned alone against an opaque backdrop, the figure appears almost as a specimen drawn out for scientific observation, or as an allegorical image through which the tortured body functions synecdochally to convey deeper societal wounds, those that continue to afflict humanity collectively and the nation of India more specifically.

Created in 2003, *Wounds II* represents a particular moment in Patwardhan's practice, spanning the late 1990s and early 2000s, during which the figure came to function variously as a "free-standing allegory" and an "epiphanic presence." Other works from this period, also executed in acrylic on paper or canvas, represent formal experiments in exploring the depths of human pain and compassion through highly detailed studies of individuals with "fluid, pneumatic limbs," shoulder blades and bones "etched beneath the skin," sorrowful eyes, and visible, gaping wounds.[23] For Patwardhan, the depiction of suffering was not intended solely to convey a sense of despair. Instead, he believed fully in the healing power of art. Depicting wounded bodies served as a means of bringing deep-rooted internal pain to the surface, enabling the viewer to form a connection and find paths to greater strength. [TS+EO]

13 | *Wounds II* [opposite]

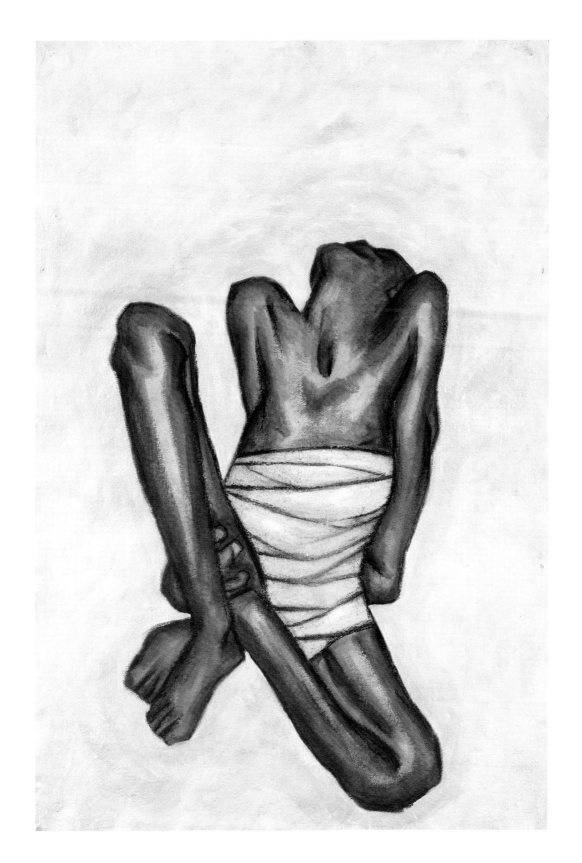

Krishen Khanna (b. 1925)

14a
Man playing cards, ca. 2002
Conté on paper
30 ⅛ × 22 ⅛ in

14b
Untitled, 2006
Pencil on paper
9 ½ × 6 ¼ in

Largely a self-taught artist, Krishen Khanna was born in Lyallpur (now Faisalabad), Pakistan. His father, a lecturer in history at Government College, had completed a Ph.D. in London, where he had developed a strong interest in European art. Under his father's encouragement, Khanna learned drawing and took art as an optional subject while attending secondary school in England. Although he pursued English as his main degree while studying at the Imperial Service College in Lahore, after graduating he cultivated his amateur passion for art making by taking evening classes at the acclaimed Mayo School of Art. During Partition, in 1947, Khanna and his family fled to Shimla. Upon arriving in India, he got a job as a banker with Grindlays, which posted him to their office in Mumbai (Bombay), where he continued to paint in his free time and was invited to join the Progressive Artists' Group. In 1953, he shifted to Madras (Chennai), where he held his first solo show at United States Information Service (USIS) in 1955. In 1961, he quit his job as a banker to pursue art full-time.

Throughout his career, Krishen Khanna has experimented with a wide range of themes, moving from works that evoke social narratives of itinerant laborers to series that focused on *bandwallas* (wedding procession musicians), Hindu epics, and the life of Jesus Christ. What brings them together are the ways in which his subjects are drawn from his personal experience. The figures that populate his drawings and paintings are closely observed, sympathetically rendered, occasionally humorous, and sometimes tinged with sadness. They reveal Khanna's deep understanding of the human condition and of the struggles of everyday existence, not merely for the downtrodden but for individuals across social stations. His ability to act as empathetic spectator comes

out in his interviews, in which he can often recall the precise names and particular characteristics of people he used to encounter regularly in the street.[24]

Delicately drawn using a Conté crayon, *Man playing cards* evokes a common theme found throughout Krishen Khanna's larger works. We see two similar figures included among the vast cast of characters, representing a wide range of individuals populating India's past and present landscape, in Khanna's majestic mural of *The Great Procession*, painted in the 1980s on the vaulted dome of the ITC Maurya Sheraton in New Delhi in the 1980s.[25] There they occupy two segments of the composition, straddling a corner of the large vaulted hall, their bodies similarly constricted within a limited frame. In the mural, the figures act as a pair playing cards in the street to an audience of window-watchers and passersby. Whereas one leans back to reveal to the viewer a robust hand flush with aces, the other leans forward, as in the Gaur drawing, wrapping his arms against his knees and his cards close to his body so as not to reveal his hand. The suspense of the game is implied through the tension in his limbs and pursed lips, and the tight focus of his gaze. In the drawing seen here, the man is decked fully in *khadi*. He is clean-shaven and wears a white cotton Gandhi cap and Nehru vest over a long *kurta* and *dhoti*, the sartorial signifiers of the post-Independence "everyman."

The untitled drawing of three men sleeping under a tree strongly resembles Khanna's biblical scenes, illustrating events from the life of Jesus Christ. He is best known for his paintings of the events leading up to Christ's last days on earth—such as the Pietà, the Betrayal, Flagellation, and his revelation to his disciples at Emmaus—and of the

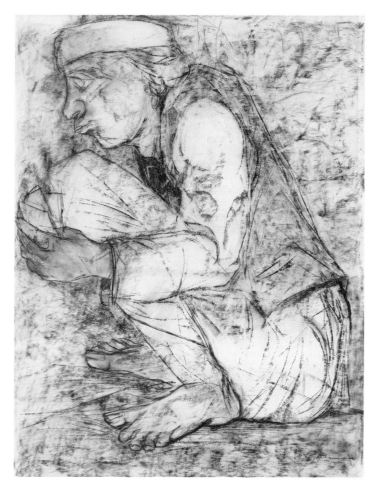

14a | *Man playing cards*

14b | *Untitled*

performance of miracles, as with Lazarus.[26] In these, the figures are similarly represented, with disheveled hair, unkempt beards and weather-worn faces, and they are also clothed in thick robes draped loosely around their bodies. This scene resonates with an episode in Garden of Gethsemane, after the last supper, and is contiguous with Judas's betrayal, leading to Christ's arrest by the Romans that very night. As told in Matthew 26:36–45, Jesus asked his disciples Peter, James, and John to stand vigil while he, his soul heavy with sorrow, went to pray thrice in order to achieve a sense of peace. Each time when he returned, he found them sleeping, unable to stave off the temptation to rest their eyes. Khanna's composition here closely follows Renaissance representations of the three sleeping disciples,

in which they are often found similarly huddled against a rocky landscape, often with a tree overhanging, famously as in Lorenzo Monaco's 1408 diptych (now in the collection of the Louvre) or Fra Angelico's ca. 1450 *Agony in the Garden* (at the Museo di San Marco in Florence, Italy), or in 16th-century prints by Dutch engravers, such as Adriaen Huybrechts, Bartholomeus Willemsz Dolendo, and Harmen Jansz Muller. Separated from the larger context of the story, these figures become, as in many of Khanna's Christian-inspired works, nonsectarian evocations of the universal, and secular, human experiences of suffering, sorrow, and grace. For it is also in Matthew (5:5) that the Bible proclaims that the meek shall inherit the earth. [TS]

K. Laxma Goud (b. 1940)

15a
Untitled (Erotic Couple with fantastical animal)
1972
Zinc etching
10 ¾ × 19 ½ in

15b
Untitled (Erotic fantasy with fantastical animal)
1973
Zinc etching
10 × 16 ½ in

15c
Untitled (Figures with books), 1980
Pencil on paper
13 ⅞ × 21 ¾ in

15d
Untitled (Landscape with figures), 1976
Copper etching
22 × 27 in

15e
Man falling, 1991
Pencil on paper
14 × 22 in

Born in the village of Nizampur in Andhra Pradesh, K. Laxma Goud received his diploma from the Government College of Art and Architecture in Hyderabad, in 1963, before moving to Baroda (now Vadodara) to study mural design and printmaking at M.S. University, Baroda under K. G. Subramanyan, who also imparted to him an appreciation for rigorous draftsmanship, a quality that is visible in his intensely detailed prints and drawings. In reflecting on Goud's time in Baroda, Nilima Sheikh describes his noted fascination with erotic subjects, culminating in the production of "obsessive sexual phantasmagoria," as rooted in his quest for "the authentic image" and his search for "a perception of his identity." This quest brought him to his village roots and "to images of adolescence pervaded by pubescent sexuality," as well as to the folk traditions and myths that sparked his youthful imagination.[27] The five works represented here exemplify Goud's remarkable ability to produce a deeply sensual experience through intensely detailed line-work, a hallmark style that he developed through an early engagement with the practice of intaglio printmaking.

The three etchings, all from the 1970s, feature couples caught in moments of heightened passion. In the untitled landscape from 1976, we see a nude male figure in a state of sexual arousal slouching against an outcropping of trees and bushes in a forest clearing. The tension in his body is suggested through the tightness of his muscles, his sharply

bent joints, and the positioning of his left hand, which presses downward against his erect phallus. He stares to the left, his brow furrowed and his mouth slightly open, to meet the gaze of his lover, a village woman standing half hidden in the densely textured foliage. Her own arousal is suggested by the state of her partial undress and the clasping of her hands. Both the work's composition and the placement of figures call to mind older traditions of Rajput painting, and particularly scenes of the god Krishna and his cowgirl-lover Radha sneaking away from the village for nighttime trysts in the forest.

The other two etchings introduce Goud's fascination with inserting bizarre animals and mythological figures into his erotic vignettes. The 1972 untitled work features a reclining erotic couple, whose moment of passion appears to have been suddenly interrupted by the appearance of a strange and daunting beast. The setting is ambiguous. It is unclear whether the couple rests on a blanket in a forest clearing or on a raft in a river, as suggested by the slithering body of the serpent just below them. A riverine setting is further implied through the appearance of the creature that has taken them by surprise. One of Goud's many fantastical composites, it features the head of a porpoise, the hands and feet of a monkey, body that is part bird, and the tail of a serpent or alligator. This motley assortment calls to mind a rural village setting, in which all of these might be found lurking near the banks of a river or stream.

15a | *Untitled (Erotic Couple with fantastical animal)*

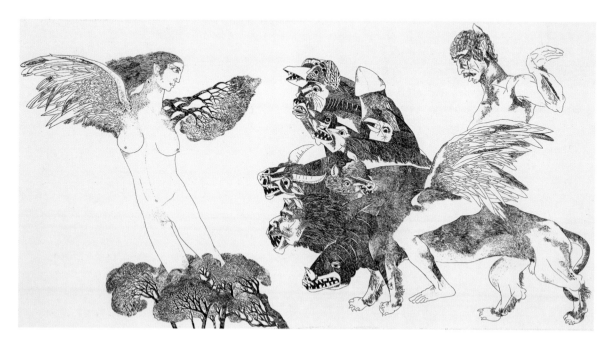

15b | *Untitled (Erotic fantasy with fantastical animal)*

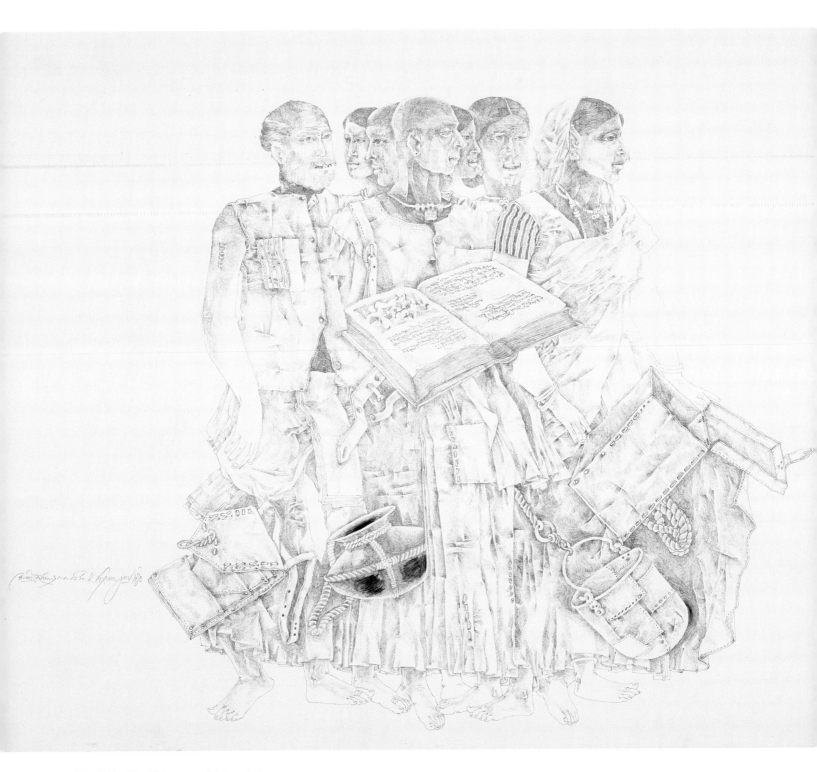

15c | *Untitled (Figures with books)*

Goud's fascination with creating ever more complex and impossible composites is fully realized in the etching from 1973. Here, a rampant male figure charges towards his female lover, who rises upwards from the forest, her naked body fully human but her arms replaced by an outstretched wing and a crop of trees. He is perched on a multi-headed beast, sporting the body of a lion but the heads of multiple creatures, culled from rural village and forest landscapes, including a rhinoceros, lion, camel, goat, horse, water buffalo, and deer. His hips are thrust forward, homologizing his mount with his manhood, as an enormous phallus, worthy of Priapus, stands erect above the head of a bird.

The two pencil drawings, from 1980 and 1991 respectively, display the more playful geometricization associated with a later phase in Goud's artistic experimentation. The drawing from 1980 features a dense cluster of seven figures. A mixture of males and females, their bodies intermingle, almost forming a single volume, with the exception of a clear trio that dominates the foreground. The trio represents a play on gender. Framing the group on the far left and right are a man and a woman. The central figure, however, is androgynous, and most likely a *hijra*. Hanging from their garments are large pots and water vessels, as well as open boxes and satchels. The focus, however, is on a large illustrated manuscript that lies wide open, its fastenings hanging off to the side, revealing pages filled with carefully composed calligraphy and what appears to be a courtly painting. The improbability of peasants possessing such an object may seem ironic unless one delves into Hyderabadi history. It may be that the group was intended to evoke the courtesan culture of Mahbub ki Mehndi, a place that by the 1970s and 1980s had become a well-known red-light district, but that in the late 19th and early 20th century had been a privileged tract of land specially granted by the sixth Nizam of Hyderabad for *hijra* residence.[28]

The 1991 drawing, playfully titled *Man falling*, is equally complex in its massing of figures, although perhaps a bit more transparent in deciphering the action. The title's referent appears to be a man lying face down in the middle of the composition, his limbs distended at awkward angles, and his naked and supine body displaying a large gaping wound. It is unclear whether he has fallen from the sky or whether he was struck by the sharp end of the pick-axe or mattock, whose sharp point juts uncomfortably against his upper right leg. Represented in various stages of undress, the rest of the figures that populate the space move seductively, hands outstretched and touching. The ecstatic dancers to the right represent a common trope found in other works by Goud from the early 1990s, which more clearly portray the group as actively coupling. Here the falling man's misfortune has momentarily disrupted the orgiastic dalliances of the group. The reactions, however, are varied. Whereas the man directly to the left holds his head in horror, others glance over slyly as if with morbid curiosity. Once again, Goud does not fail to shock and surprise his audience, forcing viewers to contend with the guilty allure of sex and violence.

For Goud, the density of texture and line in both the etchings and drawings were key to heightening the eroticism of his images. In a 1991 interview, he expressed his desire to seduce viewers with his line. He saw that moment of seduction as also an intense moment of interaction, which he described, in almost spiritual terms as "a pure sense-laden moment of communication—total communication" bringing about an indescribable experience of "pure joy."[29] In all of these works, the faces of Goud's men and women reveal a remarkable vulnerability. They suggest that Goud's quest for the "authentic image" may be found primarily not in his references to Indian tradition nor in his efforts to titillate audiences, but in the desire to capture moments of raw and undisguised emotion through highly textured images created through densely drafted lines. [TS]

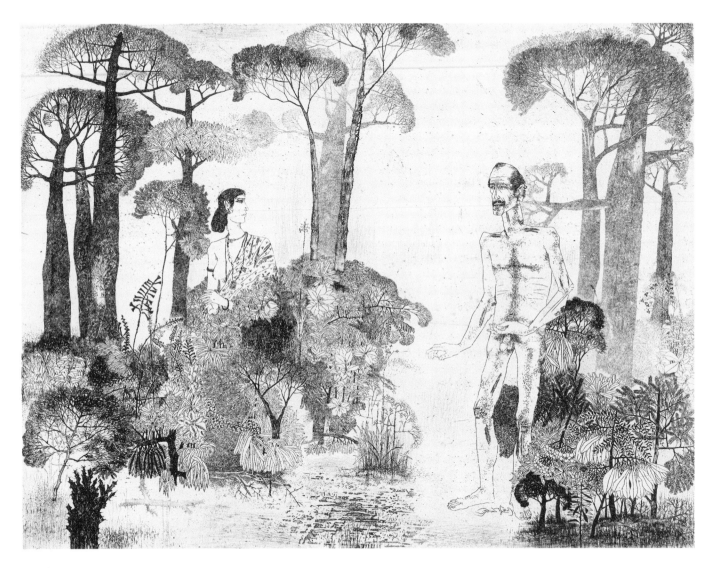

15d | *Untitled (Landscape with figures)*

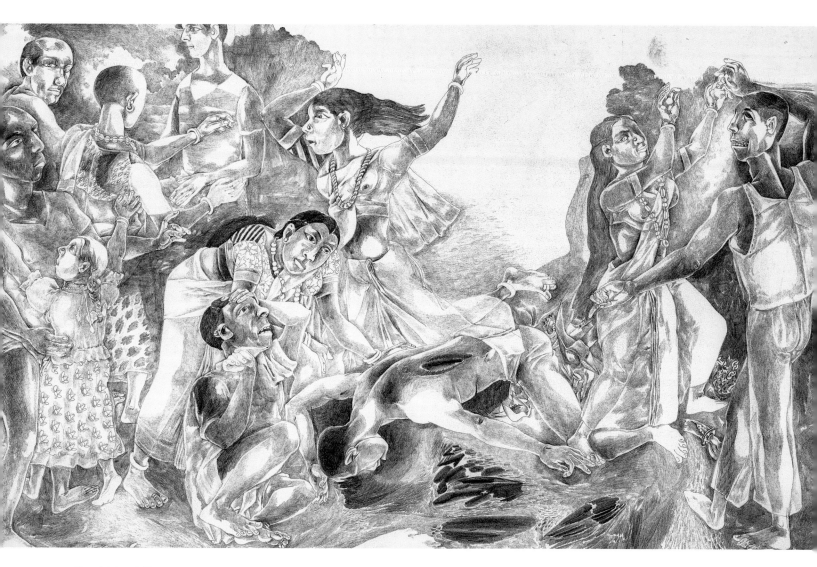

15e | *Man falling*

Anupam Sud (b. 1944)

16a
Do Not Touch the Halo
1990
Multiple plate print with
aquatint etchings and
lithographs
35 ¼ × 23 ¾ in

16b
Apparition, 1988
Etching
25 ½ × 19 in

16e
The Conference, 1984
Etching
26 ¼ × 19 ¼ in

16c
Aqua Pura, 1999
Etching
31 ½ × 19 ¼ in

16f
Your Huddled Masses, 1990
Multiplate plate etching
18 ¼ × 23 ¾ in

16d
Dialogue IV, 1985
Etching
13 × 19 in

I am an urban person. I have never lived in the countryside. In fact my studio today is the closest I have come to living in a village! I did have some kind of a romantic notion of the rural hinterland as liberated space of being but in the city as a member of the urban middle class one was restricted every moment by a moral code of conduct. Besides in the city one is forced into close proximity with other people and learns to rationalize these relationships.[30]

Arguably one of the most influential South Asian printmakers of the past half century, Anupam Sud is well known for her satirical etchings which serve as masterful commentaries on urban modernity in post-colonial India. Born in Hoshiarpur in Punjab and raised primarily in Simla (now Shimla), Sud came of age as a student at the Delhi College of Art (1962–1967). At the time, Somnath Hore and Jagmohan Chopra were actively reformulating the printmaking department in an effort to revitalize the medium and elevate its status within the Indian art world. She became the youngest member of Group 8, an influential association founded by Chopra in 1967, and, in 1971, she went on to study advanced printmaking techniques at the Slade School of Fine Art at University College, London, through a grant from the British Council. There she had her first experience of etching on metal plate, as opposed to the collagraphs that had dominated her earlier training, and its potential for producing finely detailed drawings and careful gradations of tone. In 1977, she accepted an appointment in the painting department at the College of Art in New Delhi, where she taught printmaking as a secondary subject until her retirement in 2003.

Throughout her career, Sud has repeatedly explored the human body as both a subject and a metaphorical device for engaging the conditions of modernity, critiquing social tensions, and articulating the distinctly urban experiences of alienation and belonging. Sometimes hailed as a feminist artist, Sud's work is less frequently focused on female figures than on the complex relationships between masculinity and femininity, and particularly on the frictions between men and women. At the time of her appointment to the faculty at the College of Art in New Delhi, she was the sole female member of the faculty and became adept at holding her own in a distinctly masculine art world.

Sud is particularly well known for her ability to capture the human body in intimate detail. She often depicts her subjects as nude in order to emphasize the emotional and psychic vulnerability of her subjects. The nakedness of the body strips it down to its "essence" and reveals a "naked truth," as Geeti Sen has put it.[31] At the same time, she intentionally obscures their genital regions through the use of shading in order to avert sexual specificity and call attention to the ambiguity of gender. In contrast to the hyperrealism of her figures, her settings are highly theatrical and distinctively staged. She frequently experiments with geometrical divisions of space and integrates architectural

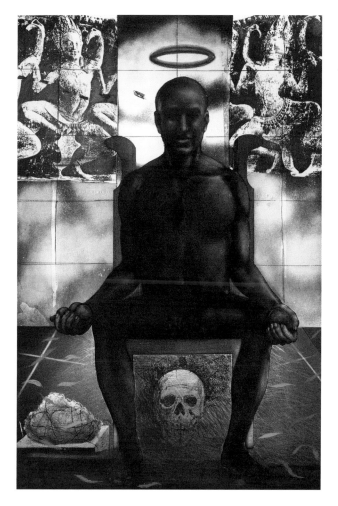

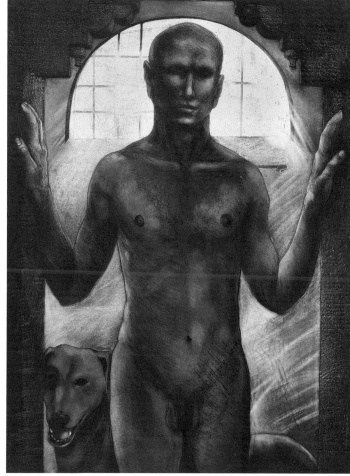

16a | *Do Not Touch the Halo* 16b | *Apparition*

elements in her compositions, a proclivity learned from her mentor, Bartholomew dos Santos, at the Slade School in England. Most of her etchings are monochromatic, executed primarily in black and white, occasionally with muted color highlights, reflecting Sud's desire to universalize her images, to intentionally obscure cultural and racial markers.

Do Not Touch the Halo and *Apparition* attest to Sud's remarkable ability to capture the human body in intimate and sometimes startling detail. At the center of both compositions is a single nude male figure, frontally positioned to engage the viewer directly. Both take on a distinctively iconic, and almost statuesque character. In *Do*

Not Touch the Halo, the central figure is seated in a rigidly symmetrical pose, his body framed by the elaborately carved posts of his throne, while he grasps the metaphorical fruits of his success. He appears almost like a deity installed within a shrine sanctum. Above his head is a glowing halo and flanking him on either side is a dancing celestial figure. His heroic physique, however, is belied by the presence of a large human skull, its rounded contours eerily mimicking the form of the figure's bald head, perhaps suggesting that a moral bankruptcy lies behind his near perfect exterior. Similarly, when examined closely, the celestials reveal themselves to be mediated imitations, inserted into the image using a process of photo transfer that Sud learned

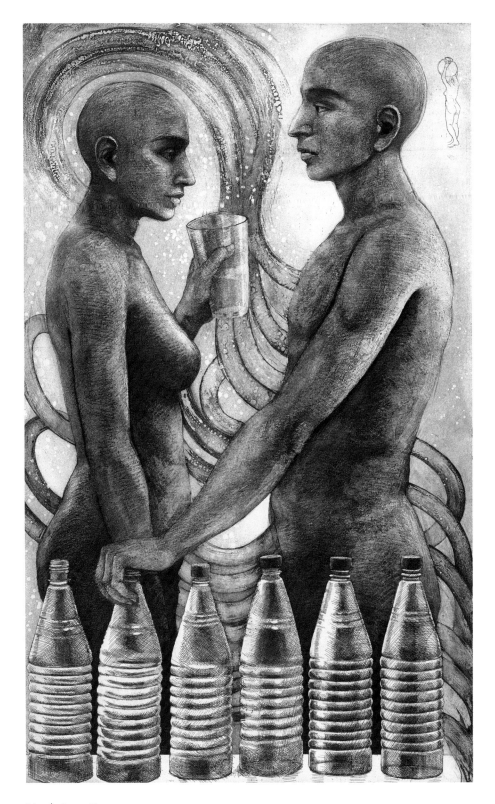

16c | *Aqua Pura*

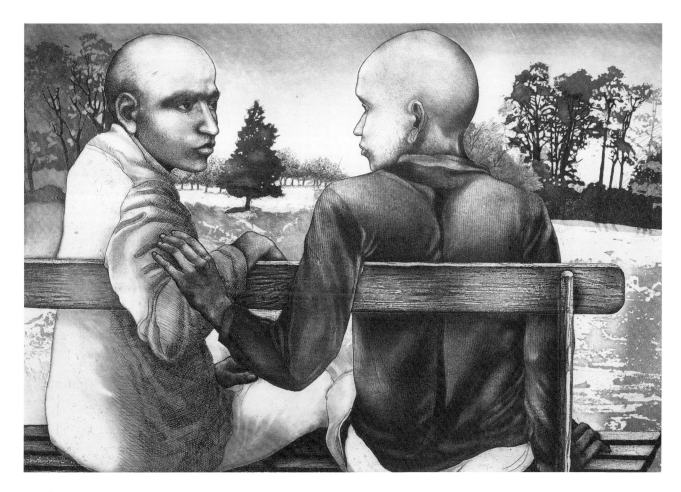

16d | *Dialogue IV*

in London. Produced two years earlier, *Apparition* similarly presents an idealized figure, in this case, his body bathed in light and framed within a *mandorla*-like archway. The dog that appears behind him, while realistically rendered, takes on the presence of an animal vehicle (*vahana*) that often appears in connection with images of Indian gods. Here the dramatic play between light and shadow undermines the corporeality of the body, momentarily transforming an image of man and dog into something supernal. Here again, bodily perfection is called into question as the dog bares his sharp teeth, which glisten a menacing white against a shaded background. In both images, the eyes are hauntingly hollow, as if to prevent the viewer from the experience of exchanging glances (*darshan*) or seeing into their souls.

The Conference represents the first major work in one of Sud's many subsequent engagements with masks and puppets.[32] It features a group of Rajasthani *kathputli* puppets, depicted in traditional fashion from the torso upward, gathered together in conference. They are being manipulated by a puppeteer, whose hands are visible—in Brechtian fashion piercing the fourth wall—above the stage's back cloth. The stage is intensely lit, and the concomitant shadows reinforce the rigidly geometrical divisions of space. Unlike in Sud's etchings of nude bodies, the puppets here are replete with social and cultural markers. In *kathputli* performance, Rajput characters are identified and differentiated through their mustaches and beards, clothing and headdresses. The performance is

16e | *The Conference*

compounded by the fact that the royal figure in the center extends a mechanical hand, as the puppet becomes puppeteer, controlling an unseen performance. This work reveals Sud's reflections on the theatrical nature of life in the city in which individuals play out a series of predetermined roles, their actions restricted by a moral code of conduct and accepted forms of social propriety.

Aqua Pura and *Dialogue IV* represent another of Sud's primary investments: exploring the nature—and boundaries—of gendered relationships. *Aqua Pura* features a pair of lovers positioned in profile, facing one another in a narrow and constrained space. Depicted as hairless and bald, their nude and muscled bodies are carefully textured, and their skin and flesh appear remarkably supple. They stand together yet apart. Their bodies overlap but are not touching, and their gazes are mismatched. They are connected by water, which swirls around them as the female figure lifts up a glass for them to share. The historical significance of the attainment of water as part of a mediated social convention is signified by a subtly outlined figure of a woman carrying a large vessel, in the upper right corner, just as its distinct commodification in "purified" form in the present is indicated by contrast through a row of plastic bottles that forms a barrier between the subject and the viewer, in the lower foreground. In interpreting this work, Roobina Karode has noted Sud's investment in the dichotomy between nature and culture, and also in notions of purity, preservation and contamination.

Dialogue IV comes from a well-known series that probes the intimate nature of human communication with remarkable subtlety. The various works from the series depict pairs of people seated together, engaging each other through body language. Together, they represent an extended study of the complexity of different kinds of relationships: heterosexual, homosexual, and homosocial. In this particular work, we see two men, well-dressed as members of the urban middle class, seated on a park bench. Their interaction is intimate; they are likely more than friends. Although we see them from behind, they turn slightly towards us, just enough to reveal an intense exchange of gazes. The tension in their faces is reinforced through the slight awkwardness through which their bodies connect. They sit with their knees overlapping, as the man on the right reaches over, touching the other's arm with a gesture that rests between a press and a caress. In capturing the view from behind, Sud emphasizes the potential for social transgression and transforms the casual viewer into voyeur, while perhaps also commenting on the ways in which, within the context of large cities, intensely private moments often unfold in unavoidably public spaces.

The absence of privacy in metropolitan spaces is also central to *Your Huddled Masses*, which expresses the experience of urban crowding through the metaphor, and reality, of

16f | *Your Huddled Masses*

public transportation. The viewer is presented with a view of an overcrowded bus, as seen from the outside looking in. The passengers inside are forced into close proximity, overlapping and pressed together but devoid of any personal interaction. They possess markers of modernity—fashionable haircuts, makeup, and headphones. One figure whistles audibly, made visible through circles of sound. The figures are individuated yet anonymous and chaotically arranged, bursting beyond the constraints of the rigidly geometric ordering of space established by the window frames.

Throughout Sud's work, the carefully defined musculature and athleticism of the represented bodies may reflect her father's investment in physical perfection and bodybuilding, an activity in which he also involved his children. However,

what makes her bodies particularly striking is the degree of tactility that she achieves through subtle line-work and texture. In a 2007 interview, Sud described her discovery of the body's musculature as occurring "through tactile sensation rather than through the eye," culled from her experience tending to her father, as, she noted, his children would assist him after a workout by oiling and massaging his body.[33] At the same time, the physical perfection of Sud's bodies forms a deliberate contrast with the less-than-perfect, and often deliberately fraught, contours of the psychological and social world that they inhabit. Altogether, the works in the Gaur Collection reveal Sud's deepening interest during the 1980s and 1990s in weaving open-ended narratives that responded to societal idiosyncrasies and the changing experiences of urban life. [TS]

Anupam Sud

17a–17l
Zodiac Series - Aries, Taurus, Gemini, Cancer, Leo, Virgo, Libra, Scorpio, Sagittarius, Capricorn, Aquarius, Pisces
1992
Twelve etching and aquatint on paper
6 ½ × 6 ½ in each

Produced the same year as a remarkable work reimagining Purush and Prakriti, the masculine and feminine that come together to make up the universal single reality embodied in *brahman*, as a male-female couple, Sud's *Zodiac* series represents an engagement with Indic traditions of religion and philosophy.[34] In this series of etchings Sud conjures up the 12 signs of the zodiac in a spectacular array that probes the dynamics between regional and universal astrological systems. The series consists of 12 etchings, each of which captures the essence of the associated horoscope in vivid pictorial detail. Each etching also includes three symbols, representing the horoscope sign, its planetary ruler (Mars, Venus, Mercury, Jupiter, Saturn, the Moon, and the Sun), and its associated element (fire, water, earth). While the iconography of the Zodiac images is easily recognizable worldwide, the individual scenes cleverly draw from a wide variety of sources to play on the complex relationship between global universality and the specificity of regional cultural traditions.

For example, the image of Aries features a classically inspired scene, depicting a naked male youth running against the backdrop of a pair of embattled rams. Both the depiction of the nude figure, which is notably different from most of Sud's works, and his pose call to mind Greek painted portrayals of Jason and the Golden Fleece, which is often understood as the original myth behind the constellation of Aries, which was associated with the golden-haired ram at the center of the story.[35] He holds up a triangle representing the element of fire. In the lower right corner is the symbol associated with the planet Mars.

Her representation of Gemini, by contrast, combines multiple regional references to create a unique cultural collage. In it she represents the twins in three ways. In the center, the pair is imagined as a male and female figure etched in beautifully textured detail and depicted in profile facing away from one another. To their right and left, respectively, are a second pair, rendered again in profile, as a set of *kabuki* theater masks, a theme that Sud frequently employed following her residency at the Fukuoka Museum in Japan, in 1988. The choice of rendering the twins as male and female, rather than as the Greek and Roman brothers, is a play on the Indian solar correspondence of Gemini with the month of *Mithuna*, which can be taken as a pun on the term referring to the type of loving or amorous couples

Terracotta column-krater (bowl for mixing wine and water) ca. 470–460 B. C. E., Attributed to the Orchard Painter

17a | *Aries*

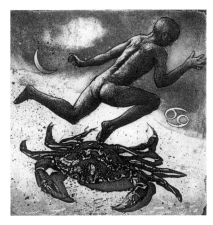

17d | *Cancer*

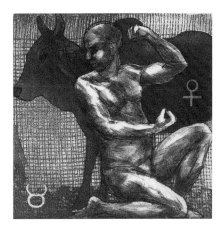

17b | *Taurus*

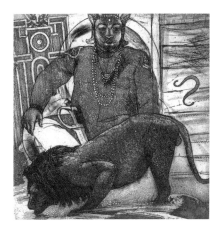

17e | *Leo*

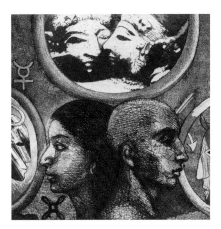

17c | *Gemini*

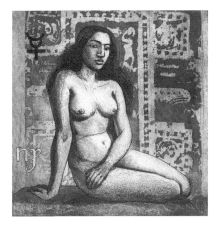

17f | *Virgo*

(*mithuna*) found frequently in temple sculpture and featured, in a photographic transfer from a publication on Indian art, in the roundel at the top center of the composition.

Others still are recognizably Indian in their visualization. For example, the horoscope sign for Leo is depicted as a Hindu ruler, seated in front of the palace gateway with a sword resting in his lap. His regal bearing is reinforced through his rich clothing and strings of pearls, as well as by the lion kneeling at his feet. The distinctively Vaishnava *tilak* on his forehead serves a dual purpose. One the hand, its curving form resonates with the universal sign for the horoscope, which appears to the figure's left, at the edge of the composition. On the other hand, it may allude to the many Vaishnava dynasties, particularly in western India, who traced the origin to the god Rama, who belonged to the *Suryavamsha*, or lineage of rulers stemming from the Sun, the ruling planet associated also with Leo.

Elsewhere, the series is interlaced with moments of deep irony and humor, as seen in Sud's rendering of horoscope sign for Virgo. Here we encounter the virgin as a young girl, her hair flowing loosely down her back and against her shoulders. She is naked, but modest. She turns slyly towards the viewer, but her gaze is averted, and her arm drapes over her lap hiding her nether regions. An informed viewer, however, would recognize the incongruity of the setting, created through photographic transfer, and the significance of the architectural framing of her body. She is positioned against the sculpted surfaces of the 13th-century Sun Temple at Konarak, infamous for its sexually explicit imagery, featuring orgiastic scenes inserted into similarly ornamented niches. Although Sud's virgin maiden appears initially as a living figure, the rendering of the crease running across her stomach and the subtly abraded surfaces of her skin raise the question of whether she too might be read as a celestial seductress similarly sculpted in stone. [TS]

Sun Temple, Konarak, ca. 1250, built by King Narasimhadeva I of the Eastern Ganga dynasty

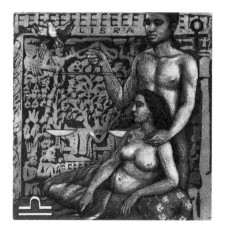

17g | *Libra*

17j | *Capricorn*

17h | *Scorpio*

17k | *Aquarius*

17i | *Sagittarius*

17l | *Pisces*

Haren Das (1921–1993)

18a
Woman at the Well, 1958
Woodcut
8 × 5 ¾ in

18b
Untitled (At Noon), 1963
Aquatint on paper
6 ¼ × 8 ½ in

18c
Untitled (Shell Girls), 1963
Aquatint on paper
6 ¾ × 10 in

Born in 1921 in Dinajpur in undivided Bengal, Harendra Narayan Das was almost a contemporary of Chittaprosad. He learned printmaking at the Art School at Calcutta (now Kolkata) under the tutelage of Ramendranath Chakravarty. In 1947, he joined the faculty as a teacher of etching, woodcut and lithography. In the course of a long career stretching from 1937 until his demise in 1993, Haren Das, unlike most of his contemporaries, remained dedicatedly a printmaker. At a time when most artists in India painted in oils, his single-minded devotion to the graphic arts, and particularly to the relief technique, is indeed exceptional. Haren Das, together with his contemporaries and classmates, Adinath, Satyen Ghosal, Murlidhar Tali and Shaffiuddin Ahmed, were trained to accurately represent the world around them exactly as they perceived it.

Perhaps the most engaging feature of Haren Das's work is the simplicity of his subject matter. Unlike his contemporaries in Bengal, Haren Das's works remained apolitical. They emphasized the gray clouds gathering on a distant horizon, the lush, rain-swept paddy fields, and the calm dignity and quiet labor of the village folk. His compositions feature faceless peasants and placid landscapes, never the slightest trace of struggle or sweat or the wrath and fury of nature. In the vast gamut of his work, there is not a single image of the elite or the middle class. In his own naïve way, Haren Das was an artist of the people.

Women and children were a recurrent subject of interest to Haren, the woodcut *Woman at the Well* and the two

aquatints *At Noon* and *Shell Girls* being fine examples. The first is a masterly relief of a village woman bending over to draw a bucket of water out of the well to fill a pitcher that rests on the rim. The well clearly stands in the courtyard of her house under the shade of a tree, barricaded by a bamboo picket fence. The sun glistens on her bare back, the whole composition suffused in a masterful play of dappled light. In *At Noon*, we see a woman in the verandah of her home weaving a reed mat, while her children are engrossed in playing with dolls in the far corner. The soft afternoon light suffuses this charming picture of calm domesticity. The second aquatint *Shell Girls* is of children on the beach collecting cowrie shells, a common enough enterprise on the Puri beach in Orissa.[36] The two young girls in the foreground are in rapt conversation, even while their hands are busy dropping shells in the little basket by their side. The tide is receding, as is necessary for this activity, and the breeze is gentle. Fishermen's huts and boats are seen moored on the beach, probably indicating the end of the day's work.

In all three works, Haren pays great attention to details of costume and accessories, thus differentiating his subjects as per ethnicity. The woman at the well and the children on the beach, by virtue of the sari draped short on their dark-complexioned bare bodies and the anklets on their feet, are marked as Adivasi, possibly of the Santhal tribe. By contrast, the mother and children in the verandah of their home are distinctly Bengali Hindu in their attire, complexion and environment. [PS]

18a | *Woman at the Well*

18b | *Untitled (At Noon)*

18c | *Untitled (Shell Girls)*

Haren Das

19a	19b	19c
Untitled (Boats on Riverbank), 1963	*Untitled (Friendship)* 1965	*Untitled (Shop at Night)* 1954
Aquatint on paper	Aquatint on paper	Aquatint on paper
7 ¼ × 10 ½ in	7 × 13 in	4 ¾ × 7 ¾ in

In 1947, as India was partitioned, in one fell swoop the British sliced through Bengal, dividing it again along religious lines. Haren Das was one among the countless refugees displaced from East Bengal that thronged the great, heaving colonial metropolis of Calcutta (now Kolkata). Even as he settled into the big city, finding employment and consequently a home and a family, the yearning for the sweeping, riverine plains of East Bengal and his village in East Dinajpur remained alive in his heart. In print after print, with unwavering precision, he captured the monsoon clouds burgeoning on the low horizons; the crop swaying gently in the paddy fields; the palms standing like silent sentinels along the muddy pathways; and always, the swollen rivers and ponds, full with fish. In prints that are unbelievably small, such as the *Boats on Riverbank* aquatint here, Haren encapsulates the sweeping beauty of vast rivers, such as the Padma, Meghna, and Jamuna, silhouetting boats and fisherfolk along their pristine banks. The boat seen here is of the flat-bottomed *kosha* type, called either *bhudi* or *raptani*, used both as fishing boats and also to ferry passengers and lightweight goods. Bangladesh has a wide variety of traditional wooden boats that go out to both ocean and river, *bainkata* being the other type of vessel. True to the riverscapes of this fertile land, Haren depicts here a horizon almost as distant as in a seascape where the opposite bank is barely visible.

In the post-Partition years, Haren lived with his wife, Arati, in Bagmari on the eastern fringes of Calcutta. In 1950, he began to construct a house in Sisirbagan, Behala, then a southern suburb of the city and today a respectable South Kolkata neighborhood. At the time, both these neighborhoods would, at best, have qualified as semi-urban. As refugees from East Bengal trying to rebuild their lives in the big city, these were the sort of colonies or localities that were affordable, even to those who came of better stock, for almost everything they possessed had been lost in migration. Thus, in these neighborhoods, the literate rubbed shoulders with the semi-literate, and the middle class with the poor. Nearly everyone lived in temporary or semi-permanent dwellings that they sought to make permanent or *pucca*. Scenes of construction were visible everywhere—sites of transition from rural to semi-rural, semi-urban to urban.

Shop at Night is a fine example of these transient spaces that the artist likely inhabited in his years of resettlement. In nuanced aquatints, Haren captures silhouetted customers visiting a shop illuminated by lamplight on a dark suburban night. The clay oven with a large wok atop it indicates that this is probably a wayside eatery. In the background, baskets of grain are visible, tended by a shopkeeper. An illuminated bench is placed in the covered, paved porch of the shop—a common prop in small, wayside eateries in Bengal. Haren's use of chiaroscuro is masterly, his aquatints ranging from jet-black to paper-white, with a host of grays capturing the dark shades of a suburban night.

Picture-perfect villages attempting to unite with encroaching industrialization, followed by the process of urbanization, are clearly visible in works such as *Friendship*. An embracing pair of friends/neighbors occupy center-space, while all manner of activities/trades surround them. In the extreme lower right corner is a makeshift hospital outside which a sentry stands guard. Before him

19a | *Untitled (Boats on Riverbank)*

squats a roadside barber giving his customer a shave, while a potter churns earthen water vessels on his wheel. Continuing clockwise, a blacksmith hammers out a scythe in his makeshift shed, while the weaver and his wife weave cloth on the loom in the verandah of their cottage. Their little daughter, dressed in a frock unlike Haren's village children, runs out to collect a letter from the postman. Behind the embracing pair in the center sits a student learning lessons with his teacher. The middle tier of the composition is occupied by activities on the riverbank—the washer folk doing the laundry, cows ploughing a field, while a farmer harvests the wheat, and another winnows the crop. As the eye travels further left, construction hands raise a three-storied concrete building and dredge the parched earth

that permeates the entire foreground of the picture. Beyond the river, on the opposite bank, lies an industrial cityscape, interspersed with structures that appear to be temples, a mosque, and a cathedral—all perhaps identifiable on the Calcutta skyline. An airplane flies low over the river, while a country boat and a larger colonial vessel, with a cross emblazoned on its sails, bob on the river.

Like the multiple perspectives seen in Indian miniature painting, the eye travels through this landscape of suburban development in the decades following Independence. Though none of the trauma and tribulations of relocation are apparent in Haren's work, that the situation was a reality that concerned him is nevertheless clear. [PS]

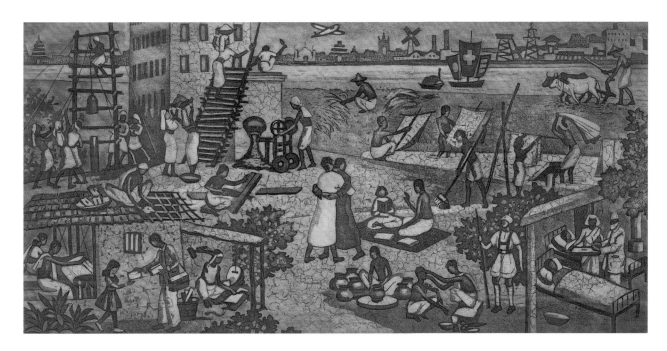

19b | *Untitled (Friendship)*

19c | *Untitled (Shop at Night)*

Haren Das

20
With her Property, 1985
Woodcut
13 × 9 ¼ in

Haren Das's enormous dexterity and control over the none-too-popular wood engraving medium were unmatched. His reliefs are a wonderful interplay of tones and textures, shadows and silhouettes. With the skillful use of the bully,[37] Haren created a fine mesh of varying strokes, each delineating a separate object or surface. Dramatic chiaroscuro effects played a very important role in his compositions. Peculiarly enough, the theatrical use of light in some of Haren's compositions seems similar (though a great deal more refined) to the late phase in Battala printmaking, when art school graduates had begun to participate in this bazaar enterprise.

While Haren Das was well known for both monotone and vividly multicolored prints, sometimes he effectively used black and one other color as a middle tone, relying on the white of the paper itself to act as a highlight. These commendable works are almost photographic in quality. A good example can be seen in *With her Property.* Dated to 1985, the work shows a woman limping with the support of a wooden staff, accompanied by an emaciated Indian pariah dog. She is laden with all of her belongings on her person, including a mat to sleep on; utensils to cook and eat in; shoes, slippers, and bundles of cloth; a broom to sweep with; and even a broken comb. She drags her left foot, which is bandaged. One of the rare instances where the protagonist of the picture is not faceless, we see a dark, snub-faced woman in a headscarf. The bandage and the snub-face may be an indication of a poor woman afflicted by leprosy, rendered homeless due to her disease—which was a common sight in Calcutta (now Kolkata) in the 1980s.

While *With her Property* is a fine example of Haren Das's mastery over his medium, it is also one of the rare works that may be read as a social or political comment. While the artist may merely have aspired to portray his subject with dedication and honesty, *With her Property* is a telling image of a city whose streets were riddled with the less fortunate at the time. [PS]

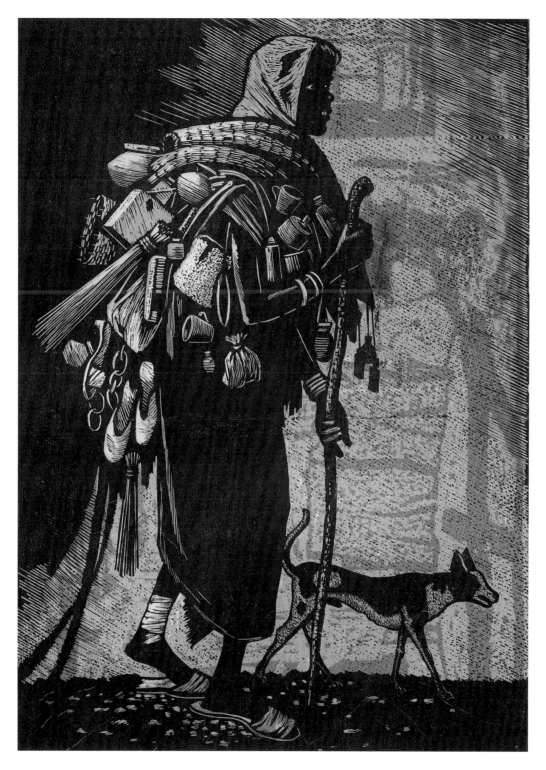

20 | *With her Property*

Bhupen Khakhar (1934–2003)

21a
Birth of Water, 1983
Etching
Plate size 15 ⅞ × 19 in

21b
Wet Handkerchief, 1993
Lithograph
29 ¾ × 21 ¾ in

In the opening lines of a letter penned to Anthony Stokes on October 28, 1978, Bhupen Khakhar playfully poked fun at the conventions of letter writing that had been imparted to him as a schoolboy, noting that his English teacher has taught them to always employ an impressive first sentence. Thus, as he informed Stokes, he had spent the last three days going through "Quotable Quotes" books to find an English proverb, idiom, or metaphor with which to delight his friend. Among these was the saying "Why, man, if the river were dry, I am able to fill it up with tears."[38]

Both of the works by Bhupen Khakhar in the Gaur Collection represent a play on the relationship between rivers and the release of bodily waters. In the later lithograph from 1993, *Wet Handkerchief*, the viewer is confronted by a large figure, seated on the bank of a large lake or river, looking out to the distance and wiping tear drops from one eye. The curving ripples of the water's surface create a halo-effect around his body, although he remains juxtaposed against, rather than immersed within, the water. If one looks closely at the village, represented in a narrow horizontal band at the top of the composition, the source of the water reveals itself to be a combination of rainwater run-off—possibly sewage—and human spillage, as revealed in a small detail of an abstracted human figure, who appears to be pouring out the contents of a deep pot. By contrast, the river flowing through the foreground of Bhupen Khakhar's earlier *Birth of Water* is one wrought neither of tears nor of run-off but rather of another not-so-subtle form of human effluence, emitted from the loins of a solitary figure loosely outlined on the far-right edge of the composition. Just below, to the left, we see a self-portrait of Bhupen Khakhar, identifiable through his characteristic side part, embracing a lover in the deepening waters. The depiction of the river's source as a stream of urination plays on notions of purity and pollution, as well as on the boundaries of middle-class sociability, as seen in many of Khakhar's earlier works, particularly in the shrine-like collages that had caused critical outrage when displayed at the Jehangir Art Gallery in 1965. Having arranged cut-out images of deities culled from calendar prints on vividly painted board, he scrawled the legend "It is prohibited to urinate here."[39]

Frequently considered one of India's most influential modernists, Bhupen Khakhar began his career as an artist relatively late in life. Born as the youngest of four children in an upwardly mobile Gujarati family in Bombay (now Mumbai), Khakhar studied economics and political science at the University of Bombay before becoming a chartered accountant. He began cultivating a side passion for painting by enrolling at evening class at the Sir J.J. School of Art. In 1958, his work captured the interest of Gulam Mohammed Sheikh, and a few years later he joined the recently founded department of Fine Arts at M.S. University, Baroda (now Vadodara), ostensibly to study art criticism. In the decade that followed, Khakhar quickly emerged as one of the most revolutionary, and irreverent, artists of his time. By the late 1960s, he had established himself as India's first "Pop" artist by producing work adopting the visual language of popular commercial prints, children's toys, and cheap figurines, including both secular and sacred imagery. Drawing inspiration from the street, he dismantled the boundaries between fine art and kitsch in ways that were not merely iconoclastic but slyly ironic and deeply aware of India's complex visual histories, both colonial and modern. He co-founded, along with Gulam Mohammed Sheikh, *Vrishchik*

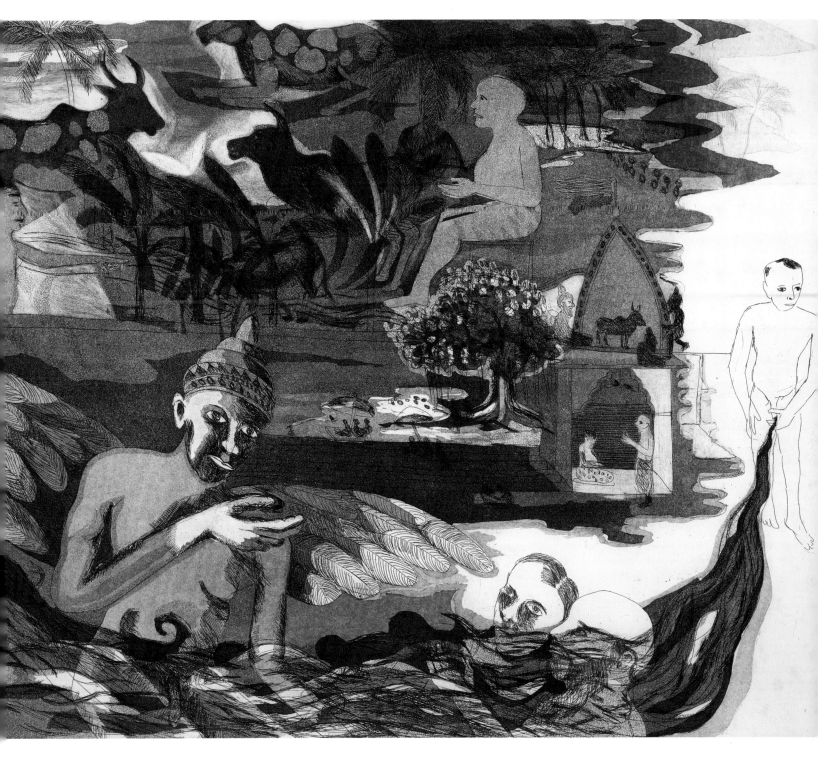

21a | *Birth of Water*

(literally "Scorpion"), a short-lived but highly influential print forum for artists, writers and critics that combined short stories, essays, and poems with folios of printed works of art.

In the 1970s and early 1980s, Khakhar became known for his insightful and colorful depictions of life in the city, which unfold as panoramic views of remarkable beauty and narrative depth. Although often understood as representing the "common man" within everyday spaces, these were constructed smartly as plays on colonial modes of representation and progressive articulations of indigenism within an increasing international art world.[40] The 1980s marked a turning point in Bhupen Khakhar's career. Following his return from an extended stay in England in 1979, Khakhar completed his famous coming-out painting, *You Can't Please All* (1981, oil on canvas), now at the Tate Gallery in London, after which he embarked on an extended exploration of sexuality through his practice. In this exploration, Khakhar drew upon the devotional aesthetics of Hindu mythology and religious practice to evoke the bodily and emotional intensity of homosexual love and desire.[41]

Produced in 1983, Khakhar's *Birth of Water* serves as a prime example of the artist's subtly ironic yet potent interweaving of devotional and erotic worlds. Here, Khakhar and his lover appear as pilgrims, bathing in a river that is both holy and polluted, while a mysterious, crowned angelic figure—naked and distinctively male—sits looking over them, perhaps offering a blessing, with his wings outstretched. He calls to mind the many *vidhyadharas* sculpted on ancient icons and along the walls of medieval Hindu temples. The hauntingly beautiful landscape that unfolds above them is layered with motifs and imagery recurrent in Khakhar's visual experiments of the 1970s and 1980s. We see a man praying at a small tree-shaded riverfront shrine along the sacred *ghats*; a group of ascetics with matted hair piled high;

a trio of cows; meditating ascetics; and scattered palm trees throughout. Khakhar uses etching to excellent effect, using distinctive lines to draw out fine details, cross-hatching to create texture, and gradations to produce figures of varying opacity. Many of the motifs seen here resonate with other etchings from this period, such as in his *In the river Jamuna* (1990–1994), now in the collection of the British Museum, which is even more overt in its reimagining of the sacred riverfront as a site of homosexual desire.[42]

Nearly a decade later in date, *Wet Handkerchief* was designed while Khakhar was in residence at the Steendrukkerij Amsterdam, as part of a 1993 "Spirit of India" country campaign, cosponsored by the Dutch high-end retailer de Bijenkorf and Inventure India. Khakhar was one of three artists from India, alongside Atul Dodiya and Sudarsan Setty, invited to create new lithographs for a series of gallery exhibitions in Amsterdam, The Hague and Rotterdam. These were sold in a limited edition publication, made available exclusively at de Bijenkorf department stores. In its coloration and composition, the lithograph draws from popular modes of painting, and particularly *pathas*, to create an image that is both iconic and deeply narrative. The man seated by the riverside is naked but not exposed. He looks outward at an angle away from the viewer, holding the handkerchief delicately in one arm, while the other drapes over to hide his nether regions. The second lithograph produced for the series and illustrated on the page just opposite in the catalog, is far more explicit.[43] Entitled *River*, an analogous figure in the foreground stands fully disrobed, visibly holding his phallus downward as if about to relieve himself. In both works, the viewer is invited to look more closely into the image, to observe the flurry of activity in the tiny houses and shrines of a nearby village. Here, Khakhar demonstrates his mastery of coloration, juxtaposing greens, yellows, reds, and blues to produce a dynamic and vividly realized landscape. [TS]

21b | *Wet Handkerchief* [opposite]

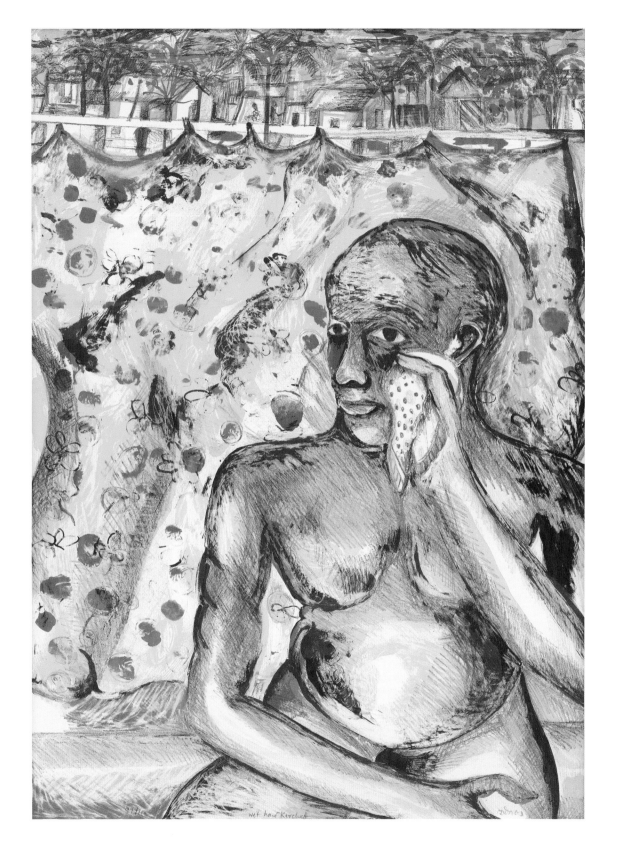

Politics and Social Critique

K. G. Subramanyan (1924–2016)

22
Best Bakery, 2004
Gouache on handmade paper
30 × 22 in

Born into a family of Tamil Brahmins in Kerala, K. G. Subramanyan began his education in economics before discovering his passion for art and enrolling at Kala Bhavana, Santiniketan, where his vision was shaped by pioneers such as Nandalal Bose and Ramkinkar Baij. In 1951, he joined the faculty of Fine Arts at M.S. University, Baroda (now Vadodara), where he served as an inspirational presence in shaping the distinctive and influential curriculum of that program, before returning to his alma mater in 1980, where he taught for nearly a decade before retiring. Often considered one of India's most important modernist pioneers, Subramanyan is well known for his irreverence, and for his deep investment in Indian mythology and folk traditions. Subramanyan fused his extensive knowledge of craft traditions with international modernism into a masterful integration of the classical, popular, and modern visual languages. Many of his works were politically engaged, addressing specific moments of conflict through sculpture and painting. He approached tragedies with a sense of irony, emphasizing the corruptness of political, social, and religious affairs throughout India.

Best Bakery directly references a significant moment of Hindu-Muslim conflict, known as the Best Bakery incident, during the 2002 riots in Gujarat, India. On March 1 of that year, a Muslim-owned bakery was ransacked, attacked, and set ablaze by a mob, resulting in the deaths of 14 people: 11 Muslims and 3 Hindu employees. Subramanyan's use of color and compositional techniques emphasize the violent nature of this event. His use of yellow, orange, and terracotta call to mind the burning fires, and his organization of space, following the style of Bengali *pattachitras*, forces the figures in this painting into occupying a small rectangular area, heightening the sense of entrapment. Subramanyan's figures suggest a deep discomfort. Their bodies are contorted, warped, and twisted, and their faces seem to wail out in agony. A broken sign that reads "BAKERY" is shown to the right of the painting, underlining its connection to the highly publicized event. As the first case connected to the Godhra riots that was tried in court, it remains a symbol of the brutality and carnage during and following the riots. In rendering the scene in this manner, Subramanyan's concern is not to be didactic, but rather to produce a distressingly accurate and sobering representation of the pain and anguish still evoked by this horrific event. [SG]

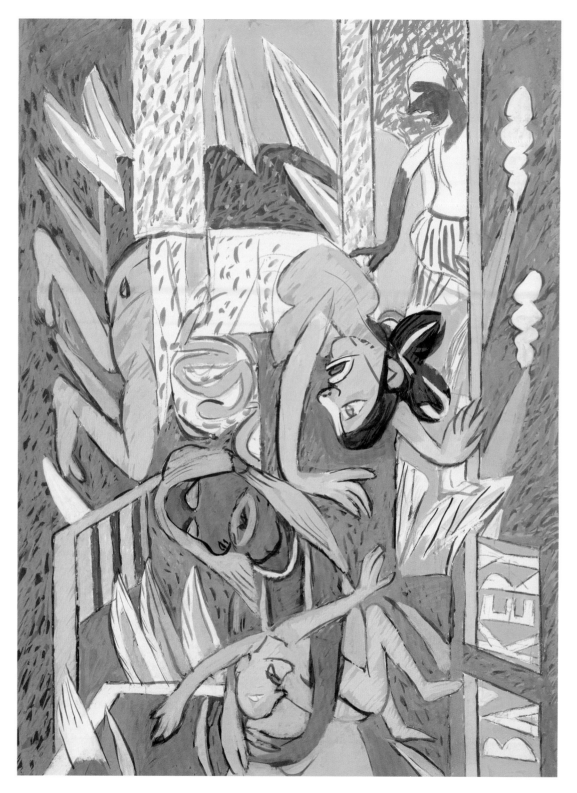

22 | *Best Bakery*

Maqbool Fida Husain (1915–2011)

23a
New Market R. Thomas & Co. (from the *Raj* series)
1986
Watercolor and ink on paper
22 × 30 in

23b
100% Literacy (from the *Kerala Experience* series)
2001
Offset serigraph
14 × 20 in

M. F. Husain's engagement with India's complex and layered histories gave rise to works that can be understood as sharp and insightful political and social commentaries. In the mid-1980s, Husain was struck with a deep desire to revisit the British Raj, which he had inhabited in its twilight years. This led to the production of a vast array of images frequently referred to as his *Raj* series. In *New Market R. Thomas & Co*, Husain evokes the vibrancy of New Market in Calcutta (today Kolkata), which served as the main commercial hub of the colonial city. Initially established in the 1830s, the broking firm of R. Thomas & Co. quickly became one of the controlling forces in the indigo trade until its bankruptcy in 1866 following the Indigo revolt of 1859. Thereafter, it was restarted as J. Thomas & Co., which today remains the oldest and largest tea auctioneer in the world.[44]

The upward angling of the neo-classically inspired buildings in the background emphasizes the dominating imperial force of the British "white town," as does also the scale of the British merchant, presumably the founder, Robert Thomas, in the lower left corner. Donning a stylish European suit and sporting full mustache and ample muttonchops, he looks outward, faceless yet imposing. He forms a stark contrast to the centrally positioned but comparatively tiny figures of a loincloth-clad native and a bull, both represented in classic Husain style but also referencing the ubiquity of Indian peasants in colonial-era representations of the British city. On the lower right corner is an impression of a one-paisa coin adorned with both Urdu and Bengali script, clearly labeled by Husain as depicting the coins of the East India Company, "struck from 1878 onwards at the insistence of Warren Hastings," who notably served as the first Governor

of Bengal from 1773 until 1785, a post that he left in ignominy, as he faced impeachment and charges of corruption that led to a protracted trial back home in London. Together, the juxtaposition of these details serves as a sly and ironic recognition, as Sumathi Ramaswamy has suggested, "that the rise of the autonomous managing house also spelled the death knell of the monopoly that was the East India Company."[45]

100% Literacy represents one of a limited edition of eight prints commissioned by the Kerala Tourism Department, which invited Husain, in 2001, to tour the state and produce images that captured its essential qualities. Most of the prints represent Kerala's colorful village life and idyllic landscapes, which Husain purportedly described as "the ethereal beauty of 'God's own country.'" This print, however, highlights Kerala's remarkable history of promoting literacy, resulting in state-wide rates of over 95% for all adults, including, most notably, women. Husain makes the point by foregrounding the presence of both women and men, some urban and some rural. Juxtaposed in the center, between a sari-clad woman and a man with a western haircut donning a kurta, both wearing glasses, is a Hindu *brahmin* priest, with Shaiva markings (*tilak*), sitting on a chair and reading. In typical Husain fashion, there is more here than meets the eye. The composition strikingly evokes Krishen Khanna's famous 1948 painting *News of Gandhiji's Death*, which depicted people of various social and religious backgrounds standing together, separate yet apart, reading newspaper reports of the assassination of the Mahatma at the hands of Nathuram Vinayak Godse, a Hindu nationalist with strong ties to the same political movements that had

23a | *New Market R. Thomas & Co. (from the Raj series)*

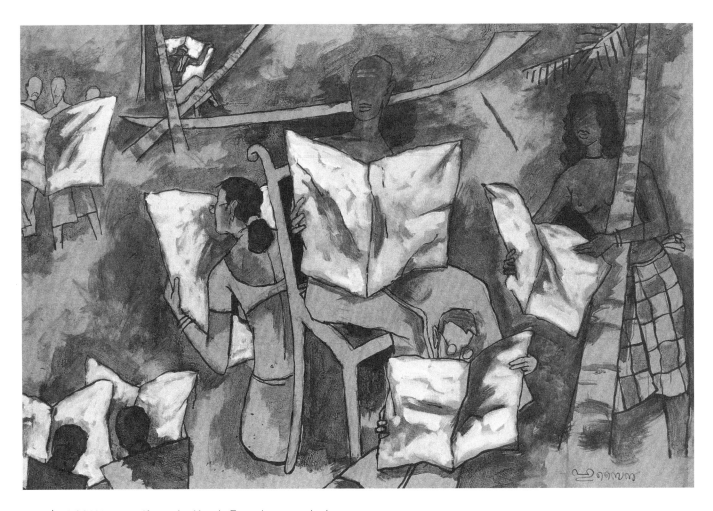

23b | *100% Literacy (from the Kerala Experience series)*

taken a leading role in their attacks on M. F. Husain in the early 2000s. In celebrating Kerala's literacy through such a recognizable art historical reference, Husain has also highlighted both the state's remarkable religious multiplicity, as it remains the most religiously diverse state in the nation, and its continuing adherence to Gandhian ideals through its resistance to the politics of Hindu nationalism that have subsumed much of the subcontinent. [TS]

Shyamal Dutta Ray (1934–2005)

24a
The Broken Bowl II, 1997
Watercolor on paper
18 ¾ × 23 ¾ in

24b
Alone, 2001
Watercolor on paper
19 × 26 in

Born in Ranchi, Bihar in 1934, Shyamal Dutta Ray's work highlights the complexities of urban life in Calcutta (now Kolkata) in the decades following Indian independence. Trained at the Government College of Art and Craft in Calcutta from 1950 to 1955, he became a founding member of the Society of Contemporary Artists (SCA), a Calcutta-based collective formed in 1960 that remains active today. He is particularly known for the reinvention of watercolor as a medium that could evocatively capture, and ironically critique, the stark economic realities and social transitions brought about by rapid urbanization. The Calcutta that Ray encountered in the 1950s and 1960s was filled with refugees, beggars, and decaying buildings, while poverty, disease, and homelessness were rampant. Departing from the muted tones of the earlier Bengal school, he used saturated hues to create melancholic and surreal portrayals of the city's most abject denizens, often depicted singly in closely cropped settings. This framing has the effect of drawing them out and imbuing them with a sense of individual presence otherwise lost in Calcutta's crowded streets.

The two works in the Gaur Collection represent two of Ray's most iconic recurring tropes. Painted in 1997, *The Broken Bowl II* draws upon Ray's well-known *Broken Bowl Series* of the 1970s. The image of the broken bowl emerged from his own personal financial struggles, and the financial prospects of artists in his circle in Calcutta. However, it quickly came to represent what Sanjukta Sunderason recently described as a new icon that "would metonymically symbolize the hunger around, and also cite the history of hunger and destitution that the city carried."[46] The broken bowl became thus a symbol not merely for the state of hunger and destitution but also for the brokenness of the social structures and political and economic systems that were supposedly put in place to safeguard the downtrodden. The artist's daughter, Haimanti Dutta Ray, recalls him describing his broken bowls as "a metaphor for the penury that surrounds us" and "a mimicry of the social milieu in a way that the begging bowl of an alms-seeker is also broken."[47]

In the 1997 watercolor, a broken bowl lies askew along a dusty and deserted street, attracting only the attention of a diving bird. To a well-schooled Bengali, the swooping bird might call to mind Rabindranath Tagore's famous 1916 poem, in which the city's stray birds become a metaphor for the ephemerality of life, the depth of Indian spirituality, and the intrinsic interconnectedness of humans and nature. Here, however, the bird is far more sinister, turning what was once a beautiful reflection into a sharply critical commentary on the failure of spirituality and the disconnection of society from the natural environment. The wandering bird dives downward at a sharp angle, claws unfurled and beak outstretched towards the bowl, which remains empty. A faint yet recognizable reflection of a human skull, a reminder of human frailty and mortality, stares outwards from the center. Behind the bowl, a city draped in darkened blue hues lies separate and unattainable. The vivid colors and volumetric roundness of the bowl stands in uncanny contrast to the flatness of the street and buildings, which resemble less a real space than a faded cloth *batik* backdrop. Cracks, created by the artist's hand, spread throughout the work and spill onto the body of the bird, evoking the crumbling state of both the city and the lives of the people it has failed to support.

In *Alone*, a woman sits facing frontally, her body loosely framed by the doorway of her makeshift slum hut. Clad

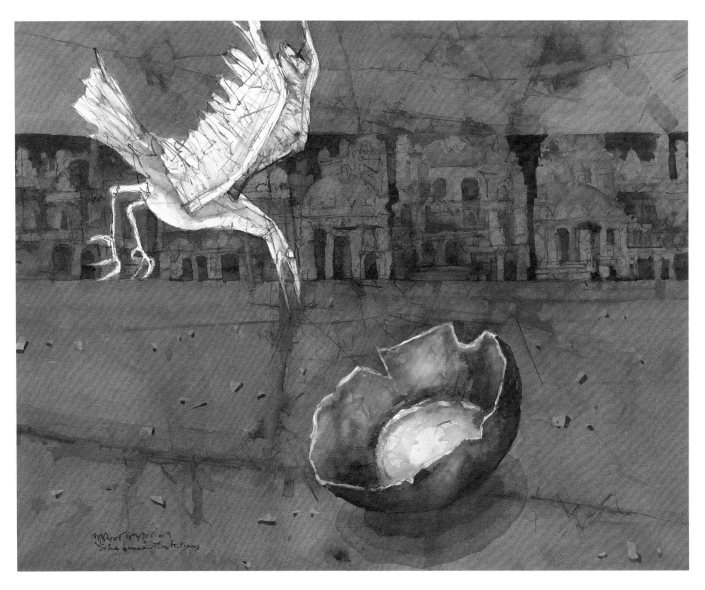

24a | *The Broken Bowl II*

only in a loosely strung sari, she looks outward, meeting the gaze of the viewer. The melancholic and pensive quality of the brushstrokes and startling intensity of the painting's hues are characteristic of Ray's watercolors. In this case, the impoverishment of the woman is carried through analogies in objects: the loose strokes of the handmade bamboo fan stand in contrast to the crisp lines of the manufactured lantern, which itself stands as testament to the failure of the city's infrastructure. [TS+EO]

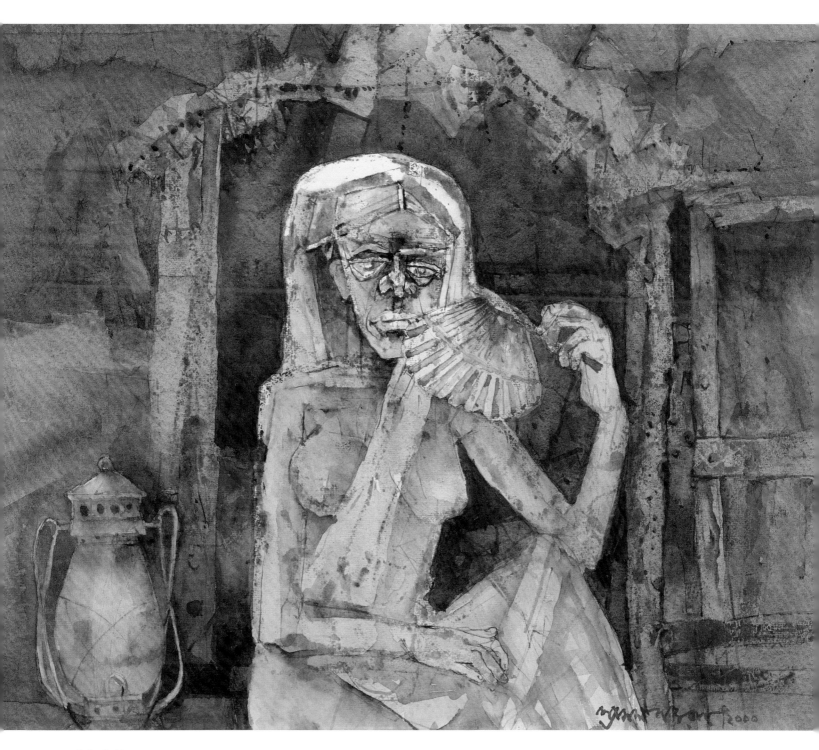

24b | *Alone*

Gogi Saroj Pal (b. 1945)

25
Untitled, 2002
Gouache on paper
30 × 22 in

Gogi Saroj Pal makes one of the most interesting case studies in the history of Indian modern art, as a feminist who fearlessly speaks her mind but whose painted protagonists are aware and accepting of their roles as nurturers and minders of relationships. Pal was born to a Himachali family from Kangra, in the Himalayan state of Himachal Pradesh, that was based at the time in a small settlement called Neoli in Uttar Pradesh. Her father had been a freedom fighter in pre-Independence India, and she has retained fond memories of time spent in Kangra and its environs amidst family—a theme that recurs in her *Homecoming* series in which a winged bird-woman can be seen flying over flowering valleys. Her training in art began at Banasthali Vidyapith in Rajasthan, and then at the Government College of Arts and Crafts in Lucknow and concluded with a post-graduate diploma from the College of Art, New Delhi.

Pal's abiding theme has been a reflection on the condition of women and their relationships, the way they are sexualized, used, neglected, as well as their ability to empower themselves, themes she has explored in *Being a Woman* or *Nayika*, as well as through the creation of composite hybrids such as *Kinnari* (Bird-woman) or *Kamadhenu* (Cow-woman). While she questions and rejects patriarchy, she is mindful of the roles women are called on to play. Her *Hathyogi-Kali* series depicts women who are fiercely independent and, according to the artist, "cannot be tamed."

This untitled painting seems to have emerged from her *Nayika* series, though there is a sense of loss about the woman—she is no more radiant with painted lips and the soles of her feet. Her dejected expression and downtrodden stance seem to be the result of abandonment by her lover. Though dejected, the woman is free to seek refuge in her mind—a space the artist often draws our attention to when addressing the issue of a woman's role in society. The protagonist here clutches a veil that resembles a stream of water over which little paper boats appear to float. You can use your mind to escape anywhere, anytime, the artist seems to be telling us—no matter where and how you are confined, your mind can never be conquered. In that sense, Pal's *Untitled* painting here is a paean to the heroic nature of everywoman. [KS]

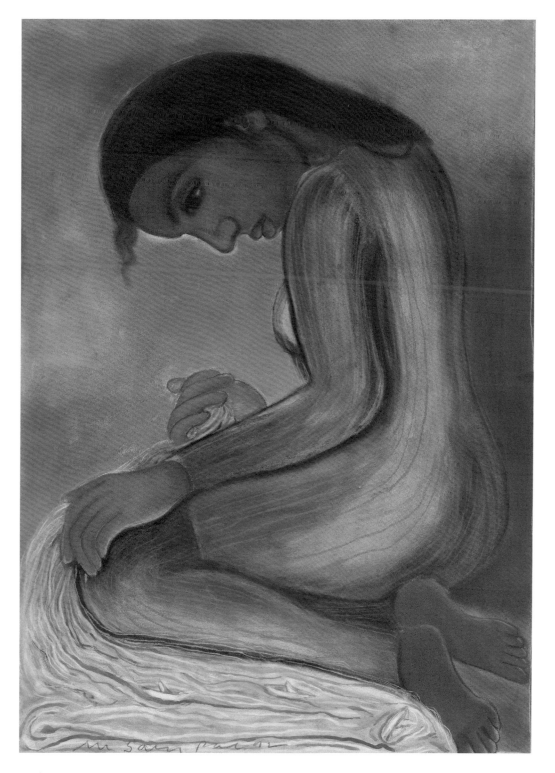

25 | *Untitled*

Somnath Hore (1921–2006)

26a – 26h
Untitled, 1983
Eight etchings
smallest 5 × 6 ¾
largest 10 ½ × 6 ⅞ in

26i
Untitled (Famine), 1978
Lithograph
17 ⅜ × 12 ¾ in

Somnath Hore was born in 1921 in Chittagong, where he spent an idyllic childhood. After a brief stint at the City College, Calcutta (now Kolkata) in his early youth, Hore returned to his village in Chittagong. While in Calcutta, Hore had begun making hand-written posters for the then banned Communist Party of India (CPI). Hore described those early years as a time of solidarity with peasants in the fight for freedom, for which it was exhilarating to produce art in the service of political mobilization. He wrote,

> While growing up, I was surrounded by the indescribable miseries of the poor who labored endlessly only to see the fruits of their toil being enjoyed by the rich. An intuitive sympathy developed…. In Chittagong, almost the whole generation of young committed anti-British terrorists turned Communist…. We hated British rule and had close ties with the poorer sections of the people…. Soon the great famine of 1943 bared its fangs. Chittagong was a frontline area. The allied soldiers were everywhere. Suddenly there was food scarcity. Mass starvation was widespread… without food or medical care, they (the poor) were dying…. In such an atmosphere, it was exhilarating to be producing political posters with slogans and illustrations.[48]

It was during this time that the young Hore met the renowned and charismatic Chittaprosad, who took him under his wing, encouraging him to directly sketch the people on the streets and in the hospitals. Appreciative of his talents and his abilities, the CPI made Hore a full-time member. Hore traveled through the villages and small towns of famine-stricken Bengal with his comrades, exhibiting his work to enthuse the people to help the starving poor. By early 1950, Hore, along with other artist comrades, began to grow disillusioned with the growing sectarian divisions within the CPI. "The urge for artistic creativity, lying dormant within me, had been awakened by my work for the CPI. But now, disassociating myself from active party work seemed inevitable if I was to pursue my passion for art."[49] In 1956, Hore ceased to be a party member.

Hore's experience with the trauma of famine-stricken Bengal haunted his experiments in printmaking, which he began in 1945 as a student in Calcutta, where he learnt from his teacher, Shafiuddin Ahmed. In 1954, Hore was invited by Atul Bose to set up a Graphics Department at the Indian School of Art. In 1958, he joined the Art Department of the Delhi Polytechnic as lecturer in charge of the Graphics Department. While in Delhi, he wrote,

> I struggled to rise above subject matter and theme, but they refused to leave me completely. The Famine of 1943, the communal riots of 1946, the devastation of war, all the wounds and wounded I have seen, are engraved on my consciousness. The burin mercilessly cuts the surface of a wood block, acid ferociously attacks the zinc or copper plate, these exercises continue without any premeditated design, but in the end an icon of wounds emerges. This icon represents the helpless, deserted, starved and tortured.[50]

Unlike the artists of the Santiniketan school, Hore's interest in printmaking as a preferred medium was connected not to its novelty but to his desire to express the injustice and untold suffering upon the poor. He wielded the burin or acid as weapons of destruction and devastation and explored its potentialities passionately to realize what he liked to describe

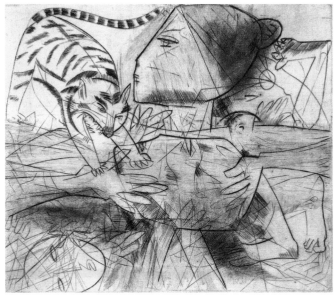

26a | *Untitled*

26b | *Untitled*

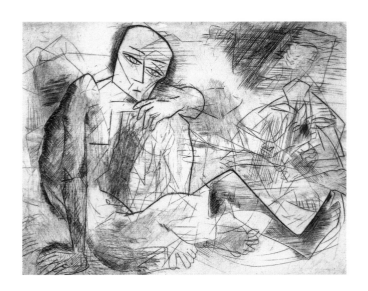

26c | *Untitled*

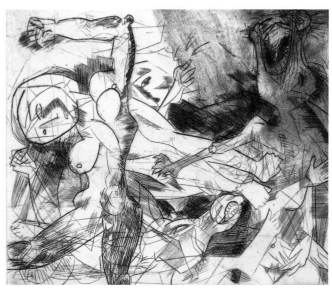

26d | *Untitled*

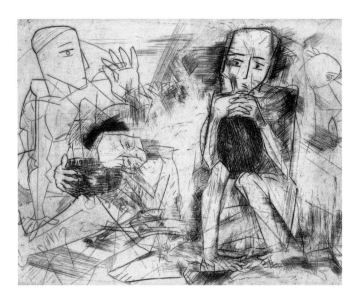

26e | *Untitled*

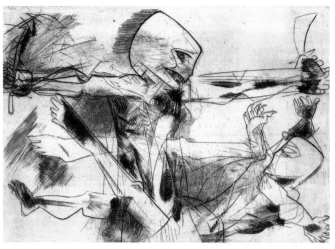

26f | *Untitled*

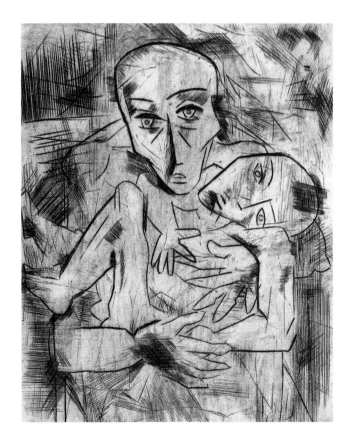

26g | *Untitled*

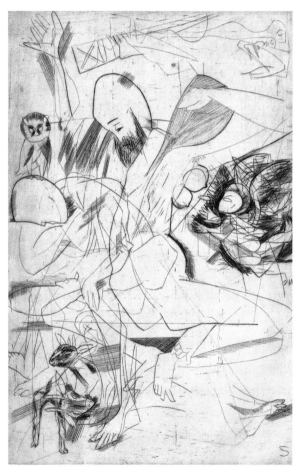

26h | *Untitled*

as his "concept." This sense of purpose had been hitherto unseen in Indian printmaking, perhaps with the exception of Chittaprosad. For the first time, printmaking had been chosen to achieve an aesthetic goal that specifically demanded it—this was a revolution in artistic thought, not merely the exploration of a new medium.

In 1967, Hore left Delhi for Calcutta, and in 1969, he joined Kala Bhavana in Santiniketan.

"The fast pace of Delhi life was replaced by tranquility and meditation.... A new awareness was created in me. In 1969-71, society was in a state of upheaval and chaos. A section of the youth was restless. There was panic and terror among the common people. Wounds is what I saw everywhere around me. A scarred tree, a road gouged by a truck tire, a man knifed for no visible or rational reason. A new concept was born. The object was eliminated; only wounds remained. White-on-white prints emerged from these wounds.... It was but an extension of the wounds a burin or acid would make on surfaces like wood or metal sheets."[51]

The metal engravings, etchings, viscosity prints, and lithographs that followed in the middle phase of his career are true examples of Hore's enormous repertoire as a printmaker. The lithographs here predate the engravings, acting as prelude to what was to come. In the two lithographs from the late 1970s, we see skeletal male figures with emaciated bodies and enlarged heads. The only article of clothing on their bodies is a loincloth, while they hold in their hands a platter (*thala*), which they use to beg for food for their survival. The sad gaze of these malnutritioned bodies, contorted with hunger, are remnants of Hore's memories from the Bengal Famine that continued to haunt him. But equally, these works follow a few years after the Bangladesh War of 1971 that spurred a fresh influx of refugees into West Bengal, as also the Naxal uprising that shook Bengal in the late 1960s and early 1970s—both once again inflicting suffering and impacting the artist.

Even as Hore drew the suffering and wounded on the lithographic stone, he sought a method to inflict the scar more directly on his image-making surface. The direct process of engraving in metal, exemplified by this series from 1983, offered this possibility for producing particularly harsh images of the starving and the dying. Sharp lines slice across the surface of the plate like knife wounds slicing through flesh stretched thin over emaciated bodies, reduced almost to carcasses. The use of the medium is very purposeful and very literal; the dark patches of ink retained from reduced wiping of the plate appearing almost like bleeding gashes in the flesh. [PS]

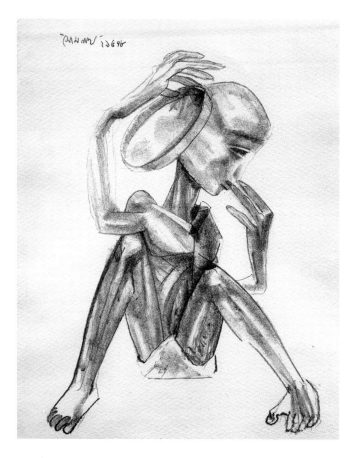

26i | *Untitled (Famine)*

Chittaprosad Bhattacharya (1915–1978)

27a
Foundry workers
ca. 1960s
Linocut on paper
11 × 8 ¼ in

27b
Untitled (Bonded laborers)
ca. 1960s
Linocut on paper
15 × 11 in

27c
Untitled (Cane Weaver)
ca. 1960s
Linocut on paper
7 ½ × 8 ½ in

Born in 1915, Chittaprosad spent his formative years in the small towns of Bengal. In the early 1930s, he and his family moved to Chittagong, where he attended college and made posters, drawings and cartoons for the nationalist movement. In the late 1930s, Chittaprosad became actively involved in agitation against the British, particularly in protest of the "scorched earth" policy that led to food shortages and poverty during World War II. In 1940, he joined the Communist Party of India (CPI) that brought him first to Calcutta (now Kolkata) and later sent him to Bombay (now Mumbai). In 1943, he was sent by the party to cover the famine in Bengal, an experience that led to his famous drawings of 1943. These were published in the Communist journal, *People's War* (renamed *People's Age* after 1945) and later in a pamphlet called *Hungry Bengal* by the People's Publishing House of Bombay.[52]

Following his rift with the CPI in 1949, Chittaprosad ensconced himself in a modest room in a Bombay suburb and began experimenting with the wood engraving and linocut mediums. He drew inspiration from the work of Nandalal Bose, and particularly from his engagement with folk and classical Indian art traditions, but added a new dynamism and a certain angst. It is this spirit that exemplifies Chittaprosad's reliefs, most of which are heroic compositions in black and white. With unfailing honesty and great passion, Chittaprosad drew the rural and semi-urban folk of India engaged in their daily toil, surviving natural and man-made hardships with dignity and self-respect.

He brought to the graphic arts a sense of monumentality and solidity seen famously in the sculptures of Ramkinkar Baij. His prints have none of the tranquil calm and placidity of the Santiniketan school. Instead, they possess a sense of agitation, a sense of the human figures and their surrounding environment being propelled forward by forces beyond their control. This is especially evident in the untitled print depicting a massed column of bonded laborers brought to the city, advancing out of the picture frame towards the viewer. The man leading the column, possibly an educated individual dressed in an attire that Chittaprosad himself often wore, walks with his head held high despite his shackled wrists. To his right is a stocky, dark-complexioned man, who may be a member of the downtrodden Dalit community, who were often forced into bonded labor. The uniformed Bombay policemen, looming in the center of the column, shepherd before them a young boy and another disheveled man, both barefoot, while a motley crew of women and children shuffle behind. Debt bondage was a colonial inheritance in India, by way of which lenders forced borrowers to repay loans through labor—a system that was legally abolished, though not eradicated, by the Indian Government in 1976.

In the *Foundry workers*, three workers form a cohesive, monumental mass, indicative of the industrial proletariat, on whom the foundations of the new India rested in the decades following Independence. Clothed in protective overalls and ankle boots, unlike the semi-clad bonded laborers, the worker in the front wears a pair of protective eyewear and holds his shovel with a cloth while peering into what is clearly the burning heat of the foundry itself. His two companions stand alert behind him, resting on their shovels.

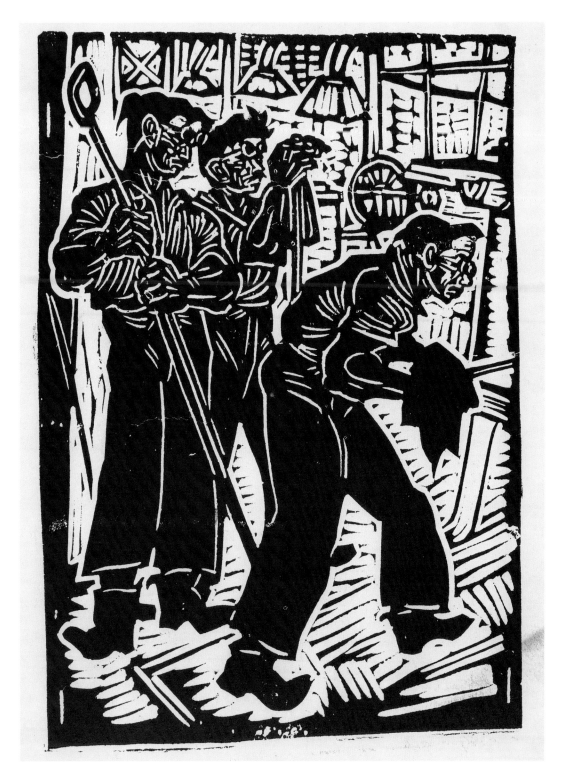

27a | *Foundry workers*

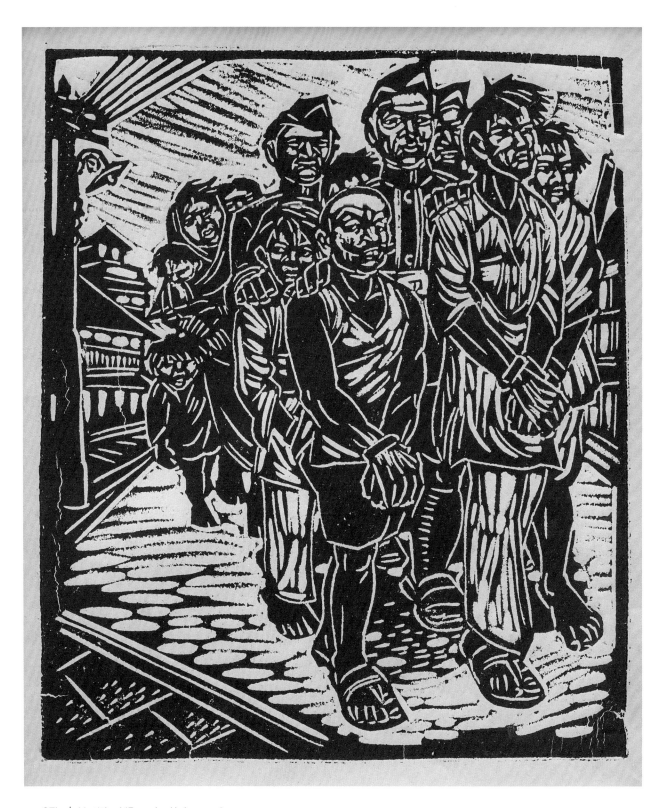

27b | *Untitled (Bonded laborers)*

156

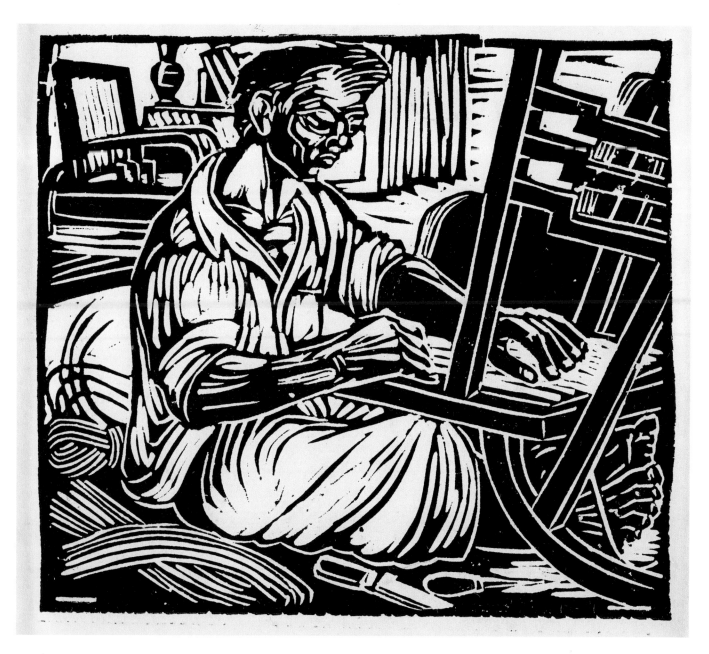

27c | *Untitled (Cane Weaver)*

Equally engrossed in labor is the *Cane Weaver*, who is caning the seat of an armchair, while another completed chair rests in the background. The tools of his trade lie by his side—a sharp knife for slicing the cane into strips, and a bodkin to pry the strips while weaving. On his person, he wears the same shirt-kurta worn by the leading figure in the column of bonded laborers, paired here with a dhoti instead of a pajama. His gaze is intent upon his work, his strong, muscular hands rendered in advancing perspective as the main focus of the composition. [PS]

Myth and Religion

Maqbool Fida Husain (1915–2011)

28a
Mother (Mother Teresa), 1982
Crayon and pastel on paper
22 × 15 in

28b
Mother Teresa Series, ca. 1990s
Screen print
26 ½ × 38 ½ in

In addition to his scenes of rustic landscapes and his reflections on social policy and colonial histories, as seen earlier in catalog entries 3 and 23, Husain is well known for his engagements with India's diverse religious traditions. In these works, M. F. Husain translates India's composite culture and creates a new social space where diverse identities and ideas can be negotiated. The works seen here grapple with events and people that shaped history not only politically but also socially and spiritually.

Husain's works portraying Mother Teresa reside on the hinge of myth, religion, and narrative. While there is no denying that Mother Teresa is a religious figure, Husain's attempt at capturing visions of Mother Teresa was also driven by profoundly personal concerns. For Husain, Mother Teresa served as a symbolic surrogate for his own mother, Zaineb, who passed away when he was just two years old. While growing up, Husain was haunted by a story, told to him repeatedly, of his mother holding him tight one time when he was ill and pleading with God to take her instead of him.

Having lost his own mother at such a young age, Husain was left unable to recall her face. His decision to replace Mother Teresa's face with a void in *Mother* thus speaks to this loss of memory. At the same time, it also enables her to transcend the specificity of a single woman to embody the idea of motherhood more broadly. This effort to universalize Mother Teresa is reinforced by the abstraction of the body and the dematerialization of location and context. In initially conceptualizing this series, Husain attempted realistic portraits. However, he quickly abandoned that endeavor in favor of subtle abstraction as a more potent way of revealing Mother Teresa's spiritual dimension and maternal aura.

Husain's *Mother Teresa* series also engages a longer iconographic tradition associated with Christianity. It references and reimagines the Pietà, replacing the Madonna with three images of Mother Teresa: the modern Madonna, depicted as a faceless figure draped with her iconic light-blue-bordered white sari. While discussing his work, Husain stated: "I have tried to capture in my paintings what her presence meant to the destitute and the dying...That is why I try it again and again, after a gap of time, in a different medium."[53] [SG]

28a | *Mother (Mother Teresa)*

28b | *Mother Teresa Series*

Maqbool Fida Husain

29a
Untitled (Ashta Vinayak Series I)
2007
Offset lithograph
16 ½ × 13 in

29b
Hanuman - Nineteen
1984
Ink and watercolor on paper
15 × 21 ¾ in

29c
Untitled (Hanuman)
ca. 1990s
Watercolor on paper
22 × 30 in

Despite being a secular Muslim, Husain frequently found inspiration in the Hindu mythology, folklore, and ritual performances that were deeply engrained from his formative years. He notably grew up in the pilgrimage town of Pandharpur, Maharashtra that is home to the Shri Vitthal-Rukmini Mandir, and also in Indore, where he watched dramatic Ramleela performances. Drawing from several artistic disciplines such as dance, music, and film, Husain integrates a performative quality into his paintings. In discussing Husain's oeuvre, Yashodhara Dalmia has written that "in negotiating the iconic, Husain has re-invested it with a mythic aura, restoring its original function.... In ancient epics, the gods stood for immanent energies and were always symbolically represented, imbued as they were with a universal significance. Husain, under modernism, empowered them with a symbolic presence while contextualizing them in the contemporary, thereby layering their form with multiple meanings."[54]

Husain revisited Hanuman many times throughout his artistic career, at one point bringing his series of paintings from the Hindu epic *Ramayana* to Andhra Pradesh, to observe the response of village folk to modern art. Created after meticulously studying several regional versions of the *Ramayana*, Husain's canvases were exhibited in villages around South India so people from all social classes, not just those privileged enough to engage with art in gallery spaces, could see and engage with his work. His narrative paintings were often executed in a softer cubist style that was paired with the vibrant colors that are often viewed as essential to Indian art and iconography.

In the works from the Gaur Collection, Husain approaches Hanuman in a manner that highlights his strength and devotion to Rama. *Hanuman - Nineteen* continues Husain's ongoing project of representing core elements of Indian culture in contemporary idioms. These depict Hanuman attacking Ravana's kingdom of Lanka, setting it ablaze with his tail. While one painting centers Hanuman in front of the burning city, the other heightens the sense of drama by setting four petrified figures beneath the monkey god, within the city walls, and among the flames. The composition utilizes swaths of black, red, and white, with a ribbon of yellow that separates our protagonist from the city engulfed in flames.

Untitled (Ashta Vinayak Series I) depicts Lord Ganesh, the patron deity of the arts and the remover of obstacles, who is often venerated prior to undertaking new journeys. Ganesh was a deity Husain revisited many times throughout his career, as part of a much larger series of work that addresses Indian deities and icons. The lithograph represented here captures both the deity's playful nature as an ebullient dancer and his significance as an object of devotion. [SG+TS]

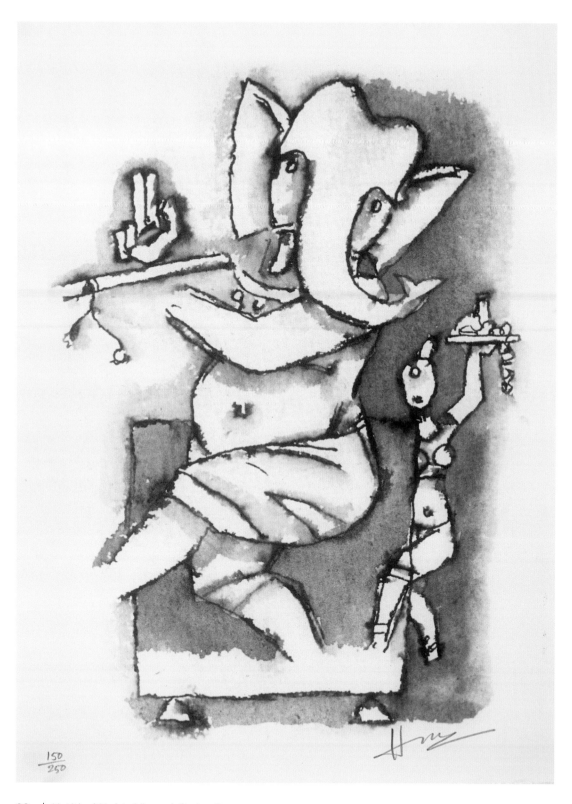

150
250

29a | *Untitled (Ashta Vinayak Series I)*

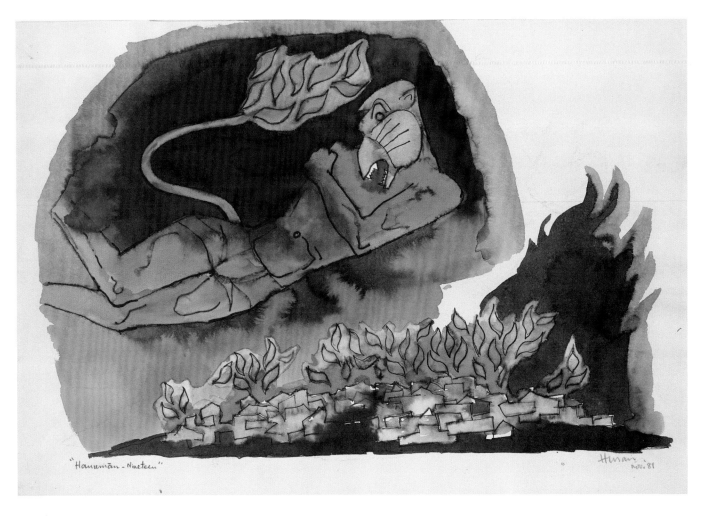

29b | *Hanuman - Nineteen*

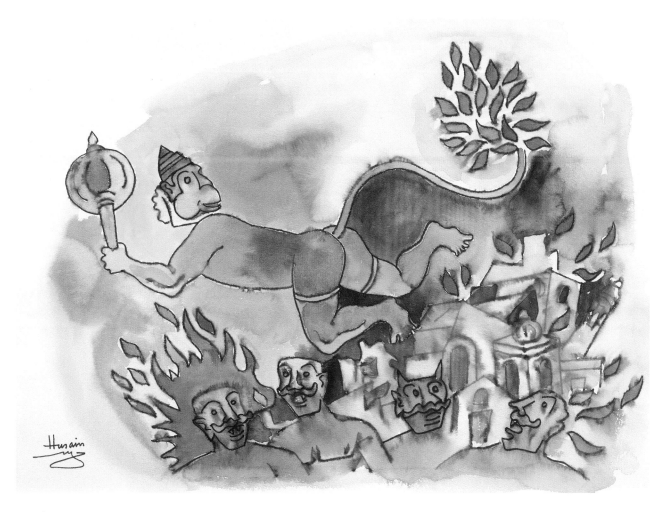

29c | *Untitled (Hanuman)*

Jyoti Bhatt (b. 1934)

30a	30b	30c	30d
Images for Saurashtra Embroidery, 1994	*Om Mani Padmaham II* 2014	*Om Mani Padmaham* 2014	*Two Faces* 1998
Etching	Etching	Etching	Mixed Intaglio
9 ½ × 10 ¼ in	15 ¼ × 8 ½ in	18 ¾ × 13 ½ in	9 ½ × 12 in

Photographs taken around the mid-20th century show an austere looking Jyoti Bhatt, bright, keen, with a suggestion of humor—attributes his colleagues and students would come to know well over the years. But what marked young Bhatt apart from everyone else was an insatiable curiosity that saw him study painting among the first batch of students at the freshly minted Faculty of Fine Arts in Baroda (now Vadodara), and, later, at Banasthali Vidyapith in Rajasthan, where he trained in murals and fresco painting. He joined the Baroda Group of artists under the mentorship of his art teacher in Baroda, the renowned N. S. Bendre, in 1955, participating in exhibitions in Bombay (now Mumbai), where he was exposed to the glamourous world of art lovers and collectors for the first time, also catching the eye of national institutions.

The result was a scholarship in 1961–62 to study art at Accademia di Belle Arti in Naples, Italy, where, for the first time, he became acquainted with printmaking, spurring him on to apply for a Fulbright scholarship in 1964 to learn printmaking at the Pratt Institute in New York, later extended under a John D. Rockefeller III Fund fellowship. Bhatt's exposure to the medium was instrumental in his taking over of the printmaking department at his alma mater in Baroda on his return. He was also a member of the iconic Group 1890, founded in 1962 by artist and intellectual iconoclast J. Swaminathan, which had exhibited in New Delhi in 1963 under the mentorship of the poet Octavio Paz (then ambassador of Mexico to India), its artists presenting the first serious challenge to the formidable popularity of the Progressive Artists' Group that had preceded it by 15 years.

The mechanical processes in art making drew Bhatt into its web to such an extent that he devoted his practice largely to printmaking and—from the late 1960s onwards—photography, particularly of a documentary nature. His printmaking reflected the popular zeitgeist tinged with a sensibility linked to the bazaar—an Indian rendition of pop that crossed high art with street posters and signs to create playful works that often caused the viewer to chuckle. Fellow Baroda artist and co-faculty at the art school in Baroda, Nilima Sheikh would write about him: "Jyoti Bhatt's visual intelligence and pertinacity had the potential to uplift the form to obfuscate questions of function."

The prints in the Gaur Collection pay homage to this visual lexicon. In *Images for Saurashtra Embroidery*, Bhatt draws from his own photographic archive of the textiles and crafts of the arid desert region in his native Gujarat that were beginning to fade away as a result of urbanization. The folk motifs in the etching combine elements of bead and thread embroideries with designs for the wall and floor drawings painted by women using rice flour or white chalk paste on their mud-washed homes. Many of these images are sacred, though Bhatt does not give them any special religious connotation, preferring to fill in busy details into the print as a representation of life in the region.

Bhatt's other enduring fascination has been with depicting faces in profile, which he imbues with distinctive inner personalities. In *Two Faces*, he evokes the polar opposites of day and night through the feathered creatures that inhabit

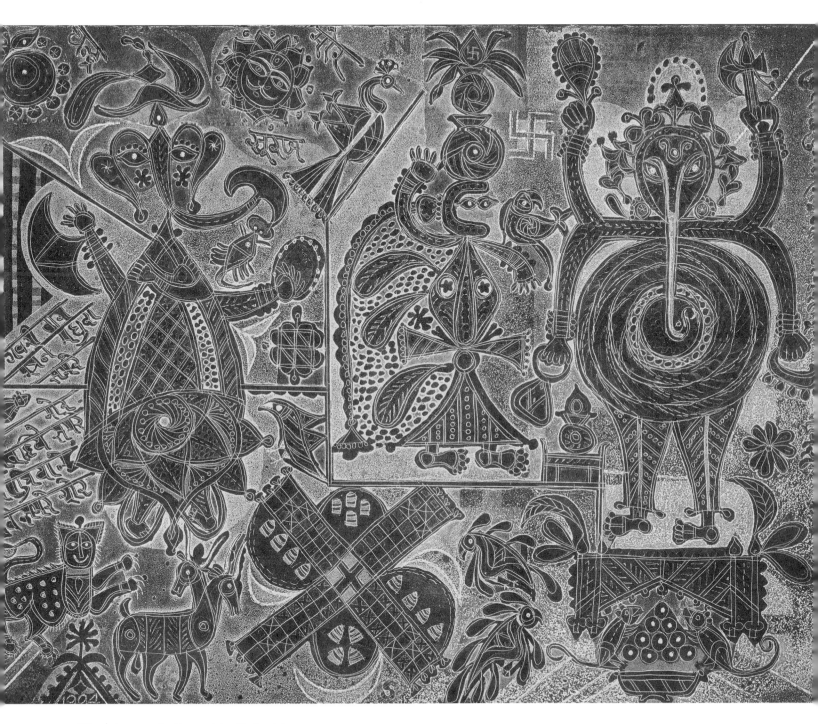

30a | *Images for Saurashtra Embroidery*

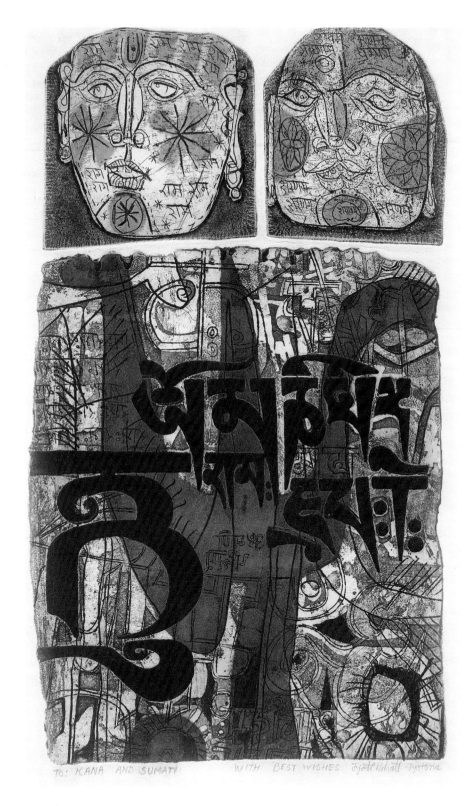

To: KANA AND SUMATI WITH BEST WISHES Jyotishatt Jyotsna

30b | *Om Mani Padmaham II*

2/10 (2014) ॐ मणि पद्म हुम (1968)

30c | *Om Mani Padmaham*

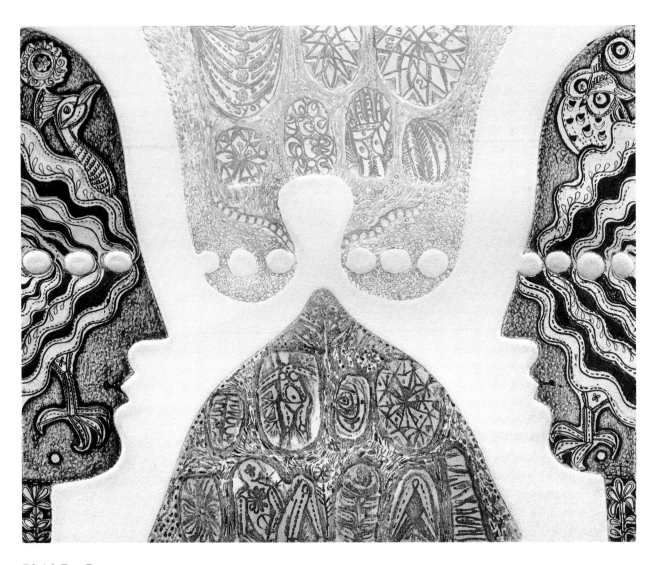

30d | *Two Faces*

their mindscapes—the diurnal peacock and the nocturnal owl. The seemingly obvious, then, can be reversed with the peacock's vanity pitted against the owl's wisdom. Without drawing on aggressive parallels, Bhatt was not averse to addressing polarities in daily life, thus subtly creating a discourse between the seen/unseen. *Om Mani Padmaham* uses Tibetan calligraphy to recall the Buddhist hymn: "Behold the jewel in the lotus," indicating Bhatt's interest in iconography and his penchant for taking liberties with it as a means to undermine religious fakery. In another version of the work, *Om Mani Padmaham II*, the faces above the stencil-like calligraphed chant appear to represent Hindu and Buddhist sacred images with lettering in Devanagari that addresses both constituencies—the former through a repetition of the name of Rama as chanted by his followers, the latter through the repeated use of the word *sharnam*, meaning "refuge," in reference to seeking sanctuary in the Buddha's fold. Such filling of a picture-plane with multiple images is Bhatt's unique quality, in evidence here with the tattoo-like letters representing a restless mind that might well benefit from the soporific effect of the sacred chant. [KS]

Atul Dodiya (b. 1959)

31a
Sabari Throwing Rings into the Chakri, 2005
Lithograph and hand coloring on handmade paper
50 × 40 in

31b
Sabari with Birds, 2005
Lithograph and chine-colle on handmade paper
50 × 40 in

Created as part of a more extensive series, titled *The Wet Sleeves of My Paper Robe (Sabari in Her Youth: After Nandalal Bose)*, produced during a residency at the Singapore Tyler Print Institute, Atul Dodiya's reimagining of Sabari moves viewers away from Sabari's more typical representation as a frail old woman. In the Hindu epic *Ramayana*, told by Valmiki, Sabari is encountered by Lord Rama only as an elderly woman, who has sacrificed her life to attaining the auspicious sight of a deity (*darshan*). Like in much of Atul Dodiya's work, here, the *Sabari* series weaves together references to Hindu myths with personal narratives. Although her form is centrally placed within each work, the resulting composite image surpasses sensuality. Approaching her figure with minimal lines, with one image that heightens her role as a mother by depicting her with many breasts, Dodiya moves the viewer's gaze away from the sensuality and sexuality of the female figure and towards Sabari's essential role in the *Ramayana*.

Stories from popular vernacular retellings of the *Ramayana* equally immortalize Sabari as a fragile and delicate woman. In talking about his vision of Sabari, Dodiya described Sabari as "a story that my mother would tell me when I was a boy. The story remained in my distant memory... All along the Sabari I had seen was old and bent."[55] The idea of creating a series of large collages and lithographs to complicate a character familiar to most Indians followed a 1998 exhibition, "Contextualizing Modernism," in which the curator, Siva Kumar, exhibited three tempera paintings of Sabari made by Nandalal Bose in 1941: *Sabari in her Youth*, *Sabari in her Middle Age*, and *Sabari in her Old Age*. In this series, Bose became the first artist to consider what Sabari might have been like as a young woman or what her life was like leading up to the events that transpire in the *Ramayana*.

Nandalal Bose's tempera triptych profoundly influenced Dodiya, whose own series acts as an extended meditation on Sabari, following her life through many moments, and transforming her into a multi-dimensional woman. Dodiya's Sabari is nuanced and comes in many forms. She maintains her long-established identity as a figure who emphasizes *tyaga* and *tapasya*, an embodiment of ultimate sacrifice, but her journey through Dodiya's series is more nuanced. Sometimes she appears as a mother-goddess. At other times, she is depicted as a madwoman, made recognizable through the depiction of a familiar set of objects and attributes: a tree, a house, and a type of millstone (*chakri*)

Nandalal Bose, *Sabari in her Youth*, 1941/42
Tempera on paper pasted on board, 15 × 10 in

31a | *Sabari Throwing Rings into the Chakri*

used for cracking wheat, splitting whole beans for making *daal*, and pulverizing spices into a fine powder. As the title suggests, in *Sabari Throwing Rings into the Chakri*, Sabari is seen throwing her rings into a grinder, dramatically cleansing herself of material possessions. *Sabari with Birds* references Sabari's wedding feast, where her parents, in preparation for her wedding, slew several birds and, shocked by the bloodshed, Sabari renounced marriage completely and devoted her life to being an ascetic. Crimson birds are shown perched on vein-like branches that emerge from Sabari's body, reflecting the wedding banquet and accentuating her association with animals and the natural world.

In both works, Sabari is visualized as a dramatically outlined linear figure with elongated features and an erect spine. Dodiya has described the spinal column as becoming

31b | *Sabari with Birds*

the "first alter image" and positing a fitting contrast to the traditional story. This mode of representation marks a distinct progression in his approach to the subject, which began in 1999 with a watercolor, *Woman with Chakki*, which he describes as "a subconscious quotation of Bose's *Sabari in her Old Age*." In the new version, he writes, "[This] time I decided that Sabari in my works would be someone special, she would be a creation of character, but she would also be lyrical."[56] In reframing and contemporizing Sabari, Dodiya breathes new life into a character who has been bound to tradition and largely ignored by history. At the same time, he also simultaneously pays homage to a pioneering modernist, while establishing his own unique approach to modernizing Indian traditions. [SG]

Chittaprosad Bhattacharya (1915–1978)

32a
Ramayana Series (Ahalya Prior to Her Deliverance, ca. 1960s
Linocut
6 ¼ × 10 ½ in

312b
The Fate of a False Friend
ca. 1950s
Linocut
7 ¼ × 10 in

32c
Untitled (The Tragic Story of Shank Chunni), ca. 1960s
Linocut
11 ¾ × 9 in

Referencing Nandalal Bose's linocut illustrations for Rabindranath Tagore's Bengali language primer *Sahaj Path* (1930),[57] Chittaprosad took to illustrating the epics, myths, legends, folklore, as also genre scenes for children, from the 1950s onwards. During the last decade of his life, in the late 1960s and 1970s, Chittaprosad embarked on a project of producing children's books based on the Indian epics *Ramayana* and *Mahabharata*. He took on the task of both author and illustrator, composing the Bengali verses and producing the accompanying images.

In the print *Ahalya Prior to Her Deliverance*, Ahalya is extolled as the first of the "five virgins," (*panchakanya)*, archetypes of female chastity. Created by Brahma as the most beautiful woman, Ahalya was married to the much older Sage Gautama. Legend goes that Indra, the king of the Gods, appeared in the guise of Gautama and tried to seduce Ahalya. Though she saw through his guise, she accepted his advances. Gautama cursed both Indra and Ahalya, turning his wife to stone forever. While she continues to atone for her sin, invisible to the world, she finally regains her human form when brushed by Rama's foot, further purified when she offers him hospitality in the forest.

An important part of Bengali folklore, ghosts are believed to be the wandering souls of those who have either died with unfulfilled desires or under tragic circumstances. *The Tragic Story of Shank Chunni* illustrates the story of a promiscuous woman who died before she was married, her unfulfilled life's desire, to marry a rich Brahmin, shackling her to haunt the mortal world forever. *Shank chunnis* are believed to inhabit trees and ponds, which is where the artist locates this unfortunate being. Here, when the Brahmins' unsuspecting wives would bathe, the *shank chunni* would possess them and try to live out her desires through their earthly bodies. Partially veiled under her sari and, oddly enough, a pair of spectacles, the *shank chunni*'s emaciated body and gaunt eyes are reflected in the crow hovering above the water—the crow being a harbinger of death and decay in Bengal.

In both *Ahalya Prior to Her Deliverance* and *The Tragic Story of Shank Chunni*, the artist's empathy with these condemned women is worthy of note. Both protagonists chosen by Chittaprosad were driven to doom by the desires of the flesh. However, referencing his many celebratory prints of lovers and nudes, desires of the flesh were clearly not considered condemnable by the artist.

32a | *Ramayana Series (Ahalya Prior to Her Deliverance)*

The Fate of a False Friend is the story of Prince Siddhartha (of Kapilavastu, in Nepal), his cousin Devadatta, and the swan. Devadatta was the gentle Siddhartha's sworn enemy, never wasting an opportunity to pick a fight with him. One spring morning, while Siddhartha was admiring a group of swans swimming in the river, Devadatta's arrow came whizzing through the air, injuring the biggest and most beautiful swan in the group. The distressed Siddhartha retrieved the injured swan, repaired its broken wing, and nursed it. However, Devadatta laid claim to the swan since he had shot it. Unwilling to relinquish the swan, Siddhartha and Devadatta took the swan to their guru, Alara Kalama, for a resolution to the dispute. The guru ruled that the swan belonged to Siddhartha, as a living being can only belong to the one who loves and cares for it, and not to the one who hurts it. Prince Siddhartha later went on to become Gautama Buddha. [PS]

32b | *The Fate of a False Friend*

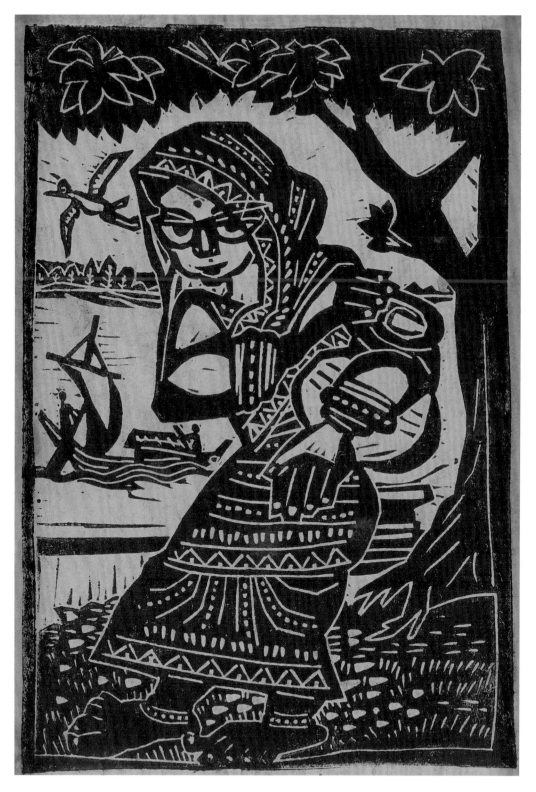

32c | *Untitled (The Tragic Story of Shank Chunni)*

Portraits/Personas

Jogen Chowdhury (b.1939)

33a
Untitled (Head), 1977
Pastel and ink on paper
15 × 14 ⅞ in

33b
Man with Piece of Paper, 1986
Pastel and ink on paper
15 × 11 in

Born in a small village in present-day Bangladesh, Jogen Chowdhury's family relocated to a refugee camp in Calcutta (now Kolkata) in 1947 following the Partition of Bengal. After graduating from the Government College of Art and Craft in 1960, he began work as a teacher in a secondary school in Howrah Zilla. A gifted writer and poet, as well as a visual artist, he spent his free time painting and organizing a literary and cultural group that published its first journal in 1961. In 1967, he went to Paris and studied at the École nationale supérieure des Beaux-Arts in Paris and in Stanley William Hayter's Atelier 17. When he returned to India, in 1968, he relocated to Madras (now Chennai) to work as a textile designer in the Handloom Board, where he remained until 1972, when he shifted to Delhi to take on the position of curator of the art collection at Rashtrapati Bhavan. In 1987, he returned permanently to West Bengal to take on the post of professor of painting at Kala Bhavana in Santiniketan.

Deliberately individual in his approach to art making, Chowdhury defied shifting artistic trends towards abstraction in the 1960s and 1970 to hone and perfect instead a unique vocabulary for figural representation. In a recent interview with Nawaid Anjum, he noted, "I believe that abstraction exists also in 'real' forms, in the human figures or any other object."[58] A close observer of people, he was drawn particularly to the facial expressions and bodily gestures associated with elevated emotive states of joy and agony, which he captured through his mastery of texture and emotionally charged line, and also through the intentional distortion of heads and bodies. He has described these intentionally distorted figures as metaphors for the social and economic imbalances that have characterized Indian society since Independence. The gaze of Chowdhury's frequently introverted figures is often focused inward, at an angle, or away from the viewer. He is best known for his portrayals of single figures, closely cropped within the composition, and set against a dark and seemingly empty background that focuses the viewer's attention on the main subject, while also eliding a specificity of place.

The two works in the Gaur Collection are outstanding examples of Chowdhury's technical prowess and discerning eye. *Man with Piece of Paper* features exactly that: a middle-aged man, likely an intellectual, with a receding hairline, stares off into the distance, while holding a sheet of paper closely against his chest in an elongated, almost Mannerist, hand. His head is tilted upward and his eyes are slightly crossed, as if his thoughts were turned inward in a state of deep contemplation, an impression that is reinforced also through his furrowed brow and the taut contours of his face. His state of dishevelment suggests that he remains oblivious to the world around him: half of his shirt buttons have come undone, and his collar crookedly frames his neck. The subject of his contemplation remains unknown, as the paper that he grasps is elusively blank.

The untitled work from 1977 portrays a man in profile, with an almost impossibly large and lumpy head resting upon strangely misshapen shoulders. The figure is stripped of any identifying markers save a pair of thin wire spectacles tucked behind a disproportionately tiny ear. Like the paper in the 1986 work, the spectacles suggest that the man being represented is an intellectual. Here, Chowdhury's mastery of the line is evident in both the delicate definition of key facial features: the eyes, the nostrils, the ear, the chin and the upper lip, as well as in the use of dense cross-hatching to

33a | *Untitled (Head)*

33b | *Man with Piece of Paper*

create the texture of the skin, giving the surfaces an almost textile-like quality. In both works, the mixture of pastel and ink gives a painterly character to the drawings, while the contrast of light skin against the deep blackness of the background evokes the idea of portrait photography. And indeed, despite the distorted forms—or perhaps because of the distortion—there is something starkly real about these figures, as if Chowdhury, through an act of imagination, has conjured an inner truth that emerges from beneath the outer skin. [TS]

Krishna Hawlaji Ara (1914–1985)

34a
Seated Female Nude, ca. 1960s
Gouache on paper
29 × 22 in

34b
Untitled (Woman with Birdcage), ca. 1960s
Watercolor on paper
26 ½ × 21 ½ in

Born outside of Hyderabad into an impoverished family of domestic servants, Ara was orphaned at the age of ten. After discovering a love for painting, he set off for Bombay (now Mumbai), where he was discovered by Rudolph von Leyden and Walter Langhammer, who helped him enroll at the Sir J. J. School of Art, where he fell in with a group of students and joined with them to found the Progressive Artists' Group. K. H. Ara's artistic career began with landscapes, still life paintings, and works that were centered on socio-historical themes. Ara is considered to be one of the earliest, and perhaps the first, contemporary Indian painters who focused on the female nude, often placing her in classical postures.

In *Untitled (Woman with Birdcage)*, Ara depicts a moment from the Sanskrit collection of stories known as the *Śukasaptati* (Seventy Tales of the Parrot). The title of the painting references stories narrated by a parrot to his owner. The primary story follows a merchant and his wife. While the merchant is away, the parrot narrates several engaging and dramatic stories as a way to keep her occupied and dissuade her from committing any adulterous acts while her husband is away. The painting also points to how parrots, in the works of Indian fiction, are often incorporated as storytellers and teachers. Pressing her fingers to her chin, the nude demurely covers her lower body in a gesture like that of the Venus de Milo and glances back at her caged parrot, which is fraught with symbolism. Far from being overtly sexual or vulgar, Ara's women have an air of sensuality and seem comfortable with their nudity. Taking cues from Paul Cézanne and Henri Matisse, Ara juxtaposed their classic poses by using intense color, abstraction, and spontaneity, evident in his gestural strokes. Ara's vibrant blues, reds, and purples echo the colors used in the Persian miniatures that illustrate scenes from the *Tutinama*, the Persian translation of the earlier Sanskrit text. Rarely facing the viewer, the women in Ara's paintings are usually occupied with their own worlds and stories, much like the woman from "Seventy Tales of the Parrot." [SG]

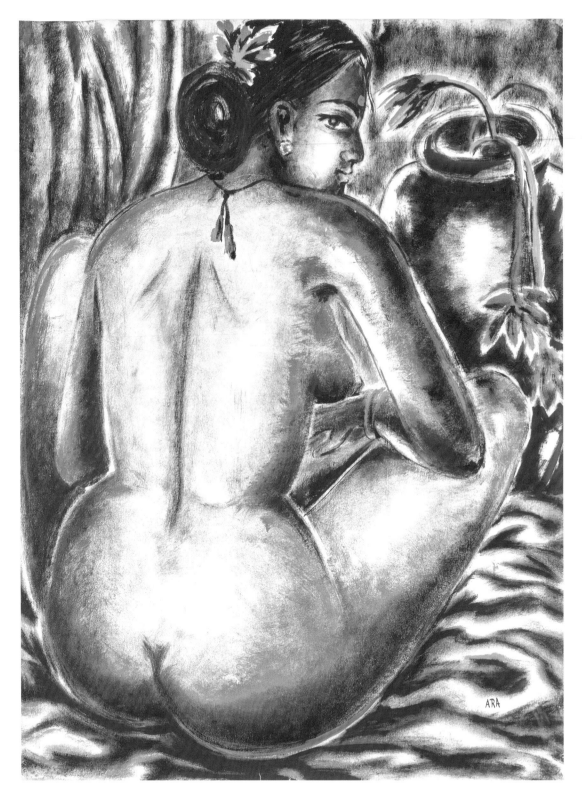

34a | *Seated Female Nude*

34b | *Untitled (Woman with Birdcage)*

K. Laxma Goud (b. 1940)

35a	35b	35c	35d
Untitled (Two Women)	*Untitled (Green face)*	*Untitled (Woman torso)*	*Untitled (Woman with goat)*
1988	2000	2000	2004
Watercolor and	Etching	Etching	Etching
pencil on paper	12 1/4 × 10 1/2 in	13 × 9 1/4 in	10 7/8 × 7 1/4 in
14 1/2 × 21 in			

In the 1980s, Goud began producing close studies of working-class women and village laborers. These represent what Susan Bean has described as the "elemental ordinariness and the deep humanity of people like the villagers of his childhood."[59] Unlike his earlier erotic vignettes, these appear almost as intimate portraits, focused on the figures themselves with only minimal occasional reference to setting or landscape. In these, we see Goud's passion for color, which became an important aspect of his work absent from his earlier etchings and drawings. We also encounter a shift from painstaking realism to more playful abstraction and elements of expressionism, befitting the more deeply emotive character of these works.

The 1988 watercolor features two village women dressed in colorful saris comprised of a patchwork of bold patterns. Their thickly braided hair, multiple piercings and rustic jewelry reinforces their rural origin, while their roughly textured and darkened skin suggests a life of labor, toiling outdoors, possibly in fields, under the rays of a relentless sun. Although their bodies fuse together, their faces are carefully individualized, and they hold their heads up high with distinct pride. The sharp contrast between the rich orange background and the comparatively muted tones of their skin and clothing heightens both the intensity of the figures and the depth of their connection.

The three untitled etchings from the early 2000s are even more abstracted in their rendering of the human form. All three depict village women with great intimacy but also significant variation. The two etchings from 2000 depict only the face and upper torso. In one, set against a green backdrop, we are confronted by a woman with oversized eyes staring straight ahead, her mouth partly open, revealing a set of slightly crooked teeth. Her multiple earrings and nasal piercings mark her origin as tribal, and her oversized *bindi* and carefully parted hair suggest that she is married. Although the work has the quality of a portrait, the presence on the far right of a vertical ornamental band, strongly resembling scroll paintings from rural Andhra Pradesh, suggests that we are looking at an image of a tribal woman rendered according to the conventions of folk traditions. The second etching from 2000 portrays a very different kind of woman, one who takes on the appearance of a lover or courtesan. Her thick hair falls loosely around her head, framing a heavily abstracted face depicted in profile, while her gaze appears pensive, as if scrutinizing a figure in the distance. Her clothing thickly covers her shoulder and neck but notably leaves her breasts bare. By contrast, the 2004 etching, set against a brown background, provides a close-cropped but full-bodied view of a woman, accompanied by a goat and seated in a rustic landscape minimally represented by an outcropping of a bush. She is barefoot but proud. She faces frontally, staring directly at the viewer with an open and almost inquisitive stare. Her oversize *bindi* and the hint of colored powder (*sindoor*) along the crack of her hairline imply that she is married.

Although not explicitly erotic, all four of these works possess an unbridled intimacy in the cropping and attentiveness to details, and also a sensuality in the treatment of the figures. In some cases, Goud has carefully depicted the crack of the

35a | *Untitled (Two Women)*

35b | *Untitled (Green face)*

188

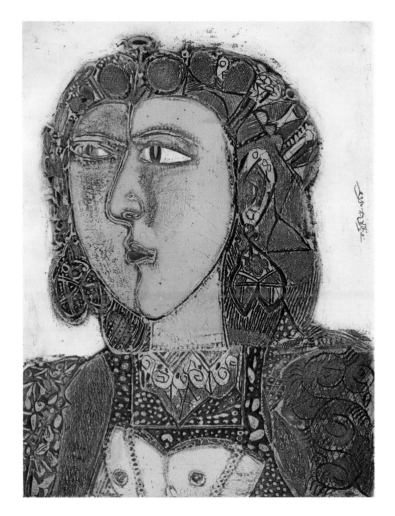

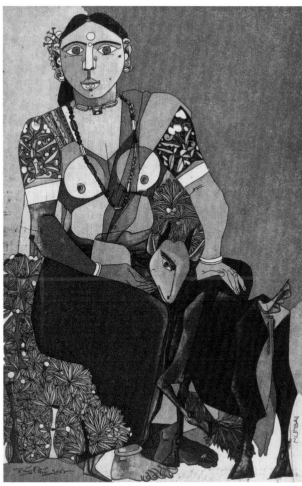

35c | *Untitled (Woman torso)*

35d | *Untitled (Woman with goat)*

cleavage and the suppleness of full breasts and nipples. Even the 2004 etching of the married woman reveals a subtle lasciviousness in the sly gaze of the goat, whose vulva-shaped head is positioned suggestively between her legs. There is a way in which this phase of Goud's practice productively repositions Indian modernism. Goud draws from the eroticized abstract nudes of artists such as Picasso. However, his figures are not stereotyped images of primitive people drawn from distant colonized spaces,

but rather carefully observed and deeply humanizing portrayals of women he knew intimately in life. As Geeta Kapur has argued, the forms of "everyday narration" seen in Goud's work represent a "locational ideology" seen more broadly among modern South Asian artists, through which the employment of "indigenist genres" and "located knowledge" produced "necessary chinks in the armour of [canonical Western] modernism."[60] [TS]

Ved Nayar (b. 1933)

36a
Untitled (Man), 1989
Mixed media on paper
11 ½ × 9 ½ in

36b
Untitled (Woman), 1989
Mixed media on paper
11 ½ × 9 ½ in

36c
Untitled, 2004
Mixed media on paper
29 ½ × 22 in

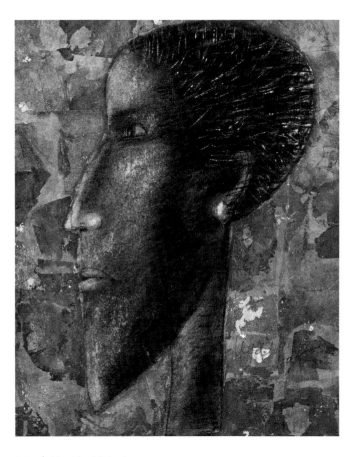

36a | *Untitled (Man)*

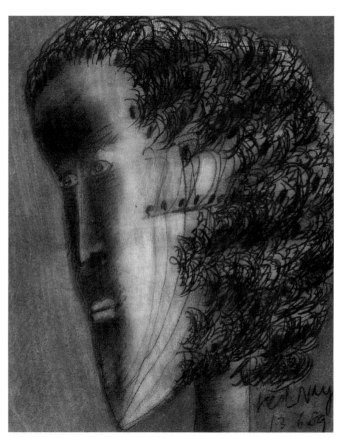

36b | *Untitled (Woman)*

It says much about the pre-liberalization art scene in India that an artist of the caliber of Ved Nayar had to seek employment in the state-run Trade Fair Authority of India (now renamed India Trade Promotion Organization), designing exhibition booths for pavilions at its grounds in New Delhi, as well as overseas. But what might have become a chore for anybody else became a source of inspiration for Nayar, whose international exposure and interactions with people led to the sort of portraits that form part of the Gaur Collection. Nayar has always been a trenchant critic of what he considers the gallery system and opted to stay away from media glare, preferring to draw, paint and sculpt in the privacy of his own studio. A graduate of the prestigious St. Stephen's College in New Delhi, he obtained a diploma from the College of Art in 1957 before settling down to a career in art that he has shared with his artist-wife, Gogi Saroj Pal.

Nayar's early works were expressionistic, and he wielded his brush almost calligraphically, drawn to the power of black. He also enjoyed experimenting with sculpture and received the national award from the Lalit Kala Akademi in 1981 for his work *Mankind 2101*. He would go on to make further iterations of his *Mankind* series that would be acquired by Fukuoka Masanori for his museum in Glenbarra, Japan.

Over time, Nayar found himself drawn to the figurative, and by the 1980s he was becoming proficient in picking out faces from among crowds to render on paper like glimpsed images. His cosmopolitan choice may have had much to do with his work as an exhibition designer. By 1989, when both *Untitled* portraits in this selection were made, Nayar was confident enough to exhibit a selection of self-portraits executed in similar vein in New Delhi. Both portraits represent a trope that Nayar would go on to master—the elongated face and form that came to represent his distinctive style. They have a sculptural quality in the way he extends the face to exaggerate the angularities while softening the surface of the skin to reveal their inner tension. His preference for the anonymous over the celebrity was in keeping with his subaltern attitude towards the making of art.

The third inclusion here was completed 15 years later and represents Nayar's response to the effects of rapid globalization and increasing commercialization of the 1990s. The liberalization of India's economy in 1991 released a slew of reforms, which fed into a culture of consumption that appalled the artist. His extenuated figures, usually female, came to represent the perils of a consumer-driven society shaped by a hyper media. The economic compulsions also heralded environmental concerns and waste, both of which the artist thought to flag. The central figure here shows the twined limbs of what appears to be a tree, its branches shorn of leaves, before the visible feet at the bottom reveal

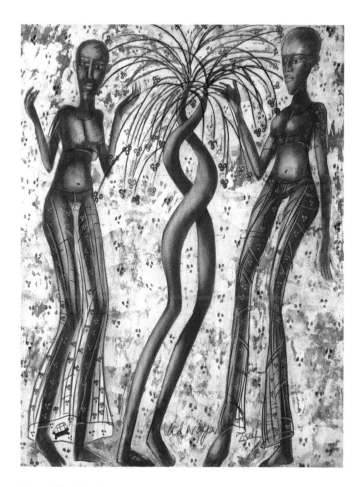

36c | *Untitled*

the exploitative relationship between nature and human beings. The figures on the side in this 2004 work come to represent the universally desirable global icon that has no connection with the cultures from which they emerge, aliens as much to themselves as to the world they hope to serve. They represent, somewhat totemically, the replacement of the ritual worship of the holy basil plant (*tulsi*), in Indian households with the worship of lucre. Nayar's scathing indictment of a society undergoing change has since been one of the most critical diatribes by any artist in India on a continuing basis. [KS]

Francis Newton Souza (1924–2002)

37
Bombay Beggars, 1944
Watercolor on paper
22 × 15 in

A rebel and an iconoclast, Francis Newton Souza had the kind of charisma that both attracted and repelled those around him, and a way with words as well as the paintbrush, both of which he wielded like a scimitar. Born in Portuguese Goa, where he spent his early years, he was raised in British India's Bombay (now Mumbai). He was scarred by the loss of his father while an infant; by smallpox as a teenager; and by his rustication from Sir J. J. School of Art in his final year for having dared to join the Communist Party of India. He had famously also been thrown out of St Xavier's School earlier on the charge of drawing obscene paintings in the lavatory—which he denied for their lack of quality.

His run-ins with the hidebound Bombay Art Society, with its strict criterion of rules and regulations, was the reason that he felt the need for a more dynamic and progressive art platform. The Progressive Artists' Group was borne of that idea, co-founded by him along with five other artists (and, later, seven associates); Souza's manifesto was an excoriating document that indicted what passed for "modern" at the time. An exhibition in which a nude self-portrait was exhibited won him opprobrium, and the continuing moral outrage was one of the reasons he chose to leave Bombay in 1949, settling in London where, after a period of initial struggle, his talent won him tremendous success. His departure, in 1967, for New York, for reasons more personal than professional, failed to further advance his career.

Bombay Beggars was painted while Souza was still an art student and likely the result of his then Marxist ideology that drew his painterly attention to the condition of the poor in the city. One of the pioneers of subaltern modernism in India, Souza's figurative muse in those formative years were the city's poor and disenfranchised. During those formative years of his career, the marginalized often formed the subject of his paintings and consisted of family groups located within the milieu of their woebegone homes. His palette tended to the somber to reflect the hardworking bronzed skins and hardened features.

Bombay Beggars stands out because the figures are shown outdoors, a space they were more likely to be found than in any tenements. The group is shown unclothed—possibly the first among such paintings in which he dispensed with the need for apparel altogether. His later paintings would feature nudes as well as landscapes but in circumstances vastly different from this. Note must also be made of the signature. Souza was then known by his middle name Newton and signed his paintings as such; the Souza attestation here points to the signature being added to the painting at a later date. [KS]

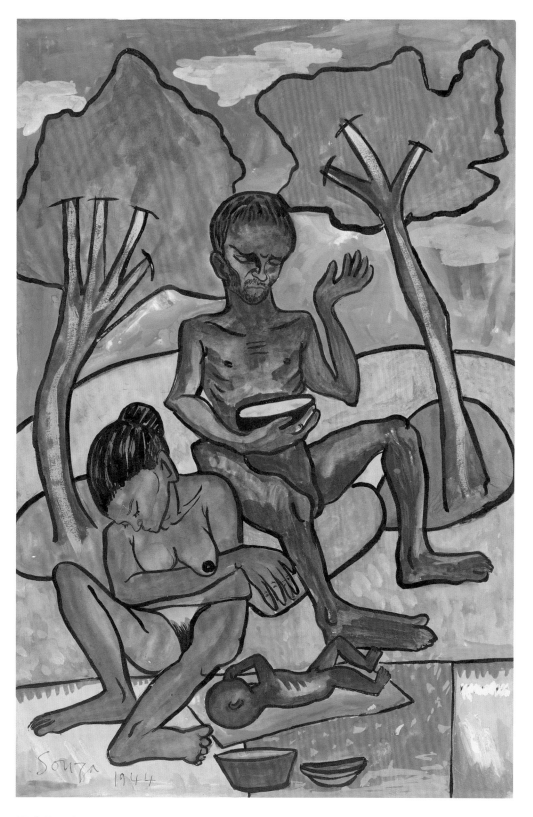

37 | *Bombay Beggars*

Francis Newton Souza

38
Savoir-faire, 1968
Etching
20 ½ × 12 ¼ in

If there is a fine line between art and pornography, F. N. Souza was unmindful of it. His female nudes were almost always voluptuous, his male nudes often in a state of arousal, and he navigated their relationships as a natural consequence of both lust and power. His lovers were often confrontational, rarely (as here) tender, almost never romantic. One could never quite escape the feeling that Souza was trying to expunge Catholic guilt and arrive at a point of catharsis through depictions of carnality.

This is a very fine example of an etching that is so well executed that it resembles, at first sight, a drawing. The physical bodies are extremely well delineated, with the male nude detailed to a degree that was rare in his works. Aspects of light and shading accentuate this further. The distorted faces above the handsome torsos of his protagonists highlight the sharp difference between the two, but what is the more remarkable is the palm and fingers of his male figure that, reaching across in an attempt to caress the female genitals, serve as an example of a tool of both pain and pleasure. Taken in its entirety, the etching emphasizes physical companionship at a time when Souza's own personal life was at a low ebb in New York, where he had migrated the previous year from London.

Souza had hoped for success in New York, but the city proved to be a disappointment for his career. The art scene in the US had become firmly rooted in the abstract; European art had had its day and was no longer as eagerly sought. Unable to return to London on account of a complicated personal life, Souza set about painting with a savagery that seemed to resemble an attack on his subjects. Earlier, his distortion was engaging; now, it seemed to rise from a contempt of all that he saw around him, people included. His art became more confrontational; violence became a feature that his protagonists seemed almost to expect. Anger seeped through his work like ugly blisters.

Savoir-faire, then, is likely among his last works in which the lovers do not appear antagonistic. The embracing couple has a proximity that is more than merely physical. The moment of lovemaking nigh, there is a suggestion of ease and comfort with their bodies. This is about as joyful a celebration of youth as has been depicted through the ages in cultures around the world. Souza was not to know it at the time but this beautifully executed etching would become his requiem to love's labors lost in his own increasingly toxic environment. [KS]

38 | *Savoir-faire* [opposite]

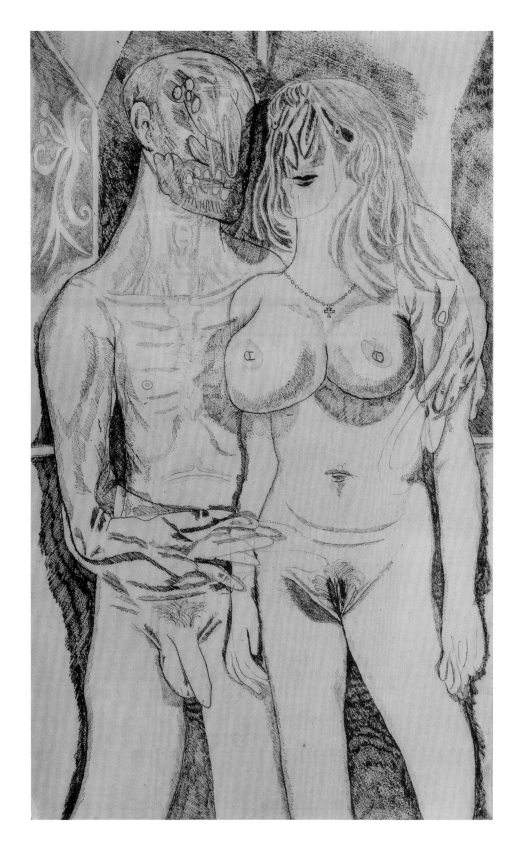

Francis Newton Souza

39a
Untitled (Head)
1951
Pen ink on paper
9 × 8 in

39b
Untitled (Colored Head), ca. 1956
Pen ink and watercolor on paper
10 × 7 ½ in

39c
Untitled (Head)
1959
Lithograph
18 ½ × 13 ¼ in

39d
Untitled (Head), 1989
Oil and watercolor on paper
28 × 21 in

While much has been made in recent times of F. N. Souza's Nudes, in terms of what they owe to the sculptural tradition of medieval India, his head portraits are distinctive for the manner in which the artist has driven their morphology independent of any previous reference. The Gaur Collection includes works on canvas and paper from the series that range across different periods and geographies.

The earliest 1951 *Head* in the collection is the smallest. It is also prescient of the direction Souza was to take in the years ahead as he pursued a painterly career that freely borrowed and discarded from the West, while retaining and nurturing an essence that he would distill in his practice. The fine lines in the drawing are indicative of the cross-hatching that would find its way into his head portraits just round the corner; the cubism that would establish him as a master of distortion is also firmly entrenched in the facial features, with the proboscis bearing the brunt of his visual brutality.

The austere heads with the hollowed eyes and sloping cheekbones formed a trope he used when depicting businessmen—his loathing for capitalism arose from a defining, if brief, tryst with communism in India—but the pointed chin with a possible goatee he reserved for clerics and clergymen, representing an institution with which he shared a relationship of animus, almost a personal and passionate engagement defined by fury and repugnance. It was like a scab on the skin that he could not stop scratching through the six decades of his career. The resulting portraits were excoriating denunciations of its officials, which began their journey as drawings, such as this, but it was unlikely they brought with them any sense of catharsis for the artist.

Were F. N. Souza's head portraits—the many that he created over the course of his career—portraits? This is one of those questions for which there can be no clear response, since the artist distilled the personalities of different individuals within each of these works. The 1956 *Colored Head*, at first glance somewhat similar to a 1959 oil (*Man in Townscape*) in the Gaur Collection, differs at a visceral level from the latter. Towards the end of the decade, Souza's portraits had begun to bare their teeth, even if only to smile or sneer; his earlier works rarely represented his mostly male subjects with their mouths open. *Man in Townscape*, despite its background of churches, depicts a businessman as evidenced in his working clothes of tie, jacket and pocket handkerchief. In the 1956 *Head*, the background is plain, but the round collar (or absence of a structured collar) seems to point at

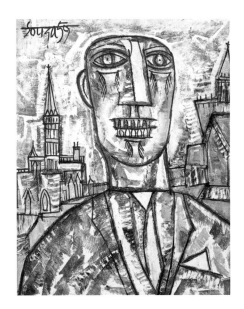

Francis Newton Souza, *Man in Townscape*, 1959
Oil on board, 30 × 24 in

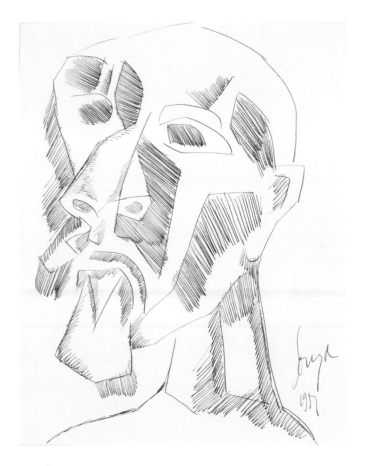

39a | *Untitled (Head)*

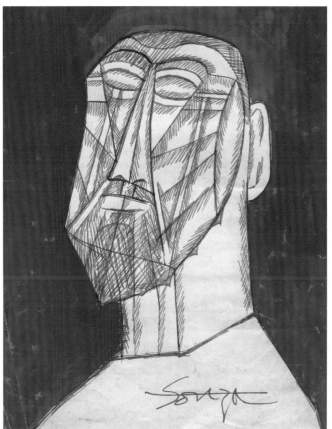

39b | *Untitled (Colored Head)*

vestments associated with the clergy. The distinctive cross-hatching has evolved from the 1951 *Head* in the collection to a level of sophistication that Souza would henceforth sustain. This was best achieved in his paper works, however, using a pen to get the fine lines that attested to his drafting skills. The crisscrossing across the face, which breaks it up into segments, is a masterclass in cubist diagramming.

There has been considerably little by way of research or conversation around F. N. Souza's printmaking skills on account, perhaps, of his prolific output of drawings. Souza, in London, was known to have created a number of lithography prints and these reveal his nuanced lines and brushwork with which he created plates that impacted his printmaking process. Souza's lithographs are always well

inked, with a sharpness of contrast that sets them apart from his drawings.

The 1959 *Head* lithograph is quintessentially Souza at the top of his game, even though the depiction of clergy—as evident from the robe worn by the priest—was similar in style to some of his own paintings, as well as those painted by Akbar Padamsee around the same time. It also recalls *Red Jumper*, a 1958 oil from the Gaur Collection, in which a figure, somewhat similar, is clad in a tunic or jumper composed of motifs implying the yuletide season. Souza's constant reference to the church in his paintings of head portraits was hardly unusual given his Catholic upbringing and his mother's hope that he might join the church. Souza seemed simultaneously attracted to as well as repulsed by the power

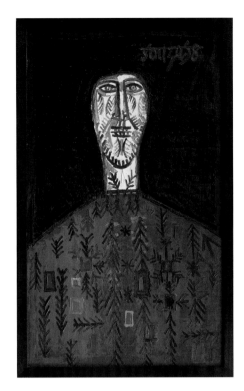

Francis Newton Souza, *Red Jumper*, 1958
Oil on board, 40 × 24 in

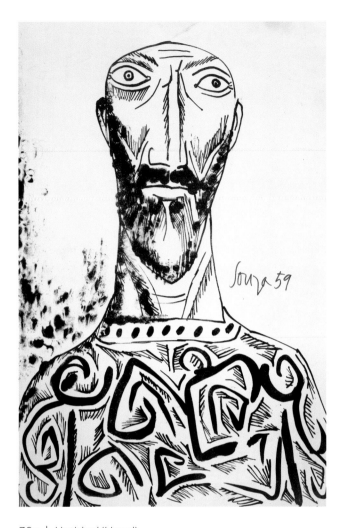

39c | *Untitled (Head)*

wielded by the church, and this found an echo in his work where it occupied a place as important as the "city," as represented by its financial institutions. A brief stint with the Communist Party of India was enough to turn the artist into a savage critic of capitalism.

The *enfant terrible* of Indian modernism, F. N. Souza's fascination with the physiognomy of the human face did not fade over time. His experimentation from the 1950s continued throughout his life, careening from extreme cubism to excessive distortion. It mattered little where the facial elements in his paintings were placed, or whether their numbers were multiplied; all that mattered to him was that, taken collectively, they alluded to a face as intended by an Indian modernist, who made the global firmament his platform for an extraordinary visual representation. His control over his medium and technique allowed him the freedom to experiment with a confidence that was liberating for the artist.

The 1989 *Head* is an example of extreme alteration in which multiple eyes (a spectacled face?), forged high across the forehead, bear down over twin protuberances representing the two nostrils, in a skull-like face slashed diagonally to represent the planes of the cheekbones. Souza's brushstrokes showed every evidence of a virile, powerful, even aggressive, spontaneity, yet were mindful of a deliberate determination of placement of lines and colors. Three decades and more separate this experimental oil and watercolor painting from other head portraits in the Gaur Collection and show the distance the artist had traveled in the interregnum, in a practice in which never once did his output or his ability to surprise flag even a little. [KS]

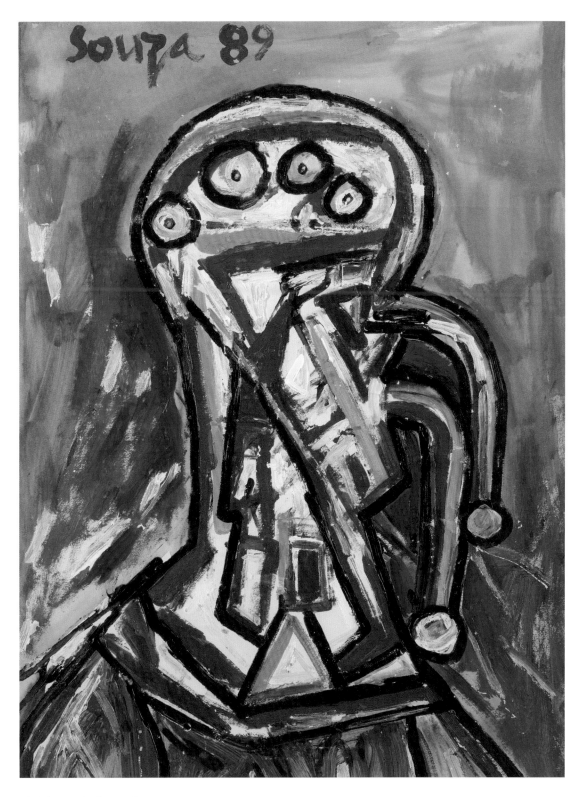

39d | *Untitled (Head)*

Paritosh Sen (1918–2008)

40
Untitled (Woman with Fruit), 2004
Pencil and watercolor on paper
40 × 30 ¼ in

Born nearly three decades before Independence in pre-Partition Dacca (now Dhaka), currently the capital of Bangladesh, Paritosh Sen's earliest works drew inspiration from the Bengal school artists, and, particularly, their commitment to developing new forms of art through engagement with tradition. After finishing school, he ran away from home to study Fine Arts at the Government College of Arts and Crafts in Madras (now Chennai), where he trained under Devi Prasad Roy Chowdhury, in the company of artists such as K. C. S. Paniker. After teaching for a few years at Daly College in Indore, he moved to Calcutta (now Kolkata), where he co-founded the Calcutta Group (1943–1953), a short-lived but highly influential artistic movement that spanned the crucial transition from colonial state to independent nation. In 1949, Paritosh Sen left for Paris, where he studied with André Lhote at the Academie Grand Chaumier, École des Beaux-Arts. In 1953, while in Paris, he spent four fateful hours with Picasso, whose advice—to "be careful about form"—served as a guiding principle in subsequent years.[61]

Sen's style of painting varied significantly over the course of his life, but certain subjects were recurrent in his exploration of form. One such were female figures, often occupying generalized domestic spaces. Often voluptuously rendered, they are never quite beautiful; rather, they tend to be weighty and strong, with slightly crooked faces and uncommon features. These works were not merely about producing images of women—or, as he put it, "a composition of breasts, hips, and buttocks."[62] Rather, they exemplify his ongoing commitment to exploring geometric artistic forms, and, more specifically, to probing the relationship between straight lines and curves through the contours of the female body.

Yakshis from Bharhut

We can see this exploration on display in the painting in the Gaur Collection, which depicts a middle-aged Bengali woman holding a platter of fruit and a bundle of fresh fish. Her body is defined by bold curving strokes and loosely angular lines, representing the outline of her body and the simple trim of her sari, which drapes downward across her hips and circles loosely upward over her parted hair. She appears to have just returned from the market, having just walked through the entrance to her home. In many ways, this work also exemplifies Sen's remarkable ability to marry his explorations of form with a desire to capture the poignancy of everyday moments. In speaking about an early work depicting a girl watering a holy basil (*tulsi*) plant, he noted, "That was the scene I used to see every morning—I used to sleep on the terrace and right in front of me, there was this courtyard, and there was this young girl watering the plant every morning. I liked the view so much—it had a lot of geometry, the lines of the square, and this bird's-eye view made it even more interesting."[63]

40 | *Untitled (Woman with Fruit)*

The work can also be seen as a meditation on the relationship between modernity and tradition, an interest that dates back to Sen's early fascination with Santiniketan artists. Although her gaze is directed downward, the protagonist in this work appears confident and dignified, a modern woman of the city rather than of the village, her urbanity signaled, in part, by the watch worn prominently on her left wrist. At the same time, her posture draws from the visual vocabulary of ancient India, exemplified by the many female spirits (*yakshis*), from Bharhut on display at the Indian Museum in Calcutta (now Kolkata), who are often depicted grasping a vine or tree, causing it to flower into fruit. Like Sen's Bengali woman, their bodies are structured similarly as an exploration of geometric counterpoints between curves and lines, with a distinct emphasis on the volume of hips and breasts. And, like these ancient auspicious matrons of fertility, Sen's Bengali woman is depicted with one arm reaching upward and the other pointed downward, each bearing a staple comestible, standing in perhaps as emblems of fecundity, prosperity, and efflorescence. [TS]

Haren Das (1921–1993)

41a
Dressing Time, 1960
Woodcut on paper
6 ¾ × 5 in

41b
Two Sisters, 1966
Etching
8 × 4 ¾ in

Haren Das was particularly fond of depicting village women engaged in routine domestic activities seen in agrarian societies in rural Bengal. These two prints represent his particular predilection for capturing intimate moments of their daily toilette. They are representative of his skill in multicolor engravings, which de-emphasize the graphic quality in order to better imitate painting.

In the multicolor wood engraving *Dressing Time*, we see a perfectly turned-out young girl in the late afternoon sun, dressing her doll in a pink sari identical to her own. In a re-enactment of her own morning routine, the girl has obviously bathed her doll with the bar of soap seen in the foreground, and wiped her dry with the white towel (*gamchha*) lying discarded on the floor. Now she is engrossed in dressing her, before returning her to the box, to the girl's right, in which the doll probably rests.

Two Sisters is a charming color aquatint of two women stopping by the wayside to pluck orange blossoms from a flowering bush while returning from fetching water. While one sister balances her pitcher of water on her hip, the other puts it down to tuck a flower into her sister's hair. Here the coiffure signals the women belong to the Santhal tribal community, in which the practice of wearing flowers, tucked neatly into hair tied into a bun, is common. The artist positions himself to the rear of his models, so as to display their bare torsos, smooth, dark skins, and the hint of a breast to maximum advantage—a precedent that had already been set by the highly successful and hugely popular painter Hemen Majumdar. However, Haren probably sought to charm rather than titillate. [PS]

41a | *Dressing Time*

41b | *Two Sisters*

Abstraction

Ram Kumar (1924–2018)

42a
Untitled, 1982
Acrylic on paper
22 × 29 in

42b
Untitled, 1986
Acrylic on paper
11 × 16 in

42c
Untitled, 1986
Acrylic on paper
11 × 16 in

Between 1949 and 1952 Ram Kumar studied in Paris with André Lhote, of the first generation of "Salon" Cubists, and with Fernand Léger. Like Léger, Ram Kumar joined the Communist Party of France, which supported the cause of the liberation of Europe's colonies. In Paris, Ram Kumar, who also wrote novels and short stories, befriended the writer Louis Aragon, likewise a member of the Communist Party, and one of the founders of Surrealism, who had by the time Ram Kumar met him turned away from that movement and embraced Socialist Realism. Perhaps it was under the influence of Aragon that, in the early 1950s, Ram Kumar painted works like *Unemployed Graduates* (1953), which depicts four young South Asian men, in suits and ties, idle and disconsolate. Ram Kumar modeled his alienated figures starkly, in the fashion of French Socialist Realists, especially André Fougeron, another leftist. But, after 1953, the discipline exerted by the Party on painters to work in a narrow Socialist Realist style loosened, and Ram Kumar shifted permanently away from figure groups towards cityscapes, influenced by his visits to Greece, Venice, and, most importantly, the sacred city of Varanasi in 1960. Varanasi (or Benares), on the banks of the Ganges, is where Hindus prefer to be cremated after their death, their ashes set to drift off on the holy river's currents, an act that promises salvation.

In 1970 Ram Kumar was awarded a John D. Rockefeller III scholarship to spend a year in New York City. It was during this sojourn that the artist began to explore fully abstract, gestural painting. The mark-making in the three works in this exhibition demonstrate an immediate, gestural expressiveness in the manner of the New York school. The two works from 1986, each painted in acrylic on sheets of 11×16 inch paper, although fully abstract, are nonetheless reminiscent of Ram Kumar's paintings of river towns. Both have jutting tongues of watery indigo flowing laterally through them or pushing forward into the center, like the canals and embankments of Ram Kumar's riverside cityscapes. They flow between and through the passages of black strokes, the only other pigment in these austere paintings. In the earlier, larger work, from 1982, the same two colors are more completely mixed together. All three works reveal something of the underlying structure of Ram Kumar's cityscapes: a quilt of knife strokes in blocks and patches, mingling the grimy blacks and grays of urban housing blocks along narrow alleys and the murky blues of city waterways. Significantly though, they lack the outlines of doorways, balconies, windows, and gabled rooftops that are the sign of cityscapes in his earlier work. There is no rectilinearity, only fluidity. These abstract paintings are, simply, awash.

And yet the fluidly spontaneous structure of these works is not simply the product of happenstance. Ram Kumar routinely produced, as part of his practice, abstract line drawings in which improvised but carefully controlled parallel and cross-hatched lines define faceted, canted and overlapping planes, and the shallow spaces underlying them. These three paintings on paper relate to those line drawings but replace the intersecting blocks of cross-hatching with individual strokes of the palette knife. Yet they also loosen the density of the drawings. Compared with the other abstract works in this exhibition, by Kapoor,

42a | *Untitled*

Reddy, and Kolte, these three pictures stand out for their spare simplicity, eschewing the complexities of process and careful compositional balance of those others. Interestingly, this unbinding of process contrasts quite a bit with Ram Kumar's own cityscapes (such as *Townscape*, in the present exhibition), which insistently explored the tension between a picturesque, irregular built environment and the plumb and level lines of the picture's edges. The poet Ranjit Hoskote has suggested that, late in his career, Ram Kumar, in keeping with the Hindu teaching of the individual's changing priorities through life's different stages, or ashramas—the progression from householder to hermit to, finally, ascetic—"turned from the cacophony of civil life to meditate on the ceremonials of decay and dissolution ... he stands upon that threshold where the anguish of the self is sublimated into the universal rhythm of creation and destruction." In these three paintings the artist seems to turn his back on the windows, doors, and façades of the city and, from the vantage point of the steps leading down into the sacred, swirling waters of the Ganges, gaze into its endless flow as it swirls the ashes of this mortal existence away in its eddies, downstream towards eternity. [MM]

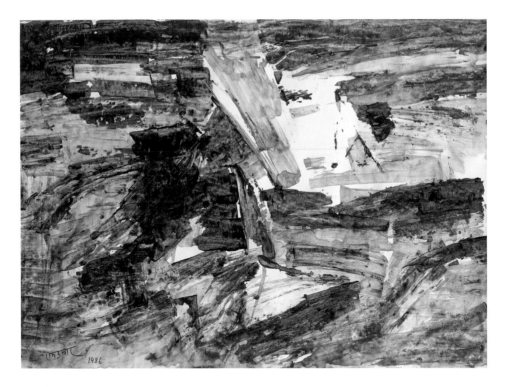

42b | *Untitled*

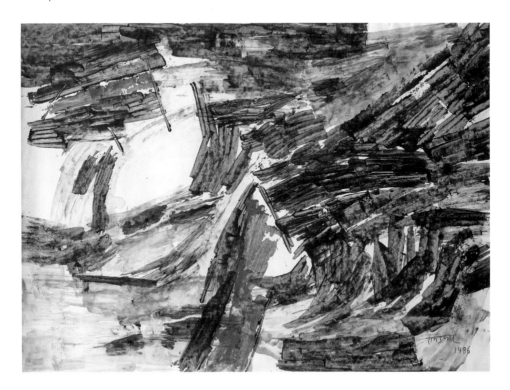

42c | *Untitled*

208

Anish Kapoor (b. 1954)

43a
Untitled, 1989
Etching with aquatint
on woven paper
30 ¼ × 27 in

43b
Untitled, 1989
Etching with aquatint
on woven paper
30 ¼ × 27 in

43c
Untitled (number 1),
from *12 Etchings series*
2007
Etching, 20 ½ × 26 in

43d
Untitled (number 9),
from *12 Etchings series*
2007
Etching, 20 ½ × 26 in

Anish Kapoor is best-known in the US for his large-scale public sculpture, *Cloud Gate* (2004–06), aka "The Bean," situated in Chicago's Millennium Park. It is the rare example of a public work of minimalist sculpture that is both aesthetically and conceptually rigorous, and also broadly popular. The gargantuan stainless-steel bean, with its convex and concave reflective surfaces, mirrors the Chicago skyline back on itself across the lobe of its exterior and then, on its underside, pulls the image up into itself. It is simultaneously the void and the plenitude of Creation, reflecting viewers back at themselves, and connecting them to the world—not least through selfies posted to social media, a practice that emerged around the time of *Cloud Gate*'s unveiling. The sculpture functions at the largest possible scale, both physically and socially. Kapoor routinely works at this size, with installations like *Marsyas* (2002–03), which filled the ten-story tall Tate Turbine Hall, and the 100×72 meter *Leviathan* (2011). The prints in the current exhibition, on the other hand, are located at the exact opposite pole, demanding—and rewarding—individual, intimate looking. The surfaces and colors created by the small-scale handwork of etching and aquatint seem to condense out of the ethereal, swirling colors of a deep but indistinct space, coalescing into unstable, sparking, spewing shapes, suggesting quarks and organelles, capillaries, and polyps. Kapoor's explorations of the cosmos extend to both the vastest and the minutest of scales.

Kapoor was born in Mumbai to a Punjabi Hindu father and an Iraqi Jewish mother. He was educated in India as a boy, and moved to London in the early 1970s, where he has lived and worked ever since, eventually becoming a British citizen. Whereas Ram Kumar represented India at the Venice

Biennale in 1958, Kapoor represented Britain at the same venue in 1990, making him a representative of both another generation and of the South Asian diaspora. He studied art in Britain in the early 1970s and can fairly be said to have won recognition as a British artist; besides showing in the British pavilion at the Venice Biennale, he has won the Turner Prize (1991), been elected to the Royal Academy (1999), been honored as a Commander of the Order of the British Empire (2003), and, finally, given a knighthood (2013).

Although he works primarily in sculpture, Kapoor does also sometimes make prints which are tangentially related to his sculpture in only one way: their emphasis on deep, saturated color. The two prints in this exhibition, from 1989, were printed with three colors of ink, on a richly textured, woven paper and the use of aquatint to create a delicate, swirling, watercolor-like impression. The two works from 2007, which come from a portfolio of a dozen similarly conceived images, combine two colors each, but with a wider range in their color harmonies. The color palettes of delicate rose, solar yellow, and blood orange suggest a fantastic journey into subatomic and primordial realms. Kapoor's works have, throughout his career, been characterized by brilliant, saturated pigments, cobalt and vermillion, or the mercury-silver of mirrored surfaces (a British laboratory that produces the blackest pigment available, a high-tech industrial surface treatment that reflects so little light that the producer has compared it to a black hole, has somewhat controversially given Kapoor the exclusive right to use their product for artistic purposes). The colors of these prints also suggest, at a remove, the saffron and turmeric-yellow pigments of the miniature paintings produced in the courts

43a | *Untitled*

of Punjabi hill kingdoms in the 17th and 18th centuries. Those paintings depicted various Hindu deities, especially Shiva and those associated with him, and even sometimes the Hiranyagarbha, the cosmic egg that was the beginning of all things, the Svyambh (a Sanskrit word meaning "Self-Manifested," which was also the title of one of Kapoor's outsized sculptural installations, from 2007, made of richly pigmented wax). Kapoor has never made overt reference to such specifically Hindu imagery and cosmography in his work, but it seems to always be just out of sight. In 1918, the Sri Lankan art historian and curator of Asian art at the Boston Museum, Ananda Coomaraswamy, wrote an essay on the medieval bronze sculptures of Shiva as Nataraja, the Lord of Dance, in which he likened the myth of Shiva's rhythmic,

43b | *Untitled*

cyclical dance of world creation and destruction to modern particle physics, explaining that,

He [Nataraja] dances to maintain the life of the cosmos ... No artist of today, however great, could more exactly or more wisely create an image of that Energy which science must postulate behind all phenomena ... the conception *of alternations of phase extending over vast regions of space and great tracts of time.*

Perhaps in these prints of primordial energies Kapoor has, after all, surpassed the famous medieval Indian sculpture. [MM]

43c | *Untitled (number 1)*

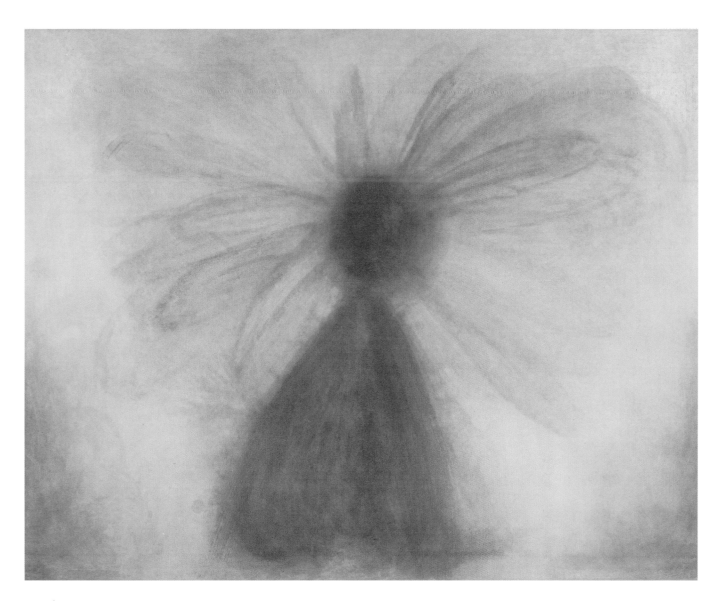

43d | *Untitled (number 9)*

Prabhakar Kolte (b. 1946)

44
Untitled, 2004
Watercolor on handmade paper
72 × 30 in

Although a watercolor, Prabhakar Kolte conceived this work on the scale of an oil painting: six feet tall and nearly a yard wide. He also painted it upright, with expressive immediacy rather than with delicate care, on a tabletop, as would be more typical of a watercolor. Rivulets of watery pigment can be seen running down at the sides. Two large, rectangular color blocks hold their own against a welter of other compositional ideas. Like the prints by Anish Kapoor in this exhibition, they share the favorite color scheme of 18th-century miniature paintings done for the Hindu courts of small states in Mewar and Basohli. The deep, rich safflower yellow of the upper, smaller rectangular field is hemmed in by overlapping layers of oily bluish gray, verdigris, and dirty shades of orange. The cooler and less saturated washes pull the background down into the depths so that the rectangle seems to float above them. In the lower register a darker, larger, heavier saffron rectangle solidly roots the composition, stabilizing the whole for now, although a yellow stain, darkening and black-flecked, spreads ominously. The top and bottom halves of the composition are separated by four even bands, turbulent as the cloud belts of Jupiter. The tension between contrasting elements resolves into an overall unity and harmony.

Kolte was born in 1946, a year before Indian independence, and studied at the Sir J. J. School of Arts in Mumbai, graduating in 1968, afterwards briefly teaching there himself. As a member of the second generation of modernists after the Progressive Artists' Group, Kolte has been practicing abstraction since his student days. His work partakes in a global re-emergence of abstract painting as a viable practice in global contemporary art. Yet he emphasizes a specifically Indian quality in his work, stating, for example, that his abstractions provide a form of *darshan*, the Hindu practice of making eye contact with the godhead in material form, suggesting that viewing his paintings provides a kind of direct visual access to the infinite.[64] In the tradition of the pioneers of abstract painting, Kolte engages in a certain introspection and interiority, imitating the *processes of* nature rather than its outward appearance, and generating his compositions by looking inward. He has written,

Nature first created and then looked. She may have improved on her own creations but never imitated anyone. I tried to do the same. Nature created with light, water, wind, earth, ether. I took dot, line, color, texture, form, and tried to create my own pictorial world. A creative source within me began to give form to formless, abstract concepts. At this point I found and developed my natural tendency to "paint and see" rather than "see and paint."[65] [MM]

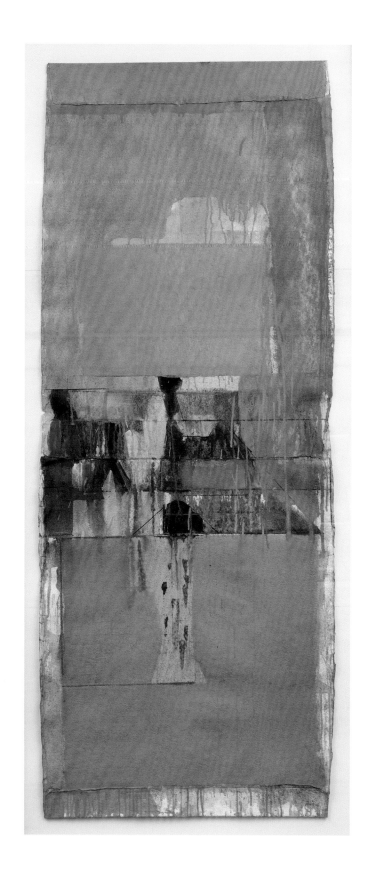

44 | *Untitled*

Krishna Reddy (1925–2018)

45a
Three Graces, 1958
Mixed color intaglio
9 ½ × 19 in

45b
Flight, 1963
Mixed color intaglio
13 × 19 in

45c
Two Forms in One, 1954
Mixed color intaglio
15 ¼ × 12 in

45d
Jellyfish, 1955
Mixed color intaglio
17 × 13 in

45e
La Vague, 1963
Mixed color intaglio
14 ½ × 18 ⅜ in

Krishna Reddy created his dazzling prints with a complexly layered and innovative printing technique, first gluing various materials to the plate, then inking over and between the networks of raised textures. Mixing different colors of ink with different quantities of linseed oil kept the colors from running together, resolving the overall abstract pattern into distinct pictorial elements, a form of simultaneous color printing that Reddy called "viscosity printing" (sometimes also called "collagraphs," from the word for glue). A master printer, Reddy had a long and influential career as a printmaking teacher in art departments across the US, retiring as head of the printmaking department at New York University in 2002.

Reddy was born in rural Andhra Pradesh in 1925. His father was a farmworker, but also made sculptures of gods for the local Hindu temple; Krishna began copying the temple's mural paintings at a young age. As a boy he attended a school founded by Krishnamurti, with a curriculum shaped by theosophy, that had a lasting influence on him. He subsequently studied at Rabindranath Tagore's innovative Kala Bhavana art school, at Santiniketan, with its goals of integrating craft design and agricultural village life, and synthesizing art, modern science, and Hindu spirituality. These early influences were very much in evidence in Reddy's own pedagogy. In his notes for a lecture titled "A New Form," from the 1950s, he wrote,

If the tree, standing on the earth, is real to our eyes and the image of the tree with all its roots, we know of, radiating like the sun's rays—from the seed to the flowers—is real, why not the whole being of the tree—the whole machinery, the cells, the molecules, the atom, and the whole structure that we have understood be revealed. To see the flame of the tree radiating like a fountain, so are nature's every form and the space itself. Like the dance of the Nataraja, space beats out a form and the form creates space.

The elemental nature imagery, the branching, root networks, and cellular patterns, began to appear in his prints around the time that he wrote these lines in the 1950s. In *Two Forms in One* and *Jellyfish* the layering of materials builds up the composition, but also scratches and etches away at it. Black ink fills the spaces between the raised tendrils of the materials glued down to the plate, which in turn print as gaps and fissures in the dense skeins of dark lines. Starbursts and red flares punctuate the disordered compositions, which refuse any formal organization, transcending human meaning and morality.

In 1949, two years after Independence, Reddy left India to study sculpture with Henry Moore at the Slade School of Fine Arts, in London, and continued on to Paris in 1951 to work with the Russian modernist sculptor Ossip Zadkine. There he discovered printmaking and studied at the influential

45a | *Three Graces*

45b | *Flight*

45c | *Two Forms in One*

45d | *Jellyfish*

45e | *La Vague*

Atelier 17 with an international group of artists, including Zarina (also in this exhibition). True to his leftist politics, he used his work to support the cause of Algerian independence, as he had supported Indian independence in his youth. It was while studying and then teaching at Atelier 17, with its radically cooperative and experimental ethos, that Reddy and the school's founder, the English artist Stanley William Hayter, together developed the method of relief and mixed-viscosity color printing.

In Paris in the 1950s, Reddy was friends with Alberto Giacometti and would have known the work of the international group around him: Jean Fautrier, Jean Dubuffet, and Wols (Otto Wolfgang Schulze). These artists engaged with the philosophy of Existentialism, which led them to emphasize the raw, formless materiality of the world, its one undeniable reality, liberated from conventional notions of compositional unity or tonal harmony, as well as from social conventions and polite manners. Like them, Reddy developed a spontaneous, gestural process that aimed at emergence, randomness, and formlessness (hence the name of the movement in French, Informel). For the rest of his career Reddy continued to emphasize direct engagement with materiality. As a teacher, he reminded his printmaking students: "It is of paramount importance for the artist to explore the materials [of printmaking] and get closer to them, rather than attempt to master them as an aloof technician." He rejected "technical invention for its own sake" in printing. Instead, he taught that a hands-on improvisation enabled authentic expression. The teaching continued,

Recognition that the image is shaped by a material process brings clarity, humility, and a sense of participation in the act of composition to the artist. … One works directly and spontaneously—like a potter feeling for his image through the clay. This journey into the deeper sources of materials should heighten our sensibilities and deepen our understanding, essential in creating a vital work of art.

In the early 1960s Reddy, still working in Paris, created images of formless movement and energy, with works like *Flight* and *La Vague* (The Wave). These prints combine the explosive marks of chance and accident with the unpredictable, dynamic motions of ocean tides and birds on the wing. *Flight*, in particular, and *Three Graces* (with the art historical reference of its title), demonstrate the use of different colors to clearly structure the print image, giving them depth and a strong sense of tactility. [MM]

Endnotes to the Catalog

1. Ranjit Hoskote, "The Poet of the Visionary Landscape," in Gagan Gill, ed. *Ram Kumar: A Journey Within* (New Delhi: Vadehra Art Gallery, 1996), 36.

2. Ibid, 41.

3. Yashodhara Dalmia, *Journeys: Four Generations of Indian Artists in Their Own Words*, 2 vols. (Oxford, New York: Oxford University Press, 2011), vol. 1, 122.

4. Yashodhara Dalmia, *Journeys: Four Generations of Indian Artists in Their Own Words*, 2 vols. (Oxford, New York: Oxford University Press, 2011), vol. 1, 48.

5. Zehra Jumabhoy and Boon Hui Tan¸ eds., *The Progressive Revolution: Modern Art for a New India* (New York: Asia Society Museum, 2018), 100–101.

6. For an example, see Yashodhara Dalmia, "The Rise of Modern Art and the Progressives," in *The Progressive Revolution: Modern Art for a New India*, Zehra Jumabhoy and Boon Hui Tan, eds., 28–39 (New York: Asia Society Museum, 2018), 33, fig. 10.

7. E. Alkazi, *M. F. Husain: The Modern Artist & Tradition* (Art Heritage: New Delhi, 1978), 17.

8. Yashodhara Dalmia, *Journeys: Four Generations of Indian Artists in Their Own Words*, 2 vols. (Oxford, New York: Oxford University Press, 2011), vol. 2, 143.

9. Sumathi Ramaswamy provides a wonderful analysis of the *Tearscape* series, as well as a summary and illustration of the 1992 panting in "The Wretched of the Nation," Third Text 31, no. 2–3 (May 4, 2017): 213–37. On the *Tearscape* series, see also Ranjit Hoskote, "Atul Dodiya: Tearscape: Recent Watercolors" (Berlin: The Fine Art Resource, 2001); Ranjit Hoskote, Enrique Juncosa, Thomas McEvilley, and Nancy Adajania, *Atul Dodiya* (New Delhi: Vadehra Art Gallery, 2013).

10. Cóilín Parsons, "Mapping the Globe: Gulam Mohammed Sheikh's Postcolonial Mappae Mundi." *English Language Notes* 52, no. 2 (2014): 189–98; p. 190.

11. See also Alfred Hiatt, "Ebstorf in Baroda: The Mappae Mundi of Gulammohammed Sheikh," in *Dislocations: Maps, Classical Tradition, and Spatial Play in the European Middle Ages*, Studies and Texts 218 (Toronto: Pontifical Institute of Medieval Studies, 2020), 262–280; Marcia Kupfer, "Worlds Enmeshed," in *At Home in the World: The Life and Art of Gulammohammed Sheikh*, ed. Chaitanya Sambrani (New Delhi: Tulika Books and Vadehra Art Gallery, 2019), 278–93; and Peter Maddock, "The Imagini Mundi of Gulammohammed Sheikh," *Third Text*, 20, no. 5 (2006), 539–553.

12. Gayatri Sinha, "Women Artists: Making a Subject Space in India," in *A Companion to Feminist Art*, Hilary Robinson, Maria Elena Buszek, and Dana Arnold, eds., (Newark: John Wiley & Sons, Incorporated, 2019), 53–68.

13. Yashodhara Dalmia, "Arpita Singh," in *Journeys: Four Generations of Indian Artists in Their Own Words*, 2 vols. (Oxford, New York: Oxford University Press, 2011), vol. 2, 72.

14. Allegra Pesenti, "Zarina: Paper Like Skin," in *Zarina: Paper Like Skin* (Los Angeles, CA: DelMonico Books-Prestel, 2012), 14.

15. Asma Naeem, "Zarina Hashmi: Refugee Camps, Temporary Homes," *Asian Diasporic Visual Cultures and the Americas* 3, no. 3 (October 4, 2017): 345–53, https://doi.org/10.1163/23523085-00303005.

16. Ibid., 346.

17. Aamir R. Mufti, "Zarina Hashmi and the Arts of Dispossession," in *The Migrant's Time: Rethinking Art History and Diaspora*, ed. Saloni Mathur (New Haven, CT: Yale University Press, 2011), 174–95.

18. Aamir R. Mufti, "Zarina's Language Question," in *Zarina: Paper Like Skin* (Los Angeles, CA: DelMonico Books-Prestel, 2012), 152.

19. Oliver Basciano, "Krishna Reddy Obituary," *The Guardian*, August 30, 2018, sec. Art and design, https://www.theguardian.com/artanddesign/2018/aug/30/krishna-reddy-obituary.

20. Ellen Smart, "The Death of Ināyat Khān by the Mughal Artist Bālchand." *Artibus Asiae* 58, 3/4 (1999): 273–79; p. 274, https://doi.org/10.2307/3250020.

21. Karin Zitzewitz, "The Moral Economy of the Street: The Bombay Paintings of Gieve Patel and Sudhir Patwardhan," *Third Text* 23, no. 2 (March 1, 2009): 151–63, https://doi.org/10.1080/09528820902840623.

22. Sudhir Patwardhan, "Three Questions: Amlanjyoti Goswami with Sudhir Patwardhan," *Urbanisation* 6, no. 2 (November 1, 2021): 172–79, https://doi.org/10.1177/24557471211047115.

23. Ranjit Hoskote, *Sudhir Patwardhan: The Complicit Observer* (Mumbai: Sakshi Gallery, Synergy Art Foundation, 2010), 36–37.

24. See for example, a poignant story about a man named Ram Lubhaiya, a doorman, whom Khanna refers to as "a wonderful man," whom he imagined as "the person who found homes and places," recounted in Yashodhara Dalmia, *Journeys: Four Generations of Indian Artists in Their Own Words*, 2 vols. (Oxford, New York: Oxford University Press, 2011), vol. 1, 75.

25. For illustrations, see Norbert Lynton, The Great Procession: *A Mural by Krishen Khanna* (Ahmedabad: Mapin, 2007), 89, 92, 109.

26. For examples, see Norbert Lynton, "The Betrayal and the Flagellation," and Ranjit Hoskote, "The Secular Miracle: On Krishen Khanna's The Raising of Lazarus," in *Krishen*

Khanna: Images in My Time (Ahmedabad: Mapin, 2007), 8–23, 52–63.

27. Nilima Sheikh, "A Post-Independence Initiative in Art," in *Contemporary Art in Baroda*, Gulam Mohammed Sheikh, ed. (New Delhi: Tulika, 1997), 53–144; p. 139.

28. Laxma Goud's personal experience with the district and his knowledge of this courtly history is related in Akshaya K. Rath, *Secret Writings of Hoshang Merchant* (New Delhi: Oxford University Press, 2016), 108, 149. See also Gayatri Reddy, *With Respect to Sex: Negotiating Hijra Identity in South India* (Chicago: University of Chicago Press, 2010), 9–10.

29. The interview was published by Geeta Doctor in *A Meeting with Laxma Goud* (Bombay: Cymroza Art Gallery, 1991), quoted here from Susan S. Bean, *The Art of K. Laxma Goud* (New Delhi: Art Alive Gallery, 2012).

30. Shukla Sawant and Subba Ghosh, "In Conversation with the Artist," in *Transgression in Print: Anupam Sud*, four decades, Geeti Sen, ed. (Palette Art Gallery, 2007), 127–149: pp. 144–145.

31. Geeti Sen, *Feminine Fables: Imaging the Indian Woman in Painting, Photography and Cinema* (Ahmedabad: Mapin Publishing, 2002), 164.

32. Paula Sengupta, "The Soul (Un)Gendered: Referencing the body as a site of power and vulnerability," in *The Soul (Un)Gendered: Anupam Sud, A Retrospective, Paula Sengupta*, ed. (New Delhi: DAG, 2020), 19–124: p. 94–95.

33. Shukla Sawant and Subba Ghosh, "In Conversation with the Artist," in *Transgression in Print: Anupam Sud, Four Decades*, Geeti Sen, ed. (Palette Art Gallery, 2007), 127–149: p. 135.

34. See Paula Sengupta, ed., *The Soul (Un) Gendered: Anupam Sud, A Retrospective* (New Delhi: DAG, 2020), 105.

35. See, for example, a terracotta column-krater, ca. 470–760 B.C.E., in the collection of the Metropolitan Museum in New York, Accession Number 34.11.7: https://www.metmuseum.org/art/collection/search/253427

36. Das has depicted the beaches of Puri dominated by the dark, looming figures of fishermen and their families in many of his prints.

37. A type of a relief printmaking tool like burin.

38. Shanay Jhaveri and Anthony Stokes, *Bhupen Khakhar: Works from a Private British Collection*, https://www.grosvenorgallery.com/exhibitions/21-bhupen-khakhar-works-from-a-private-british-collection/overview/

39. Timothy Hyman, *Bhupen Khakhar* (Ahmedabad: Mapin, 2006).

40. Sonal Khullar, *Worldly Affiliations: Artistic Practice, National Identity, and Modernism in India, 1930–1990* (Berkeley: University of California Press, 2015), 194–200.

41. Karin Zitzewitz makes this point particularly well in *The Art of Secularism: The Cultural Politics of Modernist Art in Contemporary India* (London: Hurst & Company, 2014), chapter 5, esp. 136–142.

42. British Museum object number 1995,0406,0.3.

43. J. Huisman and Jan Hoet, *The Spirit of India*, exhibition organized by de Bijenkorf and Inventure India (Amsterdam, Den Haag, Rotterdam, 1993).

44. Established by Robert Thomas, a Welshman who came to Calcutta in 1833. See Tirthankar Roy, "Trading Firms in Colonial India," in *The Business History Review* 88, no. 1 (2014): 9–42; p. 34; and Sarah Besky, *Tasting Qualities: The Past and Future of Tea*. (Berkeley: Univ of California Press, 2020) 55.

45. Sumathi Ramaswamy, *Husain's Raj: Visions of Empire and Nation* (Mumbai: Marg, 2016), 25.

46. Sanjukta Sunderason, *Partisan Aesthetics: Modern Art and India's Long Decolonization* (Stanford: Stanford University Press, 2020), 235.

47. Haimanti Dutta Ray, "Paintings and Water Colors..!" in *Reflections*, December 2021, https://reflections.live/articles/944/paintings-and-water-colours-3289-kxykmbpl.html, accessed 3/26/2022

48. Somnath Hore, *Wounds: Solo Prints Exhibition = Kshata* (Dhaka: Bengal Gallery of Fine Arts, 2011), 9.

49. Ibid, 11.

50. Ibid, 15.

51. Ibid.

52. Chittaprosad, *Hungry Bengal: a tour through Midnapur District in November 1943* (Bombay: 1944); Sanjoy Kumar Mallik, *Chittaprosad:*

A Retrospective 1915–1978, 2 vols. (New Delhi: Delhi Art Gallery, 2011). See also Sanjukta Sunderason, Partisan *Aesthetics: Modern Art and India's Long Decolonization* (Redwood City: Stanford University Press, 2020), chapter 2.

53. Ila Pal, *Beyond the Canvas: An Unfinished Portrait of M F Husain* (New Delhi: Indus, 1994), 166.

54. Yashodhara Dalmia, *The Making of Modern Indian Art: The Progressives*, (Oxford, New York: Oxford University Press, 2001), 114.

55. Interview with Uma Nair, Bodhibuzz, February 2006.

56. Ibid.

57. Rabindranath Tagore, Sahaj Path, 3 vols. (Bolpur: Visva Bharati, 1930).

58. Nawaid Anjum, "Jogen Chowdhury: The Enchantment of the Everyday," The Punch Magazine (December 31, 2020), https://thepunchmagazine.com/arts/art-design/jogen-chowdhury-the-enchantment-of-the-everyday, accessed 4/14/2022.

59. Susan S. Bean, *The Art of K. Laxma Goud* (New Delhi: Art Alive Gallery, 2012).

60. Geeta Kapur, *When Was Modernism: Essays on Contemporary Cultural Practice in India* (New Delhi: Tulika, 2000), 292–293. Kapur includes an image of the 1976 untitled landscape, cat. 15d, p. 114, in this publication.

61. Yashodhara Dalmia, *Journeys: Four Generations of Indian Artists in Their Own Words*, 2 vols. (Oxford, New York: Oxford University Press, 2011), vol. 1, 229.

62. Ibid, 231.

63. Yashodhara Dalmia, *Journeys: Four Generations of Indian Artists in Their Own Words*, 2 vols. (Oxford, New York: Oxford University Press, 2011), vol. 1, 227–228.

64. Statement on the Center of International Modern Art website, https://www.cimaartindia.com/profile/prabhakar-kolte/

65. Prabhakar Kolte, *From Art to Art* (Mumbai: Bodhana Arts Foundation, 2008), 44.

The Collections of Umesh and Sunanda Gaur: Acquisitions and Aspirations for Modern Indian Culture

Jeffrey Wechsler

At the publication time of this catalog, the 2022 exhibition *Paper Trails: Modern Indian Works on Paper from the Gaur Collection* represents the most recent public presence of an exceptional private exploration of modern and contemporary art from India. Expanding from its first relevant acquisition in 1995 to a collection that numbered approximately five hundred items, the ongoing acquisition activities of Umesh and Sunanda Gaur have produced one of the premiere collections in its field. The significance of the collection has been widely noted; for example, the Gaurs were listed among the "100 Top Collectors" by *Art & Antiques* magazine in 2006 (fig. 1). In the same year, I had the pleasure of working with the Gaurs to organize an exhibition, which was, as a selection of work on paper, a predecessor of sorts of the current display. For that event, I wrote the following:

> The creation of collections of art can become among the most significant of personal undertakings. To outside observers, the simple impact of quantity and value may be impressive in themselves. But the true worth of a collection may also be expressed in how a collector ultimately wishes a collection to function in relation to the world beyond the walls where the art resides. To some, collecting is a truly personal – indeed, an insular – enterprise, to be enjoyed by the collector alone, and perhaps a limited number of family members and friends. To others, the inspiration and joy behind the acquisition of objects is enhanced by sharing them with the wider community. ... The latter category is paramount [for] Umesh and Sunanda Gaur.

The Gaurs have continued to emphasize the potential for public education and enrichment, not only in growing their collection with a careful consideration for the historical impact of the art, but now further propelling their insight and passion for the art of their nation of origin into a vastly enlarged realm, through major donations of coherent sections of their collection to public institutions. This generosity further disseminates the historical, cultural, and aesthetic concepts that grounded the Gaurs' interests and acquisition priorities.

Fig. 1
Cover, *Art and Antiques*
March 2003

The art and culture of India, the homeland of the Gaurs, has been a natural focus of their collecting. Although they have ventured into several aspects of Indian visual production, such as decorative art and even postage stamps, fine art eventually gained pride of place. The first major purchase in that field was a work on paper by M. F. Husain depicting Mother Teresa, acquired in 1995. The impetus for this selection was in good part due to Husain's status as perhaps the best-known of modern Indian artists. Husain was also a major figure in the Progressive Artists' Group, whose initial members included Francis N. Souza, Sayed Haider Raza, Krishna Ara, H. A. Gade, and Sadanand Bakre. Formed in 1947, the group was crucial to the gradual development and flourishing of modernism in post-Independence India. Given the fame and historical significance of the group, the Gaurs realized that a substantial representation of these artists in their collection would create a coherent set of works with historical impact. Acquisitions of works by Husain, Raza, Ara, and Souza represented the core of the Progressive Group, and these were soon accompanied by other first- and second-generation Indian modernists, such as Ram Kumar, Tyeb Mehta, Akbar Padamsee, Krishen Khanna, Ganesh Pyne, K. G. Subramanyan, Jogen Chowdhury, and many more. Then, members of more recent generations were added, including major figures such as Jitish Kallat and Subodh Gupta. It is also important to note that the Gaurs wished to properly call attention to the many talented Indian women artists who were making their mark within the contemporary art world: among these in the collection are Zarina, Bharti Kher, Arpana Caur, Reena Kallat, Nalini Malani, and Madhvi Parekh. Within the scope of modern Indian art, the Gaurs were amenable to all two-dimensional methodologies, including paintings and works on paper in all media, such as drawings, watercolors, printmaking, and photography. Only a few sculptures are in the collection, and this is likely a purely practical decision based on the limited space for home display or storage. However, the Gaurs' decision to consider their collection as a method of documenting various historical, stylistic, artistic media, as well as cultural subsets within the overall production of modern and contemporary Indian art, has become a hallmark of their acquisition procedures. The selection of specific works to enter the collection is a shared decision between Umesh and Sunanda. Working with the parameters of what they want the overall collection to illustrate, both halves of the duo must agree that a given piece is appropriate. Fortunately, as Umesh has commented: "Over the years, our tastes have synchronized."

As the collection grew, and its significance became increasingly evident, the Gaurs determined to make their art available to a wider audience, through presentation of the work in public museums. The first large-scale instance of such a project was an exhibition of over a hundred works loaned by various private collectors of modern Indian art, shown at the Zimmerli Art Museum of Rutgers University in 2002. The exhibition concept was initiated by Umesh Gaur, who contacted the museum's Director and me to inquire whether a project of this sort would be possible or appropriate for the museum. Located in central New Jersey, the main campus of Rutgers University was within Middlesex County, which had the highest

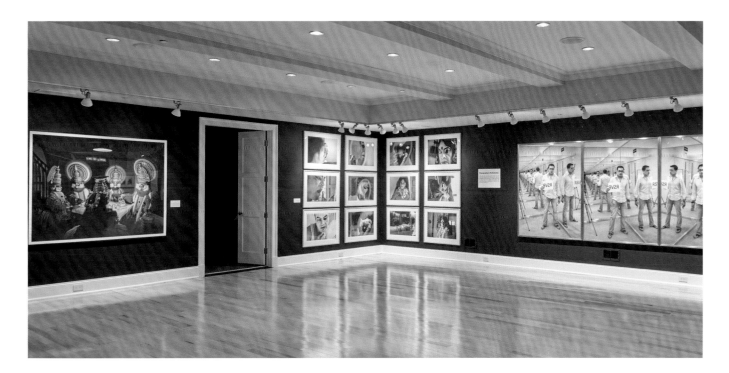

percentage of its population with Indian heritage of any county in the US. Therefore, we realized this was a perfect fit to attract and involve the important regional Indian community, as well as to present a high-quality exhibition from a culture whose modern art was not well known to the general public. The exhibition received an enthusiastic response, and the press noted its status as the first major survey of contemporary Indian art in the US since a show at the Hirshhorn Museum in 1982. Building upon that success, the Gaurs have initiated a series of exhibitions derived exclusively from their collections at many venues throughout the US. A list of these exhibitions appears at the end of this essay.

The Gaurs' commitment to advancing the cause of modern Indian art through public display was not limited to sending the work far afield. In 2010, the Gaurs built a new home, which afforded not only the opportunity to present more work within the family living spaces, but included an entire purpose-built level, designed as a gallery space for rotating exhibitions drawn from their art holdings (fig. 2). These exhibitions were available to the public by appointment, and the space was occasionally also used for various community events, further exposing the art to the regional population. At first, the gallery was called *Bindu Modern*, with an accompanying website. The word *bindu* means "focal point," suggesting the gallery as a center for the appreciation of Indian art. However, after the name began to suggest to some observers that the exhibition space was a commercial gallery, the name was removed. The educational potential of the collection was further realized in part through this exhibition at the home gallery, organized in conjunction with graduate students in art history from Rutgers University.

Over time, with the growing presence and importance of Indian art within the international art community, the Gaurs' natural impulse toward exhibition and education of this cultural heritage led to another important step. As noted before, the Gaur Collection contains cohesive groups of works focusing on historical periods, artistic media, and cultural groups. Two of these subsets are photography and recent indigenous art. With great generosity, the Gaurs have made donations of these sizable collections to public institutions and have done so with careful consideration to which venues will best enhance their impact.

The photographs have been given to the National Museum of Asian Art of the Smithsonian Institution, Washington, D.C., where they will complement large collections of photography from Japan and Iran, as well as the photographic estate of the major Indian photographer Raghubir Singh. In its introduction to the Gaur donation on its website, the museum states: "The subject matter and format of these photographs complement our archival collection of early Indian landscape and portrait photographs that circulated in popular ethnographic and tourist channels. With works dating from 1983 to 2013, the Gaur Collection not only documents South Asian contributions to the development of photography, but it also addresses critical issues affecting the broader global community."

The tribal art collection has been gifted to the Philadelphia Museum of Art, where Dr. Stella Kramrisch, a past curator at the museum, who did pioneering work in researching and collecting tribal Indian art, had donated her own collection. The Kramrisch Collection is considered one of the best and the largest collections of its kind, but mostly consists of objects created before the 1980s, when Dr. Kramrisch retired after a long tenure as the curator of Indian art at the Philadelphia Museum of Art. The Gaur Collection, which consists entirely of paintings which have been created in the last three decades, extends this significant collection to the current times. The Gaur donation also complements the already impressive general holdings in Indian art at the Philadelphia Museum of Art, which notably include illustrated manuscripts, as well as the remarkable Temple Hall of oversize sculptural pillar figures from Madurai. Thus, these examples of the Gaurs' collecting acumen will contribute to even greater appreciation of these aspects of traditional and modern Indian art.

The *Paper Trails* exhibition now takes its place within the continuity of acquisition, exhibition, education, and donation that sets the Gaur Collection apart from many other private collections. However, beyond creating exhibitions drawn entirely from their collection, the Gaurs have also offered their cooperation and participation in various other ways to spread the knowledge and appreciation of modern Indian art. Works from the Gaur Collection have been loaned to exhibitions of Indian art at significant cultural institutions, including the Peabody Essex Museum in Salem, Massachusetts and the Rubin Museum of Art in New York City. The Gaurs also spearheaded the development of *India:*

Public Places, Private Spaces, a highly significant 2007 exhibition of Indian photography, held at The Newark Museum of Art, New Jersey.

The Gaurs' efforts also reflect a compelling characteristic that can be perceived in a considerable number of contemporary India-born artists who have gained prominence on the world art scene. Although many Indian artists use contemporary techniques and media, embracing abstraction and semi-abstraction, video and installation and related formats, a considerable proportion employ traditional Indian imagery, history and mythology to express personal concepts. Inheritors of a civilization going back millennia, these artists accept the validity of the past, even the distant past, to inform and strengthen their current visions. In a similar way, Umesh and Sunanda Gaur, born in India but living in the US, advance an East/West interaction and mutual respect, capturing the creativity of their homeland from recent years, and respectfully gathering it and then dispersing it so that more people can be enlightened by the ongoing production of a venerable creative wellspring that is fundamental within the cultural diversity of the world.

Other Exhibitions from the Gaur Collection

India—Contemporary Art from Northeastern Private Collections
Zimmerli Art Museum, Rutgers-New Brunswick, The State University of New Jersey (2002)

Post-Independence Contemporary Indian Art—Selections from Umesh and Sunanda Gaur Collection
Paul Robeson Gallery, Rutgers-Newark, The State University of New Jersey (2003)

Indian Paintings of the New Millennium
Quick Center for the Arts, Fairfield University, Fairfield, CT (2005)

Modern Indian Works on paper
Georgia Museum of Art (2006); Arthur Ross Art Gallery, University of Pennsylvania, Philadelphia (2007)

Looking In | Looking Out—Contemporary Indian Photography from the Gaur Collection
Stephen D Gallery of Massachusetts College of Art and Design, Boston (2015)

Many Visions, Many Versions: Art from Indigenous Communities in India
Ben Shahn Center for the Visual Arts, William Paterson University, Paterson, NJ (2015); Grinnell College Museum of Art, Grinnell, IA (2017); Surrey Art Gallery, Surrey, Canada (2018); Frost Art Museum, Miami (2018); Weisman Art Museum, Minneapolis (2018–19); McClung Museum, Knoxville (2019); Susquehanna Art Museum, Harrisburg, PA (2020); Leigh Yawkey Woodson Art Museum, Wausau, WI (2020)

Paper Trails: Modern Indian Works on Paper from the Gaur Collection
Grinnell College Museum of Art, Grinnell, IA (2022)

Smithsonian's National Museum of Asian Art in Washington, DC will present a series of thematic exhibitions, based upon the gift of the Gaur Collection of Contemporary Photography to the Smithsonian. The first exhibition in the series, entitled *Unstilled Water*, will showcase works of photo artists Atul Bhalla, Gigi Scaria, Ketaki Sheth and Ravi Aggarwal (December 2022).

Philadelphia Museum of Art will present a major exhibition featuring the Gaur Collection of Indian indigenous paintings gifted to the museum. The working title of the exhibition is *Running Up: Individuality and Indigeneity* (2024).

About the Contributors

Dr. Tamara Sears is Associate Professor of Art History at Rutgers University in New Brunswick, where she has also been co-directing the Global Asias Initiative for the past three years. Her research focuses on the art and architectural history of South Asia, with a particular focus on the Indian subcontinent. Her first book, *Worldly Gurus and Spiritual Kings: Architecture and Asceticism in Medieval India* (2014), received the PROSE Award in Architecture and Urban Planning. Her essays have appeared in well over a dozen edited volumes and journals, including *The Art Bulletin, Ars Orientalis, and Archives of Asian Art*. Her research has been supported by grants and fellowships from Fulbright, the J. Paul Getty Foundation, the National Humanities Center, Dumbarton Oaks, and the Clark Art Institute.

Dr. Michael Mackenzie is Professor of Art History at Grinnell College. A specialist on German modernism between the two World Wars, he has also published on postwar art and architecture in divided Germany. His teaching has covered European modernism more broadly, including the history of modernist architecture, contemporary art and globalization, and the art of India. Significant publications include *Otto Dix and the First World War: Grotesque Humor, Camaraderie, and Remembrance* (2019) and essays on Leni Riefenstahl's film of the 1936 Berlin Olympics, and on painting and architecture in East Berlin in the early 1960s.

Dr. Paula Sengupta is Professor of Graphics-printmaking at Rabindra Bharati University. Trained as a printmaker, her repertoire as an artist includes broadsheets, artist's books, objects, installation, and community art projects. She is the author of *The Printed Picture: Four Centuries of Indian Printmaking* (2012) and *Foreign & Indigenous Influences in Indian Printmaking* (2013). Her curatorial projects include the landmark exhibition *Trajectories: 19th-21st Century Printmaking from India and Pakistan* (2014), *The Printed Picture: Four Centuries of Indian Printmaking,* (2012), *Popular Prints and the Freedom Struggle* (2019) and *Ghare Baire – The Home, the World, and Beyond* (2020).

Emma Oslé is an advanced Ph.D. Candidate in Art History at Rutgers University, New Brunswick, where she is also currently an Adjunct Lecturer in the Department of Latinx and Caribbean Studies. Her dissertation research examines Latinx visual production in the US post–World War II, with special interests in motherhood/mothering, indigeneity, race, and intersectional decolonial feminisms. Prior to beginning her doctoral program, she studied printmaking and sculpture, which appears in her work as an emphasis on process-based art making practices. Additionally, she has accumulated curatorial experience in several museums, including the Museum of Modern Art, New York, NY, Crystal Bridges Museum of American Art, Bentonville, AR, as well as multiple smaller institutions and private collections.

Dr. Darielle Mason is the Stella Kramrisch Curator and head of the Department of South Asian Art at the Philadelphia Museum of Art and Adjunct Professor of the History of Art at the University of Pennsylvania. Beginning with the study of India's historic temples, Mason's work spans two millennia of South Asian culture, from ancient to contemporary. Major exhibitions include *Gods, Guardians, and Lovers: Temple Sculpture from Northern India, A.D. 700–1200, Intimate Worlds: Indian Paintings from the Alvin O. Bellak Collection,* and *Kantha: The Embroidered Quilts of Bengal,* for which she won the College Art Association's Alfred H. Barr Jr. Award for outstanding museum scholarship. She led the curatorial team that transformed Philadelphia's South Asian Art galleries (2016) by breaking traditional museum boundaries of time and geography. She helped the Seattle Museum of Art achieve the same goal as consulting curator on the full re-envisioning of its Asian Art Museum (2020). Her recent monograph, *Storied Stone: Reframing the Philadelphia Museum of Art's South Indian Temple Hall,* uses Philadelphia's focal architectural ensemble to delve into a century of debate about exhibition, authenticity, and interpretation.

Dr. Rebecca M. Brown, Professor and Chair of the Department of the History of Art at Johns Hopkins University, is a scholar of colonial and post-1947 South Asian visual culture and politics. She has served as a consultant and a curator for modern and contemporary Indian art for the Peabody Essex Museum, the Walters Art Museum, and the Shelley and Donald Rubin Foundation. Her work examines urban space, modernity, visual political rhetoric, cultural diplomacy, and rhythm, motion, and time in art, visual culture, and exhibitionary contexts. Her many publications include *Displaying Time: The Many Temporalities of the Festival of India* (2017), *Rethinking Place in South Asian and Islamic Art, 1500–Present* (co-edited with Deborah S. Hutton, 2016), *Gandhi's Spinning Wheel and the Making of India* (2010), and *Art for a Modern India, 1947–1980* (2009)

Jeffrey Wechsler was Senior Curator at the Jane Voorhees Zimmerli Art Museum, Rutgers, the State University of New Jersey, retiring in 2013 after 36 years of service. Specializing in lesser-known aspects of 20th-century American art, he has organized well over fifty exhibitions in that field, including *Surrealism and American Art, 1931–1947* (1977), *Realism and Realities: The Other Side of American Painting, 1940–1960* (1982), *Abstract Expressionism: Other Dimensions* (1989), *Asian Traditions / Modern Expressions: Asian American Artists and Abstraction, 1945–1970* (1997), and *Transcultural New Jersey: Crosscurrents in the Mainstream* (2004). He has authored over fifty writings on a variety of art subjects for museums, galleries, and other art institutions, which have been published in catalogs, exhibition brochures, or journals. He has acted as a curator and consultant to the Gaur Collection since 2002.

Kishore Singh is a former journalist and editor, who has been columnist, documentary scriptwriter, and author of books that range from business and history to travel and art. He has written and edited several artist books in recent years, including monographs on Avinash Chandra, Natvar Bhavsar, Rabin Mondal, and M. F. Husain. He was an editor with *Business Standard* newspaper for 13 years where he wrote a column on art and was also an art writer for *Forbes India* and *GQ* magazines. In 2010 he joined DAG to head its exhibitions and publications program and continues to be associated with its content department.

Swathi Gorle is an advanced Ph.D. candidate in the Department of Art History at Rutgers University, the State University of New Jersey with a concentration in Cultural Heritage and Preservation Studies, specializing in religious heritage in South Asia. Her research examines contemporary notions of sacrality through pilgrimage circuits in Andhra Pradesh, India. Swathi's research looks at the relationship between the dynamics of rapid urbanization and pilgrimage experience and how lived religion and "living heritage" complicate work done in heritage studies that emphasize the presumed tensions between tradition and modernity and religious and secular futures.

Sources of Illustrations

The Intimacy of Paper

Figs 5, 7: Reproduced with permission of DACS; © Estate of F. N. Souza; All Rights Reserved, DACS, London/ ARS, NY 2022.

Fig. 6: Courtesy of the Google Art Project.

A Brief History of Printmaking in India

Figs 1, 2: Courtesy of Christie's Images Ltd.

Fig. 4: Courtesy of the Pennsylvania Academy of Fine Arts.

An Aesthetics of Borders, Globalization, and Migration in Post-Partition India

Figs 2, 3: Reproduced with permission of the artist and Luhring Augustine, New York; © Zarina.

Fig. 4: Courtesy of Julio César Morales, the artist, and Gallery Wendi Norris, San Francisco.

Fig. 5: Reproduced with permission of the artist and Luhring Augustine, New York; © Zarina. Image courtesy of Lamay Photo.

Fig. 6: Courtesy of Nyugen Smith, the artist.

Fig. 7: Courtesy of Nyugen Smith, the artist, and the Solomon Collection.

Fig. 8: Courtesy of Alexander and Bonin, New York; © Emily Jacir.

Ancient Narratives of Devotion: Continuity, Transformation, Rejection

Figs 1, 2: Reproduced with permission; © the M. F. Husain Estate.

Fig. 3: Courtesy of the National Museum, New Delhi.

Fig. 5: Courtesy of the Kiran Nadar Museum of Art, New Delhi.

Fig. 6: Courtesy of DAG, New Delhi.

Fig. 7: Courtesy of the Freer Gallery of Art, Smithsonian Institution, Washington, D.C.

Fig. 8: Reproduced with permission from the Bhupen Khakhar estate; courtesy of Christie's Images Ltd.

Fig. 9: Reproduced with permission from the Bhupen Khakhar estate; courtesy of Artforum.

Fig. 10: Courtesy of Atul Dodiya, the artist.

Fig. 11: Courtesy of STPI - Creative Workshop & Gallery, Singapore.

Fig. 12: Reproduced with permission of the Cy Twombly Foundation; © Cy Twombly Foundation; courtesy of the Philadelphia Museum of Art.

Cacophonies and Silence: Hearing Abstraction

Fig. 1: Reproduced with permission of the artist and Luhring Augustine, New York; © Zarina.

Fig. 5: Courtesy of Navjot Altaf, the artist.

Fig. 6: Reprinted from *Hanning dadi (Frozen Land)* (Changsha: Hu'nan Meishu, 2000).

Fig. 8: Courtesy of the Reading Public Museum, Reading, Pennsylvania.

Figs 9, 10, 11: Reproduced with permission of DACS; © Anish Kapoor. All Rights Reserved, DACS, London/ARS, NY 2022.

Figs 10, 11: Courtesy of Ken Lee.

Catalog Entries

Entries 3, 23, 28–29: Reproduced with permission; © the M. F. Husain Estate; Image on p. 74 courtesy of Christie's Images Ltd.

Entry 5: Image on p. 78 courtesy of the Wikimedia Foundation.

Entries 8–9: Reproduced with permission of the artist and Luhring Augustine, New York; © Zarina.

Entry 11: Image on p. 100 courtesy of Museum of Fine Arts, Boston; © 2022 Museum of Fine Arts, Boston.

Entry 17: Image on p. 122 courtesy of the Metropolitan Museum of Art; Image on p. 124 courtesy of Tamara Sears.

Entry 27: Image 27a courtesy of DAG, New Delhi.

Entry 31: Image on p. 171 courtesy of the National Gallery of Modern Art, New Delhi.

Entries 37–39: Reproduced with permission of DACS; © Estate of F. N. Souza; All Rights Reserved, DACS, London / ARS, NY 2022.

Entry 40: Image on p. 200 courtesy of Tamara Sears.

Entry 43: Reproduced with permission of DACS; © Anish Kapoor. All Rights Reserved, DACS, London/ ARS, NY 2022.

Entry 45: Image 45e courtesy of DAG, New Delhi.

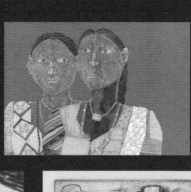

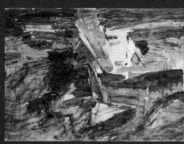
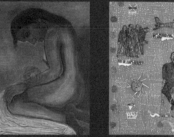
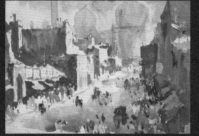
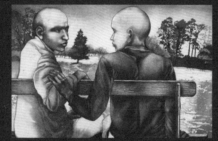
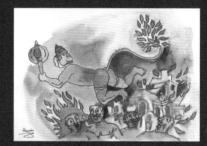
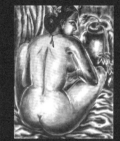
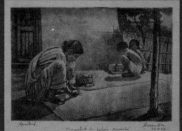
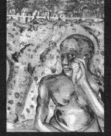

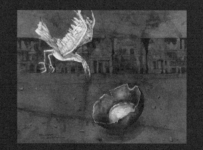
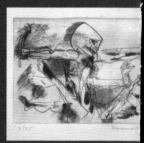
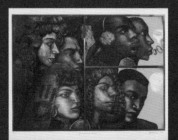
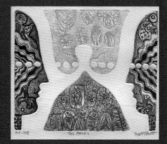